Manfred Schmalriede: What Germans wanted

What Germans wanted

30 Years of Photography in Germany
30 Years of the BFF

Hatje Cantz Publishers

Thank you.

This project would not have been possible without Kodak AG.

BFF

German Professional Photographers' Association

Contents

A Visual Change in the Times in Photography?
Kurt Weidemann.

Fear of Freedom

The human dream of making time, place and event sustainable—by means of an illustration using light—remained wishful thinking for centuries. The enduring and insatiable element in a human life is sight, curiosity. In it physical and intellectual worlds are telepathically linked, related to one another. And we are intent on illustrating it, holding it tight, disassociating it from time. Basically this is how it will still remain—indefinitely. Simply copying what we have seen is as old as humanity. Even our "inner eye" produces innumerable pictures which surge forth.

The more we are able to experience the world around and in us—as captured by the eyes of others—the richer and more fulfilled we consider our brief existence to be and the better we are able to understand the meaning of it. New knowledge becomes art. And art becomes new, beautiful knowledge. Our eyes give the best impulses to our brain. From the very first day and "until the eye breaks".

In the most recent phase of photographic development, electronics has given photography vast freedom of manipulation and opened it up for the intellect: photography is no longer completely dependent on existence and essence. It can do montage, reductions, fade out, change colors, virtualize. This greater freedom, as all freedom, also involves greater dangers: certainty of style, command of forms, control of color, all allow uncertainty and erroneous taste to be recognized more quickly than in a "natural" picture. The really new element has not yet found its artistic form of manifestation. It is only playing with the possibilities.

Control of communications apparatus and of communications media and transmission systems has developed with such speed and become so wide-spread that the human transmission system with its five senses is lagging behind increasingly helplessly. Resignation at the aberrations and complicated nature of the systems is on the increase as is the ever more unscrupulous use.

Our perception is being opened up to new extensions. This changes our living world, blurs reality and stages virtual worlds of experience. The picture interpreter makes his own illusions, uses his own imagination and no longer requires an intermediary. In this process of extension, technology

must adapt what is possible to what is humanly possible and determine locations which bestow fulfillment on life and experience.

The correspondences and processes of differentiation will demand pictorial thought processes of the creator of images—whatever methods are used—which vastly surpass anything we can imagine today. Now that technology has become so perfect and so simple that hardly anything can go wrong, a process has been initiated which requires picture-thinkers and world pictures in new aesthetics. The picture element pixel must create new pictures just like the pointillists in the last century who put certain colors in certain places and their sum total made a picture. The pixel is the smallest medium for information in color or as a shade of gray, in a finite quantity which is intended to impart infinite experience. These basic elements of supply for our perception are supposed to present our senses and not just our eyes with a precise pleasure, as perfect as possible, and grip us so that we need to dry our eyes.

Digital photography combined with direct exposure of the printing plate opens up new quality standards for the faithful reproduction of the original. Note the emphasis on faithfulness, not a manipulated shooting the bolt with the power of color. The scope for fantasy must not be slain by ideas. Restricting the limits of desires is not exactly a popular precept in times intoxicated by consumption.

Were things better earlier, or just different? Everyone only experiences time and the spirit of the age subjectively and time judgments change, correct, discover and reject what has been. The founder generation of freelancers had larger districts. There was not so much crowding in the market. People still talked to their bosses and proprietors. Trends were not so hectic. The nit-picking, head-counting intermediaries from research, marketing and controlling had not yet set up their stumbling blocks and information boards.

Today only a few large hounds can still manage to prevail over the agency boys. The mainstream faithfully takes snaps of the scribbles which result from the compensatory pricing of these interferers. Since then, medals in the toughest area, in advertising, have been hardly more prolific than the coins in the cleaning lady's plate at the public convenience. It is

easier for the shock photography of photo reporters. The cocktails of digital picture mixers produce a hangover. There are only a few left who manage to more or less put the household of their soul in order with their freelance work.

The new rules of the game, markets, opportunities and freedom are de-stabilizing and leave fear in their wake. Fear puts a brake on progress, gives poor counsel, and certainly bodes no good. And to no longer be in on things, to be cast aside, is something which we must learn to be unjust but true. New digital technology makes everything possible and is making our copyright law totter.

In the correspondence between our eye and our brain there is no standstill in historical development. Pictorial worlds are just waiting to be exposed. And for this a solo run is better than a collective search for the zeitgeist. "Creative natures are not speculative. This distinguishes them from the copiers" (Robert Walser). But here, being studious but not industrious, cautious but not careful, controllable but not controlled is not enough. Manifesting something characteristic is not sufficient, it is better to have character and to show a convincing standpoint.

In our search for meaning and values we will reach a new era of awakening. And then contents will be wanted again and forms found for them.

The book in your hands is by no means a commonplace volume of photographic plates. We live in an era of picture worlds, an era inundated with images. This volume provides a retrospective of 30 years of a German professional association which represents creative and inventive photographers. Our members are selected by a jury. The BFF (German Professional Photographers' Association) was founded in 1969 and is an association of photographers from fields such as advertising, education and fashion. They include Germany's top photographers.

"What Germans Wanted" which has the German title "Zeit Blicke" is neither a jubilant nor a jubilee publication. It takes stock of non-commissioned and commissioned photographic work in Germany. "Zeit Blicke" was conceived as an exhibition to commemorate the BFF's 30th anniversary. The renowned photographic art historian Professor Manfred Schmalriede and our honorary member Hans Hansen, a master of the masters of German still life photography, selected these photographs from over 2000 researched pictures. The selection was based on their immense knowledge of photography in Germany over the last 30 years and of the highlights offered by our members. They sifted through countless annuals, monographs, exhibition catalogs and volumes of picture plates.

Both the book and the exhibition constitute a very personal statement by both curators and make no pretense of being complete. And yet the selection does show what our members understand by the term photography. Photography where the picture has to speak for itself. Detached from magazine typography, freed (?) from any advertising message, without any direct pointer to the purpose of the motifs depicted. As a viewer you will be less interested in the name of the photographer than in the year the picture was taken. Here in Germany free-lance photographers are subject to two-fold pressures. Several customers act according to the Biblical saying that the Prophet is always disregarded in his own native country. They fetch shooting stars from abroad convinced that: "If he can't manage it, then no-one can!" Furthermore, the professional image of photography in Germany appears to be so tempting that scores of youngsters are spilling onto the market. But the globalization of advertising

campaigns for instance means that, in addition, several national campaigns have to come to terms with one central image which is dictated to them. Whereas 18 different European photographers used to be involved on the same product in their own individual countries, only one is required today. Thanks to the Internet and digital imaging, the BFF and thus BFF's members are increasingly and intensively endeavoring to obtain protection for their copyright and utilization rights.

I now hope that you enjoying reading "What Germans Wanted", that it becomes an important reference work for you and does not merely serve as a space filler on your book shelf.

Dietmar Henneka
BFF Chairman of the Board

30 years full of exciting developments in the world of photography: of creative design, of progress in society and in technology. In Germany the BFF (German Professional Photographers' Association) has initiated, accompanied and reacted to these developments. Continuous interplay which it is difficult to decipher in retrospect. But one thing is certain: Germany's photographic world would be different and poorer without the BFF. The BFF established the profession of photo designer, thus helping freelance photographers with highly creative standards to obtain a new degree of self-assurance. This positioning is particularly significant in photography, a medium oscillating as it does between craft, design and art.

This is something which becomes particularly apparent at College. Photography or photo design can now be studied at several universities, art schools and technical colleges either as a major or as a minor subject. Every year the young professional prize jointly sponsored by BFF and Kodak and awarded to the best photographic diploma work provides evidence of how high the standard of the photographic graduates is. Their complex and often very comprehensive projects are convincing from a conceptual point of view and also as regards their design creativity and contents.

The expectations made of photo designers are high. They change synchronously alongside developments in the advertising, industrial and journalist professions. And so a magazine photographer constantly has to create profound and intelligent pictures in order to prevail over the faster medium of television. In advertising it is the image of a brand or of a company which comes to the fore and all the more differentiated and exciting photographs are required as a consequence. For quite some time now, fashion photography has been considered to be a seismograph of developments in society. People working in this sector need to have a subtle intuition for trends. And we could quote further examples. Photography is a diverse communications medium. The exhibition "Zeit Blicke" shows that the best pictures fit this bill irrespective of when they were taken.

Technical developments in photography have always provided both amateur and professional photographers with constantly improved films, cameras, lenses etc. Extensive equipment is available for every different

requirement. Over the last few years it has been digital techniques above all which have extended our possibilities for depicting images and changed production methods. They have confronted photo designers with new challenges and their colleagues in allied professions too. However, the Pixel Award, jointly presented by Kodak AG and the BFF for the third time now in German-speaking countries, also demonstrates that analog and digital tools are, above all, a means to an end and that it is creative pictorial ideas which are ultimately the convincing factor. It is no longer possible to imagine a world without photography. A camera is a household item. Pictures by professional photographers are ubiquitous every day in publications and advertising. And yet the status of photography has improved not merely in quantitative but also in qualitative terms as can be seen from the large number of exhibitions of photography. Today many fine artists use photography as their favorite medium of expression. Photographers and photo designers, including several BFF members, present their work at exhibitions and in books. The demarcation line between commissioned and non-commissioned work is becoming increasingly blurred.

Photography is currently experiencing a period of radical change. It has often been predicted that analog photography will experience a development similar to that of painting over 100 years ago. Several areas will succumb to more modern (digital) media. But one thing is certain to prevail—a constant desire to have individual and expressive pictures.

Rainer Dick
Business Unit Manager
Kodak Professional
Germany

The BFF (German Professional Photographers' Association) has been the uncontested brandname for top quality professional photographers in Germany for the last 30 years. Not only great names such as Peter Lindbergh, Reinhart Wolf (†), Sarah Moon, Hans Hansen, Raymond Meier, Alfred Eisenstaedt (†), Thomas Hoepker, Prof. Robert Haeusser, Oliviero Toscani, Volker Hinz, Christian von Alvensleben, Peter Keetman, Andreas Feininger (†), Eliott Erwitt, Ben Oyne and world famous advertising campaigns produced by BFF members are behind this association but also an efficient range of services offered.

Established as an association in 1969, the BFF and its 500 members who are exclusively freelance photographers or university lecturers is today one of the most renowned photographers' associations in Europe. One cannot become a member simply by signing an application form, but must comply with membership conditions such as independent activity as a photo designer and have a portfolio of at least 30 recent works positively assessed by a jury. In a way this makes the BFF an elite association, but ultimately due to the high photographic quality of the members' work.

Since its inauguration in 1969 the BFF has hosted an International Congress every year (every other year since 1996), which has already become a fixed institution on the advertising, media and photographic scene even beyond Germany's borders. Similarly the Yearbook, published annually since 1970, is one of the most important works of contemporary photography and is surely the most interesting document of developments and trends in professional photography in Germany. Every year these 500 page tomes not only show the members' most recent works but also present the winners of the prizes and merits also awarded by the association annually. These include the BFF award for the best works by BFF members, the BFF promotion prize for diploma work by young photographers at photographic colleges in Germany and the Pixel Award for the most excellent digital photograph and electronic picture processing.

BFF Spots which appears twice annually and the BFF Junior Portfolio which has been published annually since 1995 bring us up to date on non-commissioned photography in Germany. In addition, the BFF

offers seminars and workshops and publishes specialist editions on setting up a business / law of contract / copyright / fees / taxes etc...

In order to track down picture rights, conduct picture searches and identify photographers, the BFF has developed a new information system in conjunction with the Fraunhofer Institut fuer Graphische Datenverarbeitung (IGD) and within the framework of an EU sponsored project. Entitled PILOT (Pictures & Licences Online Trail), it is an online clearing unit which is freely accessible to everyone via the Internet: http://bff-pilot.igd.fhg.de.

At an international level the BFF has already run photographic exhibitions in the USA, Canada, China, Singapore and in several European countries. Members' works are regularly on show at exhibitions in Germany too.

According to the BFF Statutes, "... the duty of the association is to safeguard and represent the common interests of freelance photo designers. The objective of the association is primarily to protect and promote the working and economic conditions of its members." The fact that the executives of the BFF have managed to realize this objective not only vehemently but also enormously successfully during the past thirty years, is, alongside the BFF's photographic and artistic potency, one of the most significant factors which has contributed towards the BFF's standing as an exceptional association of professional photographers both in Germany and abroad. And there is a further component too. Perhaps it is the most powerful "motor" of the association's numerous activities: The BFF manages to realize visions and thus to develop a large degree of future potential. If one visualizes all of the things which are on the move at the BFF and which move the BFF, then this association can certainly be described as being the "primus inter pares" of relevant professional photographers' associations.

Norbert Waning
BFF Managing Director

Professional Photography
Manfred Schmalriede

The photographs can answer this question better than this article, because they have been created from the point of view of photo design. The aim of the association "Bund Freischaffender Foto-Designer" is to assert designing photography as well as to represent the photographers' joint professional interests.

Thus men and women photographers linked their ideas up to a long tradition of design in Germany which was, however, interrupted by the Nazis at the beginning of the thirties and did not start up again until after the war, when, after the founding of the Ulm design college, the "hochschule für gestaltung", a center for intense creative activity had once again be found. Even before this event, the photographer Dr. Otto Steinert had invited other photographers to hold joint discussions on photography. The Group entitled "fotoform" constituted an important nucleus for the analysis of photography. In 1949 Peter Keetman, Siegfried Lauterwasser, Wolfgang Reisewitz, Toni Schneiders, Otto Steinert and Ludwig Windstosser formed an association in order to realize their joint goals. In his exhibition "subjektive fotografie" held in 1951 Otto Steinert considerably extended this basis and made the surprisingly wide-spread, creative photography available to the public. In so doing he was particularly intent on relating to the photography of the twenties which had also survived the thirties internationally. This first exhibition also included work by Herbert Bayer and Man Ray which introduced two trends: experimental and surrealist photography. Photographing both possibilities justified the emphasis on the subjective element in photography, something which was the precondition for making creative intentions meaningful compared with a picture-producing machine.

The description "photo design" was coined a few years after the BFF was founded in 1969, not least due to pressure to make creativity internationally understandable by adopting the concept of "design".

But what is photo design? Photography is employed as a creative medium, in a way similar to that of the "New Vision" of the first quarter of this century and the "New Functionalism" of the twenties. The insights and practices of this first great phase of creativity soon became a standard,

which was to form the basis for realizing the ambition of exercising a positive influence on people by means of the new media. In order to understand this ambition, a brief glance at some of the early achievements of photography will help to elucidate some of the aspects of the meaning of photographic pictures.

The interests satisfied by photography during its invention and initial development phase as a workable medium can be seen in some of the "topics" which were favored in early photographs. Portraits, architecture, landscape and "posed" events. The last category is particularly eye-opening. As the exposure times were too long to photograph moving people or things, scenes were posed. Activities were represented by characteristic body posture and gestures. The decisive element was that first of all a "picture" had to be made of what was to be "readable" as a picture afterwards. The first and a simple form of commissioned photography. The typical poses adopted in the pictures represented procedures, processes or events, thus creating identifiable symbols. The first great achievement consisted of creating symbolic worlds. Of course in so doing photographers resorted to the symbols familiar to them from the pictorial world of paintings.

Everywhere where photography proved to be useful it created transportable pictures with which it was possible to observe reality completely detached from the time and place where the photograph was taken. Photographs taken while exploring in foreign countries reduced distances, made it possible to compare things which were geographically far apart and aroused wanderlust.

Mobile symbol worlds replaced actual dimensions. The pyramids in Egypt and the cathedrals of Northern France were made tangibly close. Details became visible and one accepted the fact that a gray or sepia fog shrouded the colorful world. Something which was easy to handle in pictures of an apparently static world, had a strange effect when practiced on human beings—a person's condition in one single moment became immortalized in a picture. The preserving function of photography promised the present and eternity simultaneously. But if it was to be for eternity, then it had to be a pose which was of weighty significance and worthy of being kept. Photography seemed to promise to exchange mortality for a symbol.

Many such symbolic concepts had been tried out in art and staged in front of the camera where they could also be identified in the much smaller photographs. Portrait photography has been a successful use of photography and relevant in society since its inception.

It was, however, primarily in landscape photography, where the type of presentation adopted from painting prevailed as a familiar manner of visualization. In order to realize this it was often necessary to have a montage of picture parts taken using different exposures, one exposure did not allow for an adequate differentiation of the extreme differences in the light. Romanticizing, naturalistic or captured in an impressionistic vein, the range of symbolic forms corresponded to the requirements of the contemporaries who, spoilt by drawing and art, regarded creative photography—artistic photography—as a related type of medium. As in drawing, graphic art and painting, the photograph was designed to adapt the reality "contained" in the picture to the concepts of romanticism, naturalism or impressionism characterized by symbols. This long phase in the development of photography was determined by the search for symbolic forms, which were the precondition for the use of pictures. Photographs designed in accordance with fine art criteria increasingly lost touch with reality which meant that the copying function of photography, which was experienced as something authentic and objective, was also doomed to disappear. But before the appearance of straight photography promised a new orientation, a new form of artistic expression made its appearance on the public stage—the placard.

Artistic design became an integrating part of the message to be conveyed in these placards. It was primarily artists who designed the placards using contemporary stylistic devices. With their large format and reduced pictorial language these works were on a par with art and were soon to become cherished collectors' items which were also shown at exhibitions after they had been used. The creative element had survived the "superficial" function.

The public picture world of placards was the forerunner of the advertisements and posters in which professional photographs play a dominant role today. The pictures in early placards were aimed directly at sales objects or

events by means of their texts, they illustrated the events which they announced and presented the participants and the subjects. The early placard style was bold and therefore anti-photographic because a naturalistic reproduction of reality in placards did not have any effect when viewed from a greater distance. This placard style was an expression of artistic creativity.

In a way similar to that of the public world of placards, illustrations of sensations in illustrated magazines also aroused public interest. The first reports of the Crimean War and the American Civil War showed the disasters of war and all its horrors. And the question of the meaning of such reports was answered by the reactions to the photos and their use. A sensation for some, documentation to substantiate history for others, evidence, concrete memories, which we still have at our disposal today. The testimonies are kept in safe custody in large archives.

Here we are not only interested in documented history but in the history of pictures, the history of photography and the question of the conception and creation of such pictures.

It is not only the historically readable aspects of a photograph but also the way it is presented, its way of seeing and designing reality. For a long time symbolic forms were in the foreground, particularly for the use of pictures. Then demands grew and an attempt was made at creative processing.

When appraising part of the history of photography, account should be taken both of the contemporary relationships at the time and also of ever-changing design criteria. The pictures presented here were taken by men and women photographers during the last thirty years. They are photographs which were produced for various types of utilization but which have one thing in common—they were created for the general public, whereby the term general public must immediately be put in perspective. A large number of photographs was taken without a commission. No client, agency etc. therefore made any stipulations, thus eliminating the relationship to the general public—were it not for the associated aspiration or desire to have the non-commissioned work on show at an exhibition, in a gallery or museum, in order to achieve recognition for the design or

artistic creativity of the work. Professional jargon speaks of alternative photography. Americans are less reserved about making such claims and by using the term "fine art photography" move it right in line with the other arts.

The difference between commissioned and non-commissioned photography has hardly any role to play in this presentation, because here all of the contexts of usage have disappeared and only labels such as journalistic, fashion, people or still life photography remind us of their former use. The concrete relationship to political or society events, to contemporary fashions and design remain present, however.

From a historical viewpoint, artistically designed photography only represents a brief episode and yet it continues to exist as a phenomenon. The significance of creative photography is considerably distinct from this phenomenon. We must make a short historic digression in order to be able to use the distinction in our further considerations.

Shortly after the turn of the century, the phase of created photography, "art photography" or pictorialism called up the protagonists of "pure" or "direct" photography of "straight photography", thus paving the way for creative photography. What this exactly means can be shown by some aspects of its development.

At the time of its inception, direct photography meant direct access to reality. Without any intervention by the photographer the intention was for the subjects to be grasped in accordance with their external circumstances, camera technology and film material. This conditioned portrayal was experienced as direct and according to the conditions as "pure" i.e. unadulterated. The restriction due to the camera equipment was accepted as unalterable and was intended to be a visible and, for the beholder, understandable component in the picture. The sectioning and fragmenting picture square was employed as an organizing, that is to say creative moment. As was the abstracting realization of colorful reality in the gray shades of the film and photo paper. Experiments with photograms reduced this awareness of transforming design to elementary photographics. Photography without a camera meant that the things had to be organized on the paper, as the silhouettes or figurations in the photogram appear "meaningfully" related.

Lighting was also effected according to ideas stemming from abstract and constructivist art practice. Design phenomena of this type made photography into a design medium. Whether with or without any identifiable relation to reality, design was predominant and in the twenties this was understood as a constructive intervention in reality compared with the random representation of reality. This is where the claim to the positive effect of creativity originates from.

New Functionalism reduced everything to a common denominator: **reality had to be "presented" so that the picture could be seen as an analogy to the constructed world and could simultaneously stand as a symbol for technically constructed aggregates. Other objects, including people, flora and landscapes, were also meant to show something of the regularity or of the typical. In this connection abstracting was frequently carried out so that for instance a certain light produced an alienation of the subject, causing a magical effect similar to that of the paintings of magical realism. Dadaists such as Raoul Hausman and Man Ray were directed by the alienating practices of the surrealists, who, like Laszlo Moholy-Nagy too, considerably extended the creative palette by strong sections, negative prints and solarization. New Functionalism followed on from industrial and architectural technology with perfect camera techniques and stark pictorial concepts. The span of creativity in photography was great because pictures alienating reality were also produced using "pure" photographic means. During the period immediately after the Second World War a decisive conclusion was drawn: the technical possibilities of design were left to the subjectivity of the photographer so that the objectivizing photography of New Functionalism was passed over to the subjective handling of the photographer. The Subjective Photography we already mentioned now begins here.**

Before starting with the sixties we must first briefly sketch out another development which took place in the twenties.

Reporting and photo journalism **became additional highly successful uses of photography. Dr. Erich Salomon, Umbo and others roamed the streets of the capital in order to invent events with their pictures, which could count on public interest. The major magazines were concentrating increasingly on photography which had a more authentic touch than**

illustrated reports, although the drama of many a sensation depicted in an illustration failed to come across in a photograph. Salomon was the very first to succeed in gaining an insight into the world of politics, diplomacy and also of the rich on behalf of the politically interested public. Is it the eye of a voyeur or of a conscientious documentary presenter which is looking behind the scenes? Satisfying the curiosity of the public, once aroused, combines variants between these two poles, because how can the curiosity of others be satisfied if the photographer is not aroused by a similar curiosity? This still begs an answer to the question as to how both curiosity can be aroused and the duty of the chronicler be maintained. Or the same question another way round: What is journalistic and what is documentary photography? At the end of the seventies, Thomas Hoepker, photo journalist and art director, spoke of a crisis in documentary photography. The description of the crisis provides an explanation of the meaning and success of this type of photography. The question cannot be answered directly here. But a word about the crisis in photography which began to emerge in the fifties also affects photo journalism, since, following the spread of television, the major magazines lost their leading position in the communications market. Photography received a damper from a different quarter.

Black and white photography was still the rule in the fifties **because color photography was too expensive and the quality of color still left a lot to be desired. Rationally oriented creators or designers were quite content with black and white because a colorful world hardly fitted into their philosophy. Photographers of Subjective Photography regarded black and white photography as being a creative element, as strict as it was consistent. Reducing reality to a minimum by means of abstraction only produced at best silhouettes or figurations without any internal details. In conjunction with an equally as constructively applied script, a clear and easily comprehensible whole picture arose. A reduced form world was easier to manipulate as a picture of rational design. Photographics was a new term for these concepts. An extreme example of this photography was provided by Lothar Klimek. These pictures are based on clear concepts and equally as clearly formulated ideas. The precisely structured shapes reflected the strict concepts; the constructive and often serial organization of the subjects and**

of the respective pictorial means symbolized a proximity to the rationally conceived world of technology. The uniformity and therefore guaranteed equality of mass production goods was linked, not only metaphorically, but also at a technical level. Willi Moegle is the protagonist of this photography which created thoroughly contemporary design. This photography has, as will be explained later, created adequate pictures for rationally conceived design. Illustrative photography was put under pressure by rational design. Realistic illustrations were dependent on the rather random characteristics of reality and did not therefore seem capable of making general statements. The illustration became wide-spread in advertisements and on posters in particular as a superior form of expression. It enjoyed the privilege of being able to design freely and of giving the presentation something of the creativity of artistic activity.

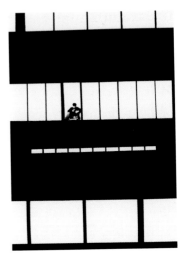

Lothar Klimek

Photography was saved from becoming extinct, because—despite cinema and television—its way of depicting the world was superior to that of moving pictures. In journalism photography managed to transform events into concise symbols which were easy to memorize. Muhammad Ali's fist—as photographed by Thomas Hoepker in 1966—is a striking example of this.

Willi Moegle

Documentary photographers employ extremely subjective methods. In the sixties, photography taken from below was a wide-spread way of seeing. Interpretive vision was enhanced by using extremely wide-angled lenses. The political scene was depicted dramatically. Radical extracts produce a proximity devoid of distance and the remaining space in

the picture forces us to concentrate our vision by means of focusing on important details. We can see the way in which different meanings can be created purely in the eyes and by a limited surround in the face of the starving child, photographed by Gerard Klijn and in the section of the eye of Germany's former Federal Chancellor, Kurt Georg Kiesinger, taken by Dieter Steffen. The observer feels drawn into the events. Political events are conveyed deep down, the beholder feels that the photographer is part of the scene.

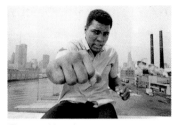

Thomas Hoepker

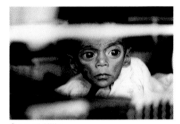

Gerard Klijn

Journalistic photography sorts out political and societal events in order to directly disseminate news. In addition, the reports attempt to highlight background and contextual information, accompanied by or illustrating a text. After over thirty years some press pictures have become symbols of political and societal change. Knowledge of the people and of the background is the pre-condition for this symbolic function, to enable the author to get to the heart of something typical in the current event. This type of live photography becomes a contemporary witness, an authentic one, because even today it is still able to convey the feeling of being or of having been there. And a subjective one, because it takes up moments which are inevitably rather random extracts of concrete events and their political, societal structures. "Invasive" photography, manipulating the event, by comparison with the photographic objectivity otherwise so often conjured up. Photographers are always on the look-out for sensations: a bank robber being shot to death, or everyday behavior when someone drives off the highway to have a break and relax in a pull-up.

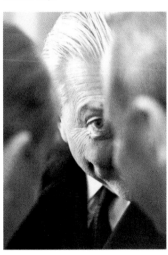

Dieter Steffen

27

Photography appears be factual when we look at industrial photography, **often used merely to illustrate annual reports. But the photographs of the steel industry shot by Ludwig Windstosser are anything but purely factual. They too were taken at close range and concentrate on brief production sequences. Reality thus becomes so abstract that we are forced to read the pictures in a second way too— either based on their strict formal organization or their color composition. The pictorial design comes to the fore, continuing the tradition of the New Vision of the twenties. And it requires a logically consistent step to do without an identifiable connection to reality and create abstract photographic pictures. This extreme pictorial conception of generative photography by Gottfried Jaeger presents aesthetic patterns in their purest form just as was practiced in abstract and constructivist art. Here the idea of artistic practice formed the basis for the technical production of pictorial worlds.**

Scientific photography primarily serves research projects **where chemical and physical processes not visible to the human eye are made visible. The photographs by Manfred Kage and Dr. Bernhardt Brill not only make the invisible visible but create a direct approximation to aesthetic patterns of art. Whilst this is not, of course, the actual intention of this photography it does constitute a direct method of providing access to scientifically processed reality by means of the patterns learnt from art. Scientific competence results in interpretations other than those superficially suggested by their colorfulness. But is it not always a question of having suitable contexts in order to use pictures in their signifi-**

Ludwig Winstoßer

cance? Commissioned work is only meaningful within the context of the respective assignment. But some quality or another remains even when disassociated from familiar contexts. Or in more general terms: the quality of design can be assessed by concrete targets, but seen from a distance, certain ways of beholding, the way in which something is presented or associated with other phenomena proves to be conditioned by the time. Deformation by using the extremely wide-angled lenses already mentioned, deformation by using concave or convex mirrors, as in the pictures taken by Dieter Hinrichs, blurring moving subjects by using long exposures or moving the camera along too, reducing the depth of focus in favor of lack of focus, these are all aspects of interpreting reality and of retaining the picture character of the photographs within the framework of what is typically photographic. Or producing pictures which become further and further removed from our concept of reality. Horst H. Baumann, Erwin Fieger, Charles Compère and Harald Mante revel in color and compare themselves with the impressionist vision of a colorful reality.

Photography creates its own pictorial worlds, which appear to be drifting in different directions. Factual photographs primarily employed with their strict order resulting from industrial production. The photos thus take up the topic of the precise and perfect uniformity of industrial production. Mass production leads straight to a systematic arrangement of the subjects in the pictures. Here black and white photography is better able to abstract from colorful coincidence. In aligning the

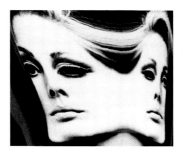

Dieter Hinrichs

29

motifs and the pictures, the systematic series becomes evident as an aesthetic pattern. In addition, when comparing the pictures, alterations and discrepancies become apparent. This consequence of photographic organization continues to remain effective. It is typical for the rationality of design production. And it appears in its pure form in abstract photography.

Photographers are aware of the artificial nature of picture-making, and this type of photography has produced visually effective aesthetic patterns more than the objects of design themselves. A different departure in photographic concepts is taken up by the surreal practice of alienation. Either the actual subjects already appear surreal or photography pushes itself between us and reality as an alien denying direct access.

The forms derived through abstraction and surreal alienation produce an irritating quietude in the photographs by Robert Haeusser — proof of the synthesis of these very divergent phenomena. On its way to abstraction reality becomes transformed into "unreality". The fashion photography of F.C. Gundlach is to be found here.

Black models photographed by Charlotte March adopted a special role during this era at the end of the sixties. In our culture anything exotic still has an exclusive touch. But anyone declaring their support for the bright objects made of the newly developed plastics, was soon to experience the unusual as the expression of their own life style. "Twen", the young people's cult magazine, devoted a special place to photography. Shrill fashions and liberation from sexual taboos provided the basis for

new interest in corporeality. Will McBride, Rita Kohmann and Guido Mangold bent the bow from the liberated life in a world of sexual enlightenment in which children and adults were able to romp about without taboos, to the romantic transfiguration of beautiful girls who were able to demonstrate their tenderness in harmony with nature. A mixture of journalism and staging forced photographers to take nudity to symbolize this new freedom. In its way the fashion of the Twiggy era also made a contribution towards disseminating the process of liberation via photography.

Robert Haeusser

The elegant opposing worlds of fashion — spell-bound rather than liberating—were launched by Regina Relang and Walter E. Lautenbacher. Alienation through color created an atmosphere, an aura, for the exotic appearance of women in the pictures shot by Walter E. Lautenbacher. Regina Relang, who had made a furor with the fashion pictures she created on the streets of Paris in the fifties, was now searching for something exotic in a montage of fashion and art. She combined her fashion photos with naive art or created an elaborate staffage of bright fabrics.

A wide-angled lens stretches people standing in the foreground and causes a slightly manneristic interpretation of the human body, creates a touch of surreality in a picture world which is otherwise so sober. Under the influence of the surrealism which was not re-discovered in Germany until late on, photographs illustrating reality were shifted. Even filtered, natural light, contributes towards this atmosphere. F.C. Gundlach is looking for extravagance of this ilk in his fashion photos—

31

and if one bears in mind the earlier subjects and locations of Grundlach's photography, then his proximity to subjective photography becomes apparent. In a way comparable to that of the work of Robert Haeusser they tend towards an existentialist symbolic world. F.C. Gundlach and Reinhart Wolf were still protagonists of slightly alienating people and still life photography right through into the seventies. Perhaps Reinhart Wolf's fashionable arrangement of a group at table precisely conceals the unnatural element by the artificial nature of the staged "natural look".

The gentle stretching of fashionable people is made dynamic by other photographers so that the suggestive pictures make a changed life feeling more concrete. Was it the dynamism of the dreams and longings of these people which became visible through the diagonal view of rooms with a distorted perspective? Or a new awareness of freedom which, anticipated in the pictures, is to serve as the model for future life. Seldom before have diagonal picture worlds corresponded to fashion pictures in this way. The pose for Courège, so typical of Goetz-Eberhard Sobek's fashion photography, does not only characterize the "off-beat" element of the time but also latently imparts something of woman's childishness. Men's trousers with wide bell-bottoms, tight jackets, high plateau soles and heavy high heeled women's shoes, short skirts showing more leg, all of this was the pre-condition for dynamic people who seemed to be at the center of life and to owe their self-esteem to the solid pedestals they were standing on. And by the way, these pic-

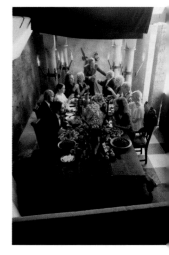

Reinhart Wolf

tures are not dissimilar to those arising at the end of our era.

The elasticity of the plastic world, **its lightness and malleability are all phenomena of a modernity which puts its faith in the future, in progress and feasibility. Furthermore, this vision was also re-vealed in politics, at least in the politics of the former German Chancellor, Helmut Schmidt, who, as a "doer" represented the law of action, of an American-based pragmatism, which was not to be proven as the motor of the economic interests of a younger generation until the mid eighties. This is when a generation unfettered by the burdens of history was to leave the path-finding traditions of the past. And yet it was not possible to impose what was politically feasible on society — not least on account of a change in consciousness following the oil crisis and the excesses of the violence directed at the state. However, there is no direct link between crises of this type and blueprints of fictitious worlds which, once they are sworn by, constantly require new fictions, so as not to be the victim of their own. In this connection there appears to be an increasingly wide-spread need to foster fictitious rather than actual realities as hav-ing the more promising future. In the photographic trade, it is the photo journalists who are respon-sible for the hard facts. In view of the increasingly effortless staging in the advertising world they re-treat in order to realize their own moral standards which they try to incorporate in their work, and so as not to be constantly corrupted.**

But what is this frequently-quoted reality which photography in particular feels obliged to

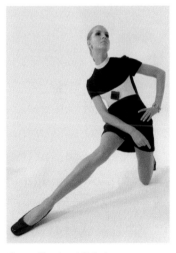

Goetz-Eberhard Sobek

33

serve? In 1960 Karl Pawek already initiated a funda-
mental discussion on the changing understanding
of reality in his book "Total Photography" and three
years later in another publication entitled "The
Optical Age". His concept of "live photo" was to
confer on modern photography the dimension of a
contemporary medium—in particular in comparison
with the autonomous picture of modern art—which
was intended to do justice to the predominance of
vision in our culture. His theoretical considerations,
as practiced in the cultural magazine Magnum,
scarcely fitted into the debate on realism fielded by
other ideologies, so that we are still waiting for an
appraisal of his thoughts with regard to the current
situation of photography. At the time it was impos-
sible to anticipate that his manner of applying
photography would have indirect consequences on
fine art. The change in paradigms which has been
in slow preparation since then, took place via art
and lead to a changed conception of photography
in the mid seventies. These changes took place dur-
ing the early age of the German photography pre-
sented here. They could provide a means of orienta-
tion for describing the shifts in the utilization of
photography.

Indirectly this is about a changed under-
standing of what reality could be and directly
about the acceptance of photography as a medium
with a conveying function. The roots of the changes
effected then by virtue of art and media criticism
had already been laid earlier in various currents of
modernism and these changes are only now being
effectively disseminated by the mass media. Media
for the masses became a decisive reference system

in pop art. In general terms it was the living world of the people which many artists now also accept as being theirs and that of their art. Reality was now the everyday world, everyone's familiar surroundings. And the photographic and movie pictures in the cinema and on television were also real.

This means that reality does not exist in isolation, cut off from people and their media, but that everything forms interconnections which constantly need reorganizing. Despite fictitious worlds, pictures are real—not only when they are used in a collage or montage to make another picture—but intrinsically for what is to be seen in the picture.

In this sense of the word we speak of photo realism, a term which was, however, circulated by analogy to a special method of painting a picture. In America photo realism as painting was a reaction to the consumer world integrated in pop art which included sub-cultures such as entertainment and advertising as well as everyday snap shot photography. Because snap shotters developed stereotypes for photographing the world which were extremely successful at shooting frequently recurrent everyday events such as family, holiday or travel photos. For some artists, this type of photography and the looks they contained were exactly the reality they fall back on when painting pictures. In large formats showing clear forms and colors applied without leaving individual traces these pictures looked just like large photographs. The precise enlargements set standards for photography. The presentation seemed to be so realistic that it appeared more realistic than reality and familiar

photographs. A perfectly painted photograph became photo realism—despite the illusionist effect. Viewed from another perspective this meant that in their fiction, the pictures' illusory world was regarded as a "second" quickly manipulable "reality".

And now, if not earlier, massive criticism was leveled at the beautiful illusion of things, and the reproach that photography was supplying the instrument for the aesthetization of the living world cannot be rejected out of hand. But there is no justification for an across-the-board criticism of photography because the photographic scene relativizes the aestheticization introduced. Although presenting the "discovery" of photography as a sheer inexhaustible medium quickly encourages pictures to be independent, when projected onto beautiful women and things, aestheticization and stylization is not long in coming. But at the beginning of the seventies Christian von Alvensleben already argued that if he exchanges the perfectly styled body of a model for a fat one then he takes her just as seriously as a model, thus maintaining the association with normal life. The still life photos by Brigitte Richter do without any staging, they just take things as they are lying or standing around. When Jacques Schumacher amusingly exaggerates perfection and eccentrics, this world remains transparent. Later on it is Peter Knaup and other photographers who present fine luxury articles in such precise enlargement that despite all the splendor it is the material, the colors and texture of the cosmetic utensils which fascinate us more than the cosmetic female luxury

which is actually meant to be conveyed.

Photographic differentiation permits one view which does not apply in the normality of the world of things. This means on the one hand, the stylization of things for the world of beautiful illusion and on the other hand, the creation of a pictorial world which has real elements, because what we observe cannot be seen like that anywhere outside the picture. A phenomenon which occurs in a very similar way in the scientific photography which has already been mentioned. One can also speak of a reality of signs which are made to relate to other forms of reality by means of interpretation. In this connection we also spoke of a sensitization of perception, in particular with regard to contexts within society politics. But sensitization cannot be restricted to certain contents but causes a differentiation in perception in all areas of life. As people we are integral beings and restrictions can, at best, only be achieved by contexts which induce us to accept certain relations but not even to perceive others. It was not possible to check the euphoria in the blow-up of the pictures by prohibitions or taboos—at best only by counter-drafts. And a counter-draft was available in no time. When a camera gets too close, then it runs the risk of cutting the world up too much, of producing sections, fragments which are hard to decipher. Till Leeser and Peter Knaup, the latter in advertising, ran the risk of an apparently arbitrary limitation which implied two consequences, however. On the one hand, the impression was created that reality continued beyond the edge of the section and on the other hand, the picture appears to have been composed extremely seve-

Christian von Alvensleben

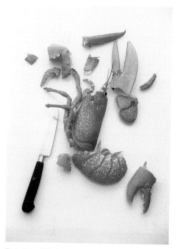

Brigitte Richter

Peter Knaup

rely, which means that the parts of things which have been cut off are not missed because the visible parts have been processed to become a new system of relation. The apparently arbitrary limitation draws our attention from the design of the things to the design of the picture and the dream of design was also fulfilled where the banality of the things hardly seemed to do justice to this desire. Of the two ways of interpreting the pictures, one leads straight back to reality.

The hand of a printer, photographed by Christian von Alvensleben, shows the beholder the obvious signs of the times and of labors, a texture "written" by life and amplified by work. In the pattern of fine nuances, parts of which are enhanced by printer's ink, we can detect similarities with other patterns in nature. Connecting patterns between far-flung phenomena, the proximity of the pictures can convey such realizations. This is why presenting a juxtaposition can clarify such common elements despite different topics.

Peter Knaup

Walter Schels works at comparing and confronting pictures. The picture of a baby's hand taken immediately after birth alongside the hand of an old person. Or he confronts the portrait of a man with the head of an animal. Whole sequences of pictures become interconnected through similar phenomena.

Hans Hansen completely relies on light when using the transparency of the background to avoid the proximity to or relationship with a materially understandable atmosphere. He proffers to the proximity to things the opposing world of what is specifically photographical: light. Light as the real

element in photography therefore becomes its "load-bearing" element, in which things appear to float. Transposed out of this world they appear to be completely photographic phenomena. Later his predilection for water (including underwater photography) is to supplement the world of light, or blue sky is to suggest the unlimited world of the picture, or the color blue is to be unfolded as in Jacques Schumacher's Blue Series. The monochrome background has an almost transcendental character but later serves to isolate the things and present them in a pointed manner. Whilst the things in Hans Hansen's pictures already have some slightly unreal traits, photographers such as Ernst Hermann Ruth and Gerhard Vormwald amplify this impression. In this way Ruth accomplishes the symbiosis of the motor cyclist with his environment, equivalent to an idealization or glorification. Through the alienation of reality, forms appear as a silhouette of the things, their specific looks or their specific figuration. In the tradition of New Functionalism this tendency goes hand in hand with an awareness of the design of things. Here there is a domain of photography from Willi Moegle to Hans Hansen and Manfred Rieker and beyond, perhaps it is a specific element of German photography.

Hans Hansen

But wherever there is "alienation", the transition to a "magical" appearance of things is not far away. The real provokes its own shifting into the surreal. If we adopt terminology from art history here in order to describe this type of alteration or transformation, then it is in the hope that these concepts have become part of our everyday language, they characterize phenomena which we

have been perceiving in artists' pictures for a long time. With his flying people, Gerhard Vormwald perfected the staging of surreal worlds. Everyday logic quickly falls by the wayside here. Either it is replaced by the logic of the pictures or the absurd element of small fictions becomes effective, fictions which help our desires and longings to find a very special form of experience.

In new dimensions photography proves to be extremely manipulable within the framework of advertising and posters and an editorial application.

Ernst Hermann Ruth

Pictures and texts mutually encourage more and more new meanings. They thus become even more distinct from documentary and journalistic photography. Let us ignore the fact for the moment that staging and manipulation is effected in this genre too, it still has to investigate and sort out an ever-changing world with its problems and conflicts. We introduced this intervention as a form of symbolization. A process which, unlike the world of fictions, somehow tries to assimilate the known and familiar world in everyday experience. Symbols arise when familiar contexts are changed or presented by unfamiliar ones. A piece of cake showing the red cross emblem and above it the picture of a report on a red cross ball: shots taken by Volker Hinz at a time and in a condition where the dreariness of a charity event is re-discovered in the dreariness of a table setting. Rather sarcastically one could evaluate the performance of a photo journalist by the way in which he succeeds in maneuvering familiar symbols into the significance intended by shifting the context.

There are pictures which we always remember because they present people or events which portray complex areas of experience. Hilmar Pabel's picture "Death of 'Little Orchid' " (1964) with the American GI in the early days of the Vietnam War. Or the photograph of the meeting between Guenther Wallraff, Wolf Biermann and Rudi Dutschke, taken by Wolfgang Steche in 1976, which seems to anticipate future developments in the passive posture adopted by Biermann as compared with that of the comrades to his right and left. Perhaps such observations only apply to contemporary onlookers who have experienced the symbolization process in these pictures and pursued the historical context. Although not only reports, also our history books refer to individual pictures which are able to portray political events by condensing an extensive description.

Hans-Juergen Burkard

Pictures' dependence on context becomes particularly clear in scientific photography. Because the commission for this type of photograph relates to possible findings within a research project and is actually only decipherable in this context. If we still find the pictures Manfred Kage took using an electron microscope fascinating, even though we do not have the respective scientific knowledge nor can we reap any possible benefit from them, then it is because the colorful forms, textures or figurations resemble those of abstract painting or remind us of bizarre objects of everyday life.

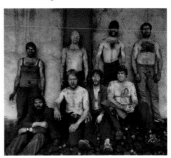

Eberhard Grames

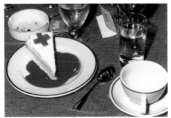

Volker Hinz

The pictures of a balloon bursting and of an airbag inflating are taken in incredibly short fractions of time. The pattern of the yellow balloon which remains visible in the photo shot by Dr. Bern-

hardt Brill gives us an insight into the uniformity of physical processes. By analogy, the idea could take shape that the random nature of patterns in the section of a picture could serve as an orientation for us to identify something meaningful. Concepts such as landscape, architecture, portrait or still life are rather roughly hewn and worn out. And precisely the changes in this type of pattern or their shifting within familiar sections of pictures give reason to produce new pictures. In this way we typify and classify, organize style criteria with which we attempt to identify distinctions between individual photographers or the vision of certain eras.

A comparison between two completely different series of photographs can help to clarify this important aspect. Reinhart Wolf photographed skyscrapers in New York using highly sophisticated camera equipment. The sections taken have turned the monumental architecture into austere pictorial constructions. The location of a colorful art-deco building in front of the simply-structured facade of a much higher building results in a mixture of two "ornaments" within the picture as a result of the photographic transformation. The much simpler picture by Till Leeser is comparable. It shows a limited section of a zebra behind wire netting. In both cases the existent patterns were removed from their surroundings and aesthetically re-associated in the picture, opening them up for interpretation. Whereas clarity and comprehensibility are exposed by Wolf's pictures, Leeser's provoke irritation about the desolate living conditions of animals in captivity.

The end of unequivocal design concepts is in the offing. **The medially mixed concepts from pop culture on the one hand and artists' experiments in concept art on the other are resulting in consequences. An unequivocal use of pictures is becoming increasingly less feasible. Since they are, as a rule, dependent on a context, this context determines their significance. Yet the contexts do not simply ensue from texts as in journalism or advertising but from the photograph itself, from the various "ways of seeing", from presentations and technical manipulations, from its manner of being used and its history. This extensive repertoire goads us on to implement mixtures. In the seventies Ben Oyne began with the reconstruction of everyday scenes. He stages documentary photography or snap shots so as to imply that they stem from a long-forgotten era. And sometimes it looks as though a snapshotter released the shutter, because something got in front of the lens, producing an indistinguishable blur in the photograph. The scenes are constructed as in the theater or cinema and photographed in black and white in order to serve as the "document" of an era within a contemporary age. Pictures relate to examples and also to the specific method of producing pictures. Do all pictures not ensue from pictures anyway?**

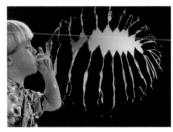

Dr. Bernhardt Brill

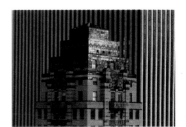

Reinhart Wolf

Now at last all photographers would want to defend their originality so as not to be decried as plagiarists. But in photography, pictures are already programmed by the camera, because the camera was designed and built to take pictures. And this is why a home-made camera obscura is sometimes taken out, in order to experience the process of

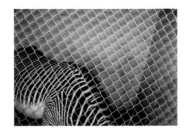

Till Leeser

making a picture in its elementary and original manner. It would be original to do without making pictures in order to discover the consequences of withdrawal. When we take a photograph ourselves, the thought that there have always been pictures actually facilitates the picture-making process, because we are only ever concerned with distinctions. Photography can only exist as a medium if it is also plays its own part as a medium, in order to keep the possibility of creating something significant as multifarious and variable as possible. The reproach of the seduction of an illusion is therefore only justified to a point, because anything staged as an illusory world can also be identified as such.

If we understand the world implied above as a real sign world, this could give rise to the realization that the world of pictures only makes sense if we constantly relate to it. This is the only way for the symbols to arise which we need to make pictures. Here we can use the differences conveyed by two albeit closely-related pictures to clarify how only by means of their differences are pictures able to contribute their entire potential. Dietmar Henneka set up a scene based on a picture by the American painter Edward Hopper, added a Mercedes-Benz car and made a picture of it. We recall the photographic or hyper-realistic painters who painted from photographs. This is the other way round, a photographer stages a "picture" in his studio and turns it into a photograph. The interplay between painting, stage and photography is one aspect, adding the car to the Hopper picture is another, namely an interpretation of the picture which the beholder then again interprets and so

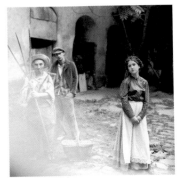

Ben Oyne

on. The other example is of a well-kept old car standing in front of an open doorway which we are looking through. Anyone familiar with American photo-realistic painting would immediately say, "that's a painting" because it appears to be so wonderfully arranged. It is futile to dwell on whether Iver Hansen may have known such examples. More important is the fact that I experience this relationship as an onlooker and can still also identify a connection with the Henneka picture.

Visually effective symbol systems become established in advertising, **and we can also relate to them just as to those of everyday life or of art, but by means of "operations" using some type of break as arises by imitation, irony, satire or pastiche.**

Two pictorial systems are frequently combined in architectural photography, **that of photography and that of architecture. The skyscrapers turned into pictures by Reinhart Wolf allow us to understand the cautious approximation of the two extremes. The austerity in the architectural pictures by Dieter Leistner shows his consistent approach of deducing the organizing pictures from the respective architecture. Tomas Riehle pursues the structures of architecture in a similar way, but sometimes adding a break which, in a photograph, makes a picture out of a doorway, and resembles paintings by Max Ernst. Dramatically "animal" is the appearance evoked by the industrial plant shot by Christoph Seeberger. I deduce the "animalistic" association from the picture of a factory chimney diagonally photographed from below by Albert Renger-Patsch, which Laszlo Moholy-Nagy published in 1925 in his book "Painting Photography Film" with the sub-title**

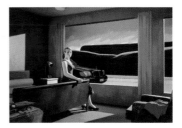

Dietmar Henneka

"The animalistic power of a factory chimney".
Pictures do not simply let us go, but they only reap-
pear when stimulated by others.

In journalistic or documentary photography
our experience with pictures is required to an even
greater extent, since the symbols are many and
varied as they represent everything which is or
could be the subject of our experience. We are con-
stantly faced with the same pictures of the world-
wide "theaters of war". And it seems as if photo-
graphers and editors are not exactly courageous in
addressing this experience in a differentiated way.

Iver Hansen

Automobile advertising is a touchstone **for**
possible behavior in the relationship between man
and machine. And photography has an important
part to play here, although, as we can soon see, it
only has limited resources with which to pursue
the phenomenon of the "automobile", it tries to
capture the vehicle from an observing distance. It
has to be content with external elements. At the
beginning of the sixties Horst H. Baumann took
shots of Jim Clark's Lotus racing car in full action.
He selected a long exposure in order to employ
the blur as an expression of high speed. Rainer W.
Schlegelmilch included the fire-spitting exhaust
pipe in the picture in order to enhance precisely
this impression. Motor sport and modern life seem
to have been used synonymously for a long time
and the photographically dynamized racing car was
considered to be the symbol of power, speed,
drama and willingness to take a risk. Culminating
in car racing since the car on the street neither
looked like a racing car nor was it able to achieve
the requisite speed. Now, at the end of the nineties,

Tomas Riehle

when ecological reason is critical of all extremes, cars are fast and powerful and show it. Photographers are now moving their cameras along again or selecting long exposure times and their pictures suggest dynamism, provoked by the catchword that anything feasible is also meaningful.

Christoph Seeberger

The shot of the racing car taken by Guenther Raupp only leaves a few traces of color on the picture, just enough to identify the subject. At first glance the Porsche taken by Uwe Christian Duettmann also seems to be a "victim" of its speed, but this picture can also be read a second way. Only just recognizable as a Porsche, the poignancy of the car is removed. The "form" is in danger of going up in smoke, of being dissolved in a cloud. Between the extremes of the cult of speed two typical forms of presentation produce quite a different "automobile". Another photograph presents a different concept of the car, because now cars all have something in common—they are all photogenic. This means that they only indirectly have something to do with a mobile car. Robert Haeusser photographed the racing car wrapped in tarpaulin in which the racing driver Jochen Rindt had his fatal accident. A memorial despite the tarpaulin—or perhaps because of it—it is a striking subject, because in spite of the wraps we can still feel the body of the racing car. Ernst Hermann Ruth took a picture of a powerful motor cycle from underneath creating a voluminous plastic form, solid and massive, making the motor bike appear compact although we can hardly actually perceive it as such when seen from this perspective. Manfred Rieker takes a shot of an Audi from above,

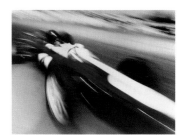

Horst H. Baumann

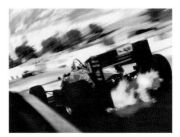

Rainer W. Schlegelmilch

one can imagine it to be suspended above a light, indefinable background. And then a section consisting of part of the body and an open door, a side mirror and nothing else. Three black Porsches surrounded by an unidentifiable darkness are only outlined by traces of light marking the contours of their typical silhouettes. Dietmar Henneka took this photo and we must add that in some of the pictures in this series it even looks as though the cars are actually driven, even in the rain and mist. And Henneka's shot of a Porsche standing in the wide-open landscape in front of a spectacular back-drop having been transported to the location on the back of a trailer conveys the impression of an ironic epilogue.

Back to the description of the details which stand for the whole as a matter of course—the design. Peter Keil trains his sights on the hood of a Mercedes and Nico Weymann fixes a "fleeting", unusual glance at a car from an unusual perspective.

Guenther Raupp

Whilst the conception of the automobile only gets a chance as an epiphenomenon, it does allow the idea, condensed to concentrate on the fundamental, to come forth. Pure photography, if one adds the long tradition of New Functionalism. Peter Keetman's Water on the beach and his drops of water are the guarantors of this tradition. And the glasses "drawn" by Hans Hansen with bright reflections against a dark background form the backdrop for radically abstracting photography. Abstracting reduction, presenting design in a nutshell, as has characterized new functional photography since the twenties. This is how photography can form an

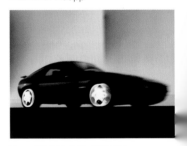

Uwe Christian Duettmann

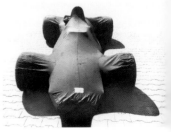

Robert Haeusser

equivalent to something much more complex. And because a car is so complex, photography starts out where it can transform the subject or parts of it into an equivalent picture. In the best case, the design of the object, which ultimately seeks to "incorporate" the whole, becomes visible. Photography is closer to the paper draft than to the actual car which it does not wish to compete with. Intellectual photography which appears to ignore whole sectors of experience and yet still seeks to preserve its uniformity conceptually by using minimalist means.

Manfred Rieker

This type of photography forms an exception but over a long period of continuity marks the way which also helps our orientation, where excursions are made into the round voluptuousness of everyday life. Photo design was these photographers' program at an early stage already and we may not forget that this phenomenon arose in a design tradition which sought to have design understood as a primary phenomenon. If we wish to exaggerate: design first, then the question of what is to be designed. The design ideals of the Ulm Design College in the fifties would not really have needed photography to become disseminated. This makes it all the more surprising that design has survived in photography.

Dietmar Henneka

Dietmar Henneka

Artistically-oriented photography **has a predilection for pictures of ballet and dance theater. And yet the pictures are very different from the events on the stage, as when photographing subjects which are to be loaded with a specific meaning. It is just like seeking an equivalent portrayal of the moving car. On the one hand, forms were**

49

described as figurations approximating the design concept. On the other, the manner related to dynamization, the presentation of motion, symbolized by blurred colors and distorted shapes. Neither approach approximates our actual perception of a car. But our idea of a moving car for instance, tends to interpret out-of-focus cars as depicting traces of motion. Joachim Giesel and Hubertus Hamm photograph moving dancers in this same way. The clear sequences in the movements of classical ballet also produce clear figurations in the picture too, consisting of a mixture of identifiable parts of the dancers' bodies and of photographic traces of light. The less clear movements in dance theater are intimated in Hamm's pictures by bodies and traces of movement. Due to the coarse-grained film the bodies appear to be dissolving, another type of movement. In a similar way, but captured in briefer moments, the dancers in Monika Robl's photos turn into sculpture-like figurations which make one fact perfectly clear—the fact that staged dance contains a wealth of possible configurations which can only be perceived on stage if performed respectively slowly. But even then they disappear quickly, to be replaced by others. The dissecting photo creates pictures which become concrete signs only to become significant when they "congeal". Dieter Blum created extreme figurations from artistic movements and jumps and has thus, as is frequently the case in stage dancing, captured figures expressed by the human body which cannot be understood by the normal spectator's own body. Nor do we need artificial figurations in order to see that we are making our own reality interpretable figuratively in a similar

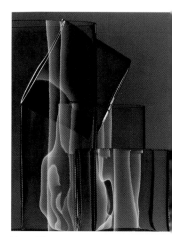

Hans Hansen

way. In a person's behavior, in his gestures, poses and clothes, in short in the whole picture of his appearance, we experience an organized world around us in which relatively unequivocal figurations become significant and which we treat as symbols. Photography has a great contribution to make in shaping the varying potential of figurations and events into identifiable figures. The off-center mouth in Beate Hansen's picture is a simple and certainly staged example: readable or not? Whatever our interpretation of the distorted mouth, that is its significance. In the world of film and theater, figurations are rehearsed so that they become meaningful within the intended inter-relation of events. We know that an actor is "crying" because he is required to do so in the play and not because he is actually sad or in pain. The same is true of photography, we have to be able to read it and in the pictures we also interpret the worlds of illusion of the photographs.

A.T. Schaefer's theater photography is not dissimilar from everyday photography. The ability with which we can interpret the pictures depends on readable constellations. It should be possible to interpret something apparently rather coincidental in everyday life during any phase of a sequence on stage, because every phase is aimed at being interpretable. But as in everyday life, only a few gestures become condensed to form identifiable symbols which are organized by A.T. Schaefer's pictures. Portrait photography in particular takes advantage of this effect so that we judge the quality of a portrait by means of our ability to identify the physiognomy as significant.

The question of the sense of staged photography is answered by the staging itself, **because everything which is staged is ultimately based on our experience. Ben Oyne frequently stages "everyday life" by means of slight exaggerations so that we always have rather more everyday. In order to perceive his stagings as such, the entire installation**

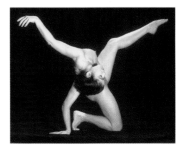

Dieter Blum

is illustrated in addition to the "original version" of the Lancia advertisement: the stage on the stage. The younger generation of photographers has long since discovered staged everyday life, the weird clothes of the love parade and the exalted movements of a disco dance. The subjects are depicted to a T by means of lack of focus, color shifting, blurred forms and colors, views from below and above "delayed" by the camera. But unlike those photographers who, following the change in paradigms, realized the extended dimensions of photography, younger photographers do not merely stage the "extensions" in a contemporary way, but their recourse to the culture of the last decades considerably inflates their staging potential. The retro-cult is largely nourished by old photos and films. Working in the same manner as one's examples is a type of mannerism. Something which, despite this retro-orientation, pursues the current concept of producing pictures by means of pictures.

The manner of dress, fashionable accessories and body language, the accompanying type of presentation and sometimes even coquetries with pictures of one's parents when they were young, all tend to inquisitively expand one's own repertoire of familiar symbols. An understanding of the figura-tive even points to a surprising source—the expres-

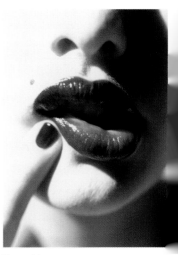

Beate Hansen

sionists, Egon Schiele and Francis Bacon are select-
ed as models. Whenever such models crop up in
fashion photography, we speak of excursions into
fine art. Although we do not mean art but the use
of art in fashion and it creates the context in which
the significance of the pictures can be unfolded.

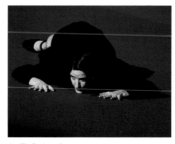

A. T. Schaefer

In food and still-life photography **Jan Kornstaedt**
abandoned the customary way of taking photo-
graphs of food. In his photographic work he has
become involved in the aesthetics of everyday life
in order to become removed from normal dictates.
In his observations he registers what is exhaled
when food is cooked and what is changed or left
over after the meal. Two phenomena are reflected in
this stance which could be something like the
quintessence of photography or of photographics.
The aesthetization of our world by means of com-
mercial photography is always pursuing new ideas.
Logically it selects whatever is favorable for the
customer for the differentiation of the products.
Of course the standards of idealization ignore large
parts of our daily life. And sometime, something
which has not yet been selected will arouse inter-
est: the normal, unimportant, kitschy things and
their random neighborhoods and locations, not

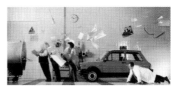

Ben Oyne

"properly" investigated, not arranged, at best
following the criteria of existing "disorder". Not
only the subjects are pleased at the freedom of this
chance presence, but the photographic element
also gets stuck in this commonplace vision, and an
only very slightly differentiated or arbitrary color-
fulness lacks all criteria. A type of "direct" photo-
graphy reacts to what is inconspicuous in our
surroundings. As we have already mentioned photo

realism, we could speak of a new realism here and this attitude recalls the "nouveau réalistes" in the France of the early sixties, who accepted everything cropping up in the coincidence of their existence. They assimilated the things directly and immediately into their art production. This approach to reality seems to be particularly close to photography. Because the camera and the film are open to reality, everything which is in front of the camera can become a picture. And we are again confronted with the question of the criteria for selection and design.

Beatrice Heydiri

Can one now still speak of photo design when, on the one side, "direct" photography tries to ignore conveying design? Or, on the other hand, photographers who work in the "manner" of other photographers?

The core of my considerations was to describe the phenomena which constitute significance. The thesis that pictures create other pictures or, expressed in a different way, that we interpret pictures by using pictures, is supported by the stance of some of the younger generation photographers. In addition to this we must again consider an important aspect of photography: The formation of symbols is in the foreground during long phases of the history of photography. This applies to the photography of the 19th century and, in general terms, to journalistic photography and documentary photography etc. It was only a small step from designed to designing photography, and one which had consequences, since the medium seemed to adopt a decisive influence regarding the "message", which was an absolute challenge to create pictures. Design concepts have since become symbol

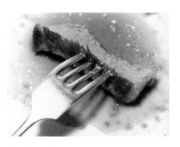

Jan Kornstaedt

systems themselves which we classify as New Vision, New Functionalism, Surrealism etc. The large number of symbol systems on offer quickly tempts one to take a generous helping. For today's era they are a piece of reality—a complex reality which the camera is directly trained at.

then this begs the question as to which of the two factors is the determining quantity, fashion or life. In order to avoid answering this question I am going to substitute a question about the relationship between fashion and photography. Since fashion appeared before photography the answer can only be that fashion characterizes pictures and photography helps to disseminate fashion. The meaning behind fashion photography could be, with different intentions, to inform the public of trends, of who should be wearing what at which occasion next season. Seen from this point of view, fashion journals offer the context and this again becomes differentiated with every target group seeking to recognize itself within this context. Since fashion exploits the changes in the seasons and the rhythm of the years and of life styles to create something new, its program is change. Parallel to this, fashion photography could also change.

When flicking through fashion magazines you must not be surprised if several fashion photographs do not fulfill their commission but present a generous interpretation of fashion in their pictures. Peter Lindbergh has a predilection for black and white photography and in his pictures he presents fashion by employing understatement as if any

contact with our colorful world would disturb the realm of his pictures. A world is celebrated which, disassociated from time and place, obviously does not seek to be anything other than a possibility of experiencing something outside the world of fashion. Merely an equivalent for something which certainly appears different in pictures. Peter Hoennemann, another black and white photographer, associates fashion with portraits and landscape in order to enable the pictures to be interpreted by means of other pictures. With a stunning elegance Lindbergh and Hoennemann create an extraterritorial poetical terrain in their pictures. Sarah Moon, in her designed photographs, knows how to shift this terrain a little further towards "unreality" and thus how to transport it away from fashion's direct access.

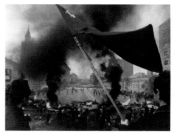

Hans-Juergen Burkard

Having drifted away slightly, let us again return to the familiar form of fashion photography and investigate a phenomenon which can be described as staging by the concept of staging. This concept is realized everywhere where staging takes place, but in fashion photography in its pure form. Dieter Elsaesser takes his shot precisely when a small group of travelers is stopped by a herd of sheep and therefore has a reason to leave the car briefly. Actually a simple documentation or a travel photo. Published in a fashion journal it is a clothes advert and indirectly a travel advertisement. Photography appears to be multi-dimensional compared with fashion, allowing us to draw the conclusion that photography has several "pictures" to offer us in one picture. The poetic element of black and white photographs, the journey, the landscape, the

restaurant or some atmosphere or another, in which fashion gets in touch with "life": all staged and realized by photography.

Beate Hansen had a model make a gentle swirl in front of the camera, so that the skirt and coat lift up slightly, creating a very specific figuration for a moment. Thus photography makes fashion, with all of the photographic and other stagable elements occurring in front of the camera. Let us again recall that the history of fashion photography, its great repertoire of "methods of vision and presentation" must also be added to what is stagable and the new spectacle commences against this background. Juergen Altmann and Mike Masoni play with perspective, with cut-outs and sections. Altmann changes from an extremely low perspective as an interpreting intervention of photography to the direct frontal view and allows the model to stage significance using body language. This is what Thomas Reutter does too when he couples the sectional nature with weird figurations, thus amplifying or contradicting them. Tilting the real into the surreal when staging takes place before the camera and the faded color of the photos leads us to the limits of what can be identified, something which was obviously calculated by Kay Degenhard when shooting the fashion campaign.

Turning the non-identifiability of one's own identity into a program is certainly something which goes beyond the realm of fashion photography but which appeals to the younger generation of photographers as a meaningful venture, since in their pictures they try out fashionable counter-worlds. With the provocative pose of his "model" Axel

Hoedt provokes without really provoking. A mixture of eccentricity and carelessness is diffused in the pictures shot by Kajatan Kandler and Tom Nagy, whereby the latter also sounded tones in other campaigns which recall classical prototypes.

The lifestyle generation who had imposed certain behavioral rituals on themselves in order to stage and enjoy what was exclusive, has been pushed to the brink—a consequence of their need for exclusivity in society. Economic circumstances were the pre-requisite and condition for this contrived lifestyle. Economic circumstances have now changed for many people or they never participated in the luxury anyway. All the more reason for them to claim their right to always design their "lifestyle" differently today. Rathermore in pursuit of a pleasure principle, according to which they obviously enjoy being seduced by "pictures" from bygone times: generosity through the retro-cult, including the multifarious nature of design.

And so we pose the photo design question here once again and the answer is: the claim to design has become irrelevant, since design has been doomed to becoming inconspicuous in a "designed" world.

But I am going to pick up the thread of photo design once again, of which I said that it did not arrive at its "pictures" until photography was thoroughly applied. A small digression through artistically-designed photography is intended to clarify this position.

The context of painting is taken up again and again in order to transgress the borders of photography.

Dieter Elsaesser

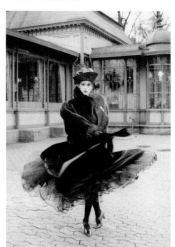

Beate Hansen

Juergen Altmann

Such aesthetizations in accordance with the patterns of art **will open new perspectives with regard to digital processing in photography, provided that we and the photographers create the pre-conditions for the interpretation of such pictures. In a campaign for the photo industry Jacques Schumacher dipped women taking photographs in artistically placed sepia spots thus cleverly blending the objective and the abstract. We will compare this with a similarly stained colorfulness, produced by a perfume phial exploding and photographed by Hubertus Hamm. Can a destroyed phial actually advertise a perfume? It depends on how the beholder knows how to interpret the explosion. When assimilated by the "prototype" of art, the similar shapes contained in these two photographs, lead us to adopt a stance which overlooks the factual elements—the woman taking the photograph on the one hand and on the other the phial exploding—in favor of the stained colorfulness. The patterns which we prefer and the circumstances in which we prefer them depend on their presentation in the picture and on our repertoire of patterns which we activate to assimilate them. If the color stains dominate in these pictures, this is proof of the fact that we also experience abstract patterns as being meaningful alongside the objectively figurative. The meaning which an abstract pattern could have depends on the context which makes this type of pattern possible in the first place. Much more concrete are the forms of an old American Buick shot by Manfred Rieker from the viewpoint of manifold forms. The whole remains conceivable despite the section, and a principle of form is also**

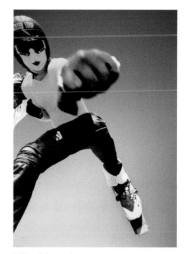

Mike Masoni

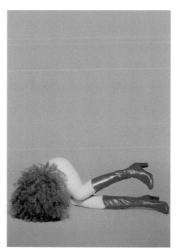

Juergen Altmann

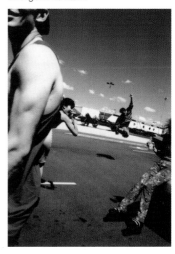

Thomas Reutter

59

conveyed through the compact three-dimensional shapes. The curls in the chocolate mass in a still life series shot by Arnold Zabert are far less uniform. Whereas the olive being coated in oil photographed by Christian von Alvensleben shows uniform but unexpected processes, since a process of this type is seldom observed so precisely. All forms which we observe have something in common, which we relate to when we recognize the differences.

Both are only relevant when the subjects are present. This phenomenon is enhanced by a comparison of the three various subjects. Transportable pictures make it possible to keep the relationships of the things of our everyday life variable.

If, at the end, I presume that the question, "what is photo design?", posed at the outset has been answered by the pictures themselves, then a theoretical note can no longer cause too much damage. Everything which has been designed in and with these pictures gives rise to interpretation. The structure of that interpretation depends largely on the context of the picture's use. Since most of the pictures no longer find their significance in their original contexts, others have to be invented. For instance an exhibition of the work of professional men and women photographers in Germany over the past thirty years. The pictures should now be seen, inter alia, in an historical context where they can act as a document of a certain time or of a certain vision. It was not necessarily possible to coordinate this ambition with the concept of documenting design standards, which are also subject to change, detached from the predilections of an era and the stipulations of the assignment. How-

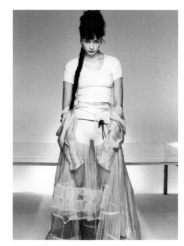

Axel Hoedt

Jacques Schumacher

Hubertus Hamm

ever in the association with design something akin to a timeless quality has become established for which we like to employ the term classical. All of these ambitions could only be satisfied to a degree so that I sought a different context, that of the pictures. What I call aesthetic patterns are layers in the pictures which enable me to invent phenomena constituting significance in the pictures, making the pictures appear meaningful to me. "Layers" in pictures is a metaphor I employ because when viewing a picture, I "divide" these layers in the form of pictures within pictures as I recall other pictures in my mind's eye. This description of reading a picture is, in itself, a picture and so on. I think that pictures interpret pictures and that is why there can never be enough of them.

Manfred Rieker

Arnold Zabert

Christian von Alvensleben

Klaus Bossemeyer

Portfolio

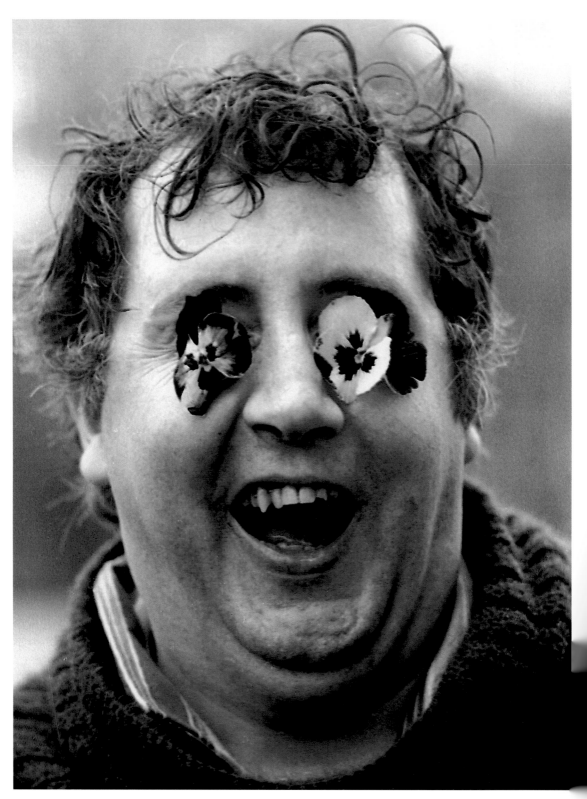

Thomas Hoepker
The Artist, Horst Janssen, 1966

Heiner Schmitz
London WC, 1975

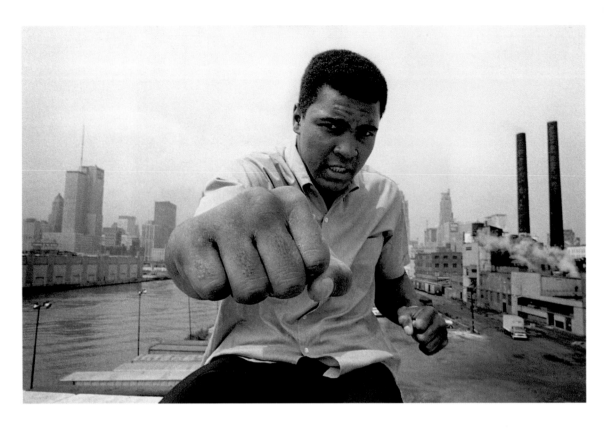

Thomas Hoepker
Muhammad Ali in Chicago, 1966

66

Henning Christoph
Black Power (top), 1968 / Muhammad Ali (bottom), 1967

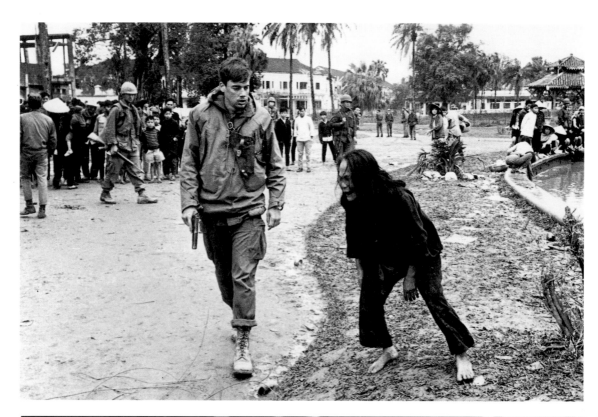

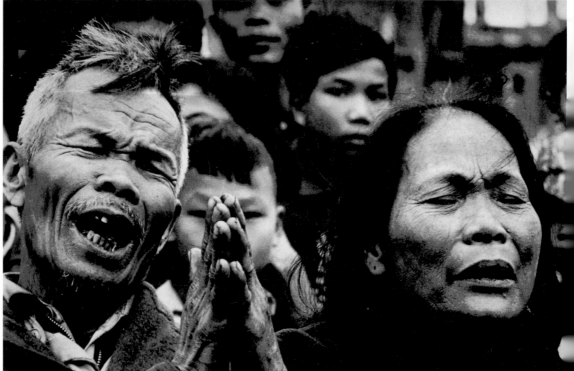

Hilmar Pabel
top: War in Vietnam—A mother implores for the life of her son, 1968
bottom: A mother and father beg for the life of their captured son / Vietnam, 1968

Hilmar Pabel
Death of "little orchid" / Vietnam, 1964

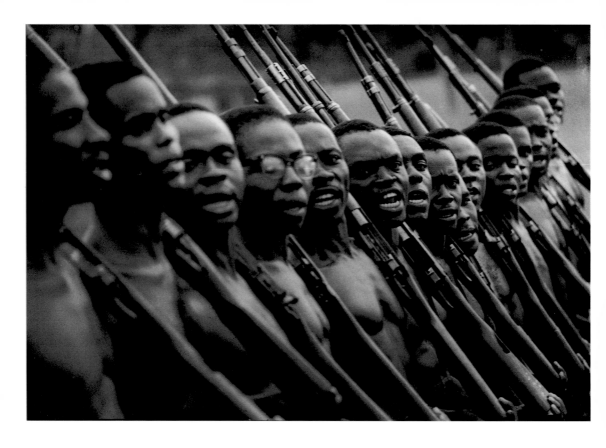

Gerard Klijn
Biafra / The last parade, 1968

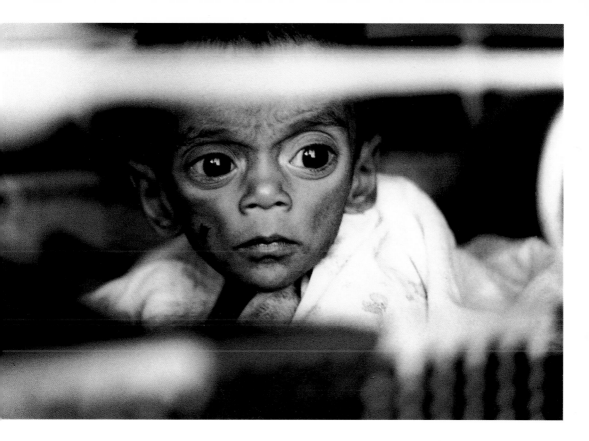

Gerard Klijn
1 $^1/_2$ years old = 1 $^1/_2$ years of starvation / India, 1967

Michael Ruetz
German characters / No. 77, 1968

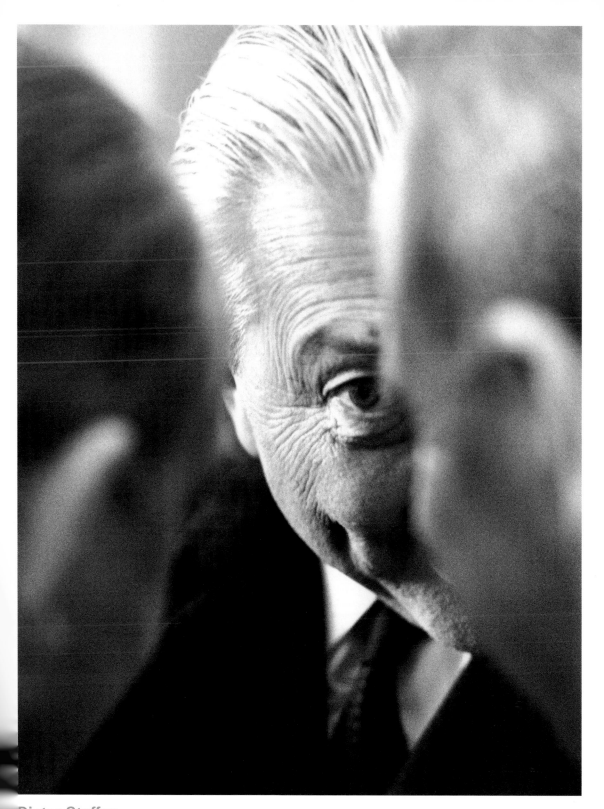

Dieter Steffen
Kurt Georg Kiesinger on the election of Gustav Heinemann
as German President, 1969

73

Thomas Hoepker
U.S. Marines recruit, 1970

Henning Christoph
Londonderry, 1972

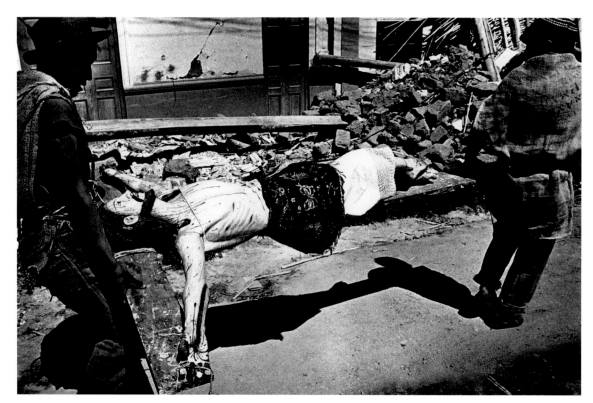

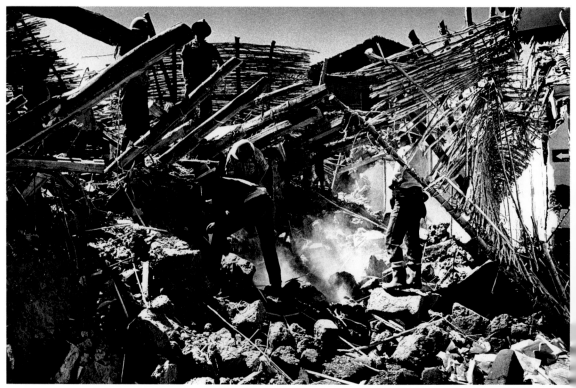

Georg Fischer
Earthquake in Peru, 1970

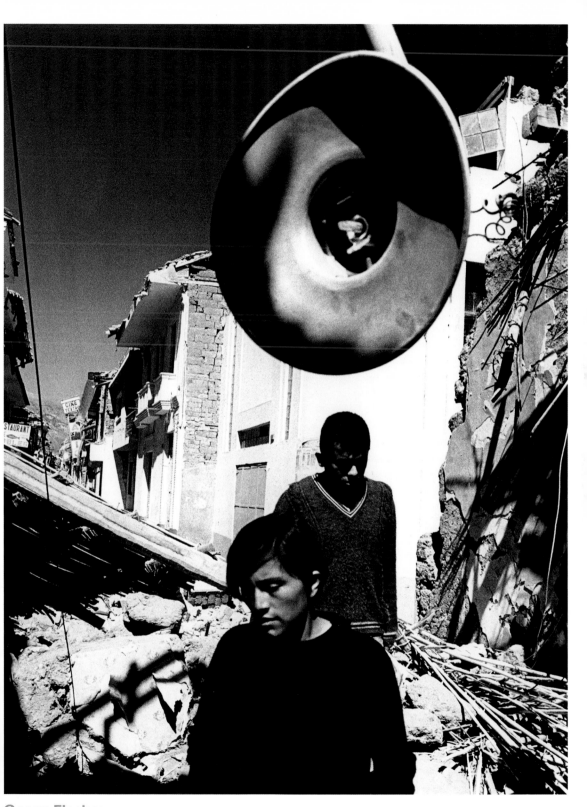

Georg Fischer
Earthquake in Peru, 1970

Wolfgang Steche
Shooting as a last resort / Bank robbery, 1974

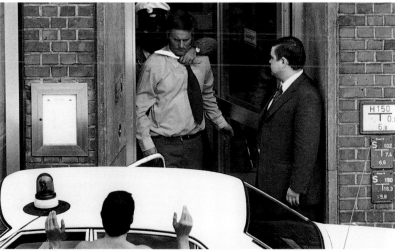

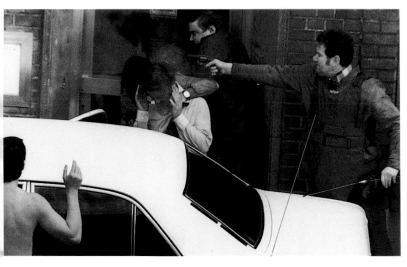

Wolfgang Steche
Shooting as a last resort / Bank robbery, 1974

Rudi Meisel
Motorway, 1971

Rudi Meisel
Motorway, 1971

Volker Hinz
Helmut Kohl as candidate to become German Chancellor /
Election Campaign "Legoland", 1976

Jochen Blume
Battue, 1975

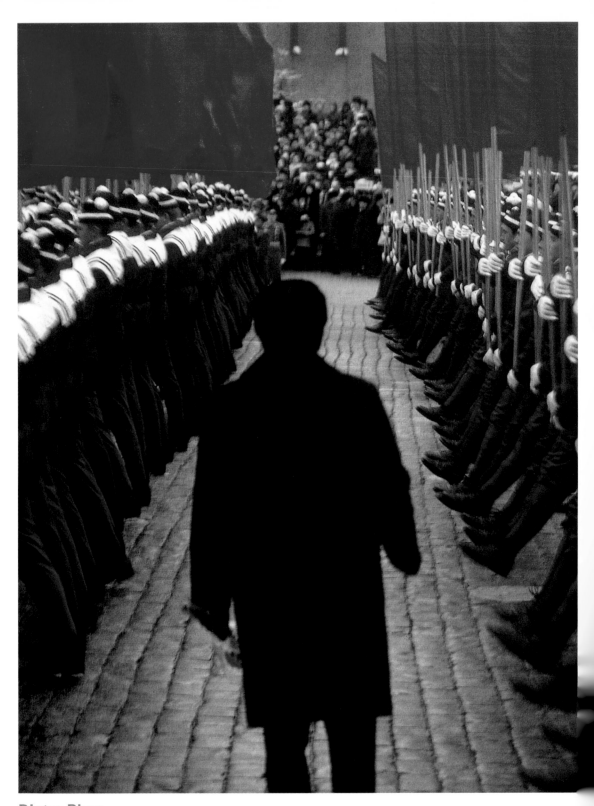

Dieter Blum
Red Square in Moscow: The invisible KGB, 7. 11. 1977 84

Thomas Hoepker
Avenue in East Germany, 1974

Volker Hinz
Bruno Kreisky — Election Campaign / Austria (top) 1975
King of Tonga / Queen Elisabeth (bottom), 1977

Volker Hinz
Pelé und Beckenbauer / Fort Lauderdale, 1977

Wolfgang Steche

Wolf Biermann / Bochum (top), 1976
SPD Election Campaign / Dortmund (bottom), 1976

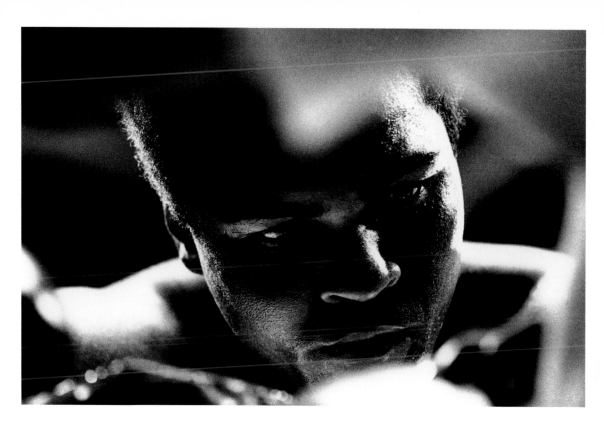

Walter Schmitz
Muhammad Ali / Boxer, 1976

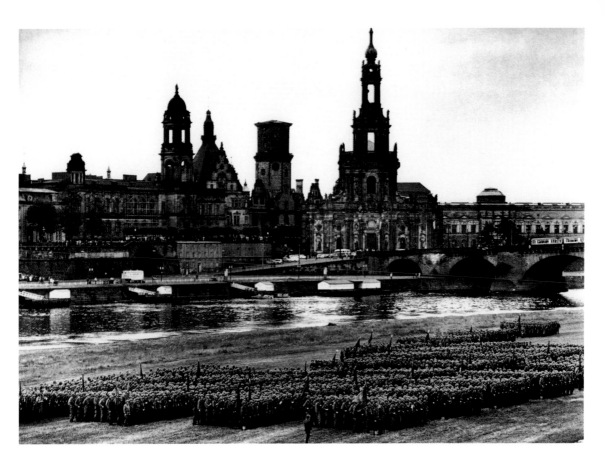

Michael Ruetz
1973

Georg Fischer
Fronte Polisario / West Sahara, 1976

(Dr. Hellmuth Karasek, BFF Yearbook 1977)

It is no more than a commonplace platitude to say that advertising slogans lead us by the nose or rather, to express it in more neutral terms, that advertising messages address us by means of catchy slogans. It is irrelevant whether this advertising is for products or political propaganda ("For Love of Lingerie" — "For Love of Germany").

It is less obvious to our contemporaries that they are not only inspired by linguistically pre-formulated ideas which they are not meant to make for themselves but also by visual slogans: by clichés, standard pictures, guiding images. Just like linguistic slogans they are formulated so that you can slip into them like slipping into an alien skin of one's own. They appeal to our urge to imitate, they style a reality in which we are all to feel at home. And now that they no longer need to make a linguistic detour, their power of suggestion is perhaps even greater, visual standardization is almost more comprehensive than the linguistic one.

We can easily examine this suggestive power of guiding images on ourselves, for instance when after watching a western in the cinema we spend some minutes walking along the street imagining that we are a cowboy hero. And it is in accordance with this very same principle that we decide on which jeans and soaps to buy, which cigarettes and coffee, once we have been animated by an image at least for a short term to imitate dream scenes.

This process has been culturally criticized often enough. We then speak of hidden persuaders, of an equalization which intimates individual happiness but in fact puts everyone in the consumer melting pot. But an opposing viewpoint is also admissible: Every society has its own guiding concepts, its guiding images. In all societies we have known hitherto, these ideals, embodied in costume and gestures, lifestyles and consumer habits alike, have stemmed from a privileged class which was also largely legitimized by a commission from on high. Societies have always imitated their upper classes: standards at court were copied and modified ubiquitously — right down to the last hut.

Our modern society is the first society whose guiding images are not

taken from hierarchical superiors. There is no longer a style-forming upper class—despite Ascot and Baden-Baden where the extravagances of the upper class compare more closely to the scarcity value of rare butterflies. Contemporary society is rathermore a society which draws its guiding images from the taste and consumer habits of a broad middle class (however vague this concept may be). These guiding images are disseminated by advertising and design. Advertising has thus been promoted to chaperone, savoir faire manual, clothes advisor, chef and book of life of modern society. Because intending to promote products means that advertising must invent the pictures, figures and pictorial stories to go with them—and these are the images which shape our habits consciously and unconsciously.

Naturally a designer does not conjure this imaginary world from out of nothing but finds his stimuli in the existing lifestyle of the consumer class he seeks to address. He imparts received information affecting him and which he, in turn, affects. One can visualize this process particularly well by observing the relationship between advertising and television in the USA for instance. Advertising has adapted itself to the "reality" of the soap operas and the soaps to the "message" of advertising.

Perhaps nostalgia, the last great optical "mood" which we have been drowning in for years now, provides convincing evidence of the function which guiding images take on in our society. However great the theoretical explanations which have been ascribed to nostalgia, it took hold of the West as its latest mood through pictorial suggestion alone. It is the expression of a consumer world which has to "consume" and occupy increasing amounts of leisure time and which also propagated this leisure as being the liberation from the pressures of the moment and of the present time. But it finally took over everyday life itself and transformed it into the strangest and most recent masquerade of the middle classes.

The American detective novelist, Raymond Chandler, once made the sarcastic remark in the forties that we should devote a monument in the form of a sky-scraper to the person who invented neon advertising—that was really someone who had made something out of nothing. A design world, so much is true at least, is a world of packaging. But the illusion placed on something is also its appearance. The picture we make of some-

thing becomes the quality of the thing itself. So McLuhan was certainly right to try to decipher the present from its optical signals (without any detour via mental processing). We can even use our turns of phrase to prove how visual our "philosophy" has become, for instance when we hear politicians refer to their opponents' "wrong perspective", if someone is "put in the picture" or a presentation is "under" or "over-exposed", when we are confronted with "focal points" or "points of view" and if someone has a "blackout"…

Someone wishing to have a picture of our modern society must be informed about our guiding images, the pictures created by photo designers.

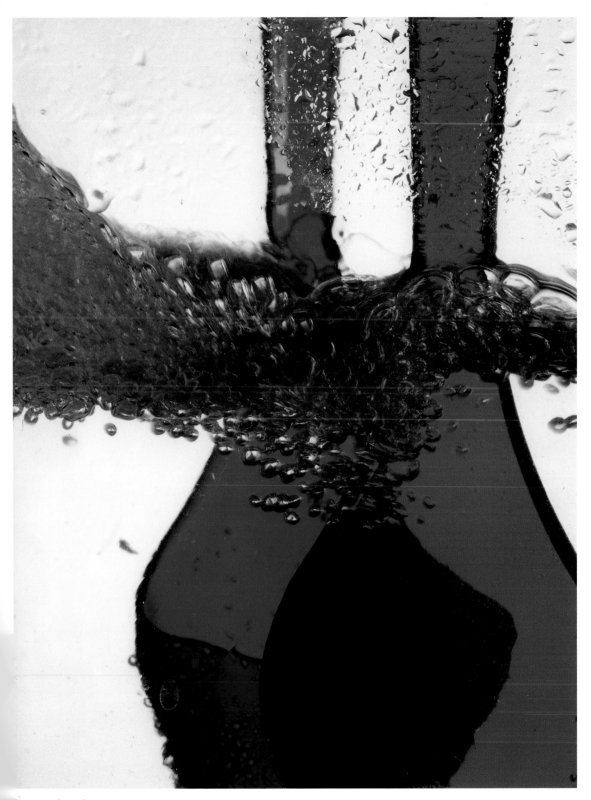

Franz Lazi
Duran, 1964

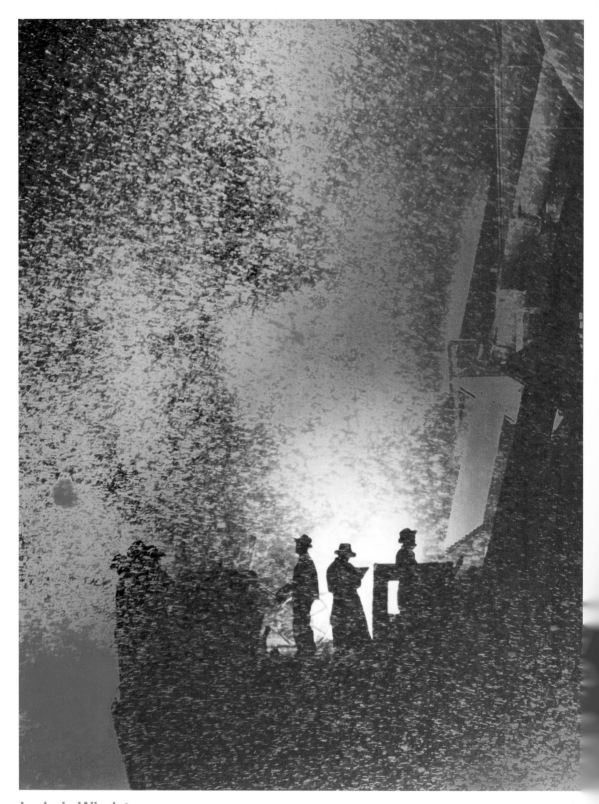

Ludwig Windstosser
Mannesmann Huettenwerk (Iron and Steel Works), 1963

Ludwig Windstosser
Iron and Steel Works / Continuous casting, 1963

Ludwig Windstosser
Assembly in the steam boiler, 1963

Gottfried Jaeger
Four diaphragm structures / Generative photography, 1967

Peter Keetman
Sea wave, 1968

Klaus Kammerichs
A person and a shell, 1969

Rainer W. Schlegelmilch
Color and liquid, 1968

Fritz Dressler
Plastic world, 1972

Manfred P. Kage
Lunar rock, thin ground section of stone / Apollo 12, 1971

Manfred P. Kage

Blossom from the magic garden. Crystallisation of bis-phenol in polarised light, 1968

Gert Körner
Bottles, 1973

Manfred P. Kage

Soldering point on quartz vibrator, REM-color photograph under a raster electron microscope, 1978

Bernhardt Brill
Proofing against current leakage, 1972

Siegfried Himmer
"C for Chromolux", 1972

Dieter Hinrichs
Portrait study, 1968

Dieter Hinrichs
Nude study, 1969

111

Christian von Alvensleben
Beach, 1969

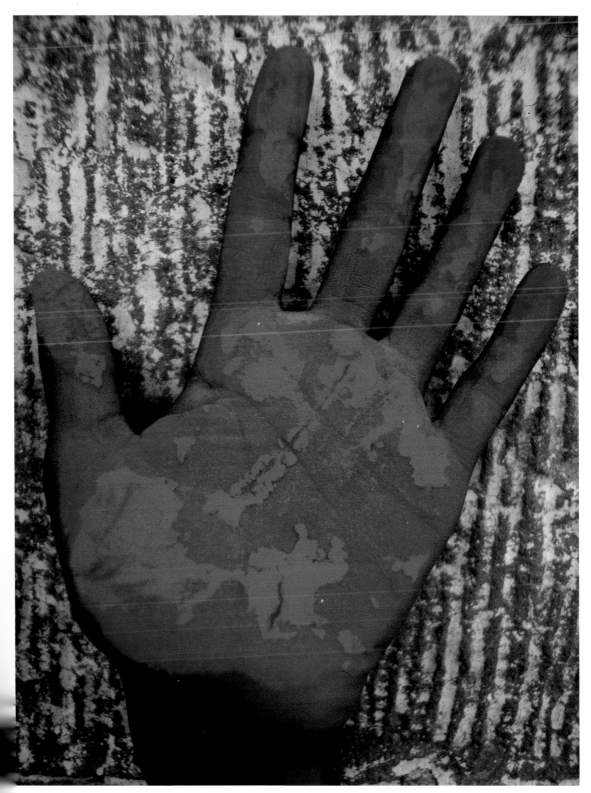

Will McBride
Stop signal / The red hand, 1969

113

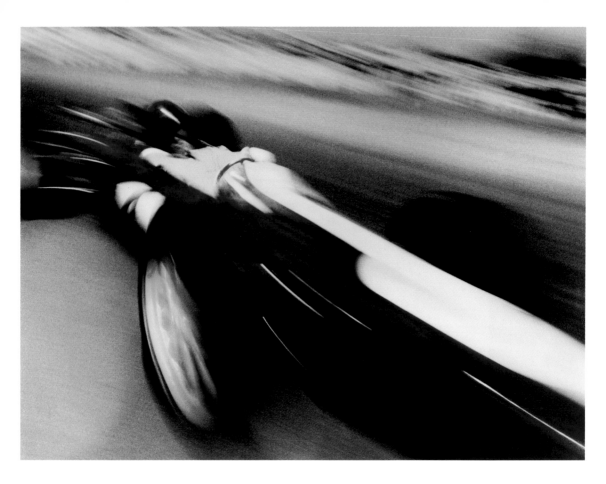

Horst H. Baumann
Jim Clark / Lotus FI, 1963

Horst H. Baumann
Carnival in Basle / The big clique (top) / The mini clique (bottom), 1966 115

Charles Compère
Cherry garden in Franconia, 1969

Harald Mante
Spring in Portugal, 1971

Gerhard Binanzer
Shab Rumi / Port Sudan, Red Sea, 1973

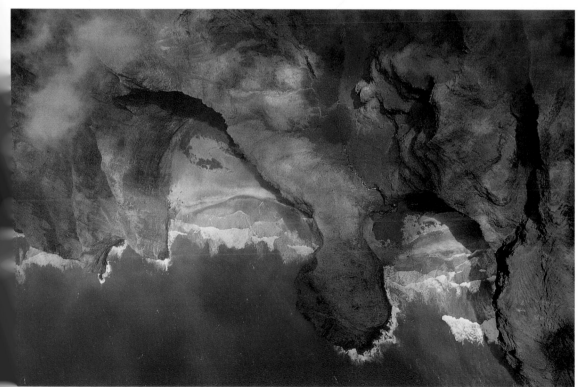

Michael Friedel
Male Atoll (top), 1973 / Hawaii—Kauai—Napali Coast (bottom), 1976 119

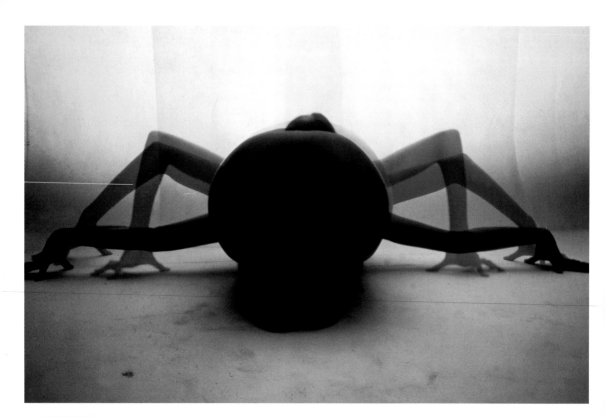

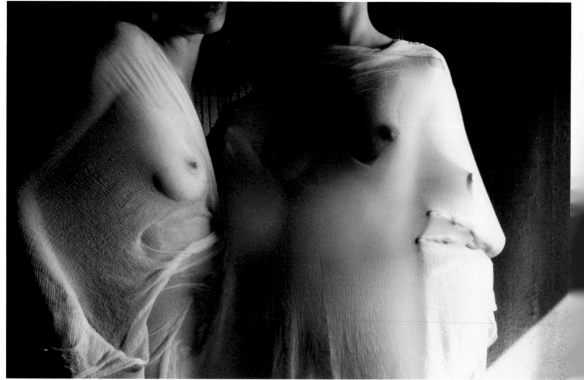

Will McBride (top)
The woman, 1970

Karin Székessy-Wunderlich (bottom.)
A deux, 1969

120

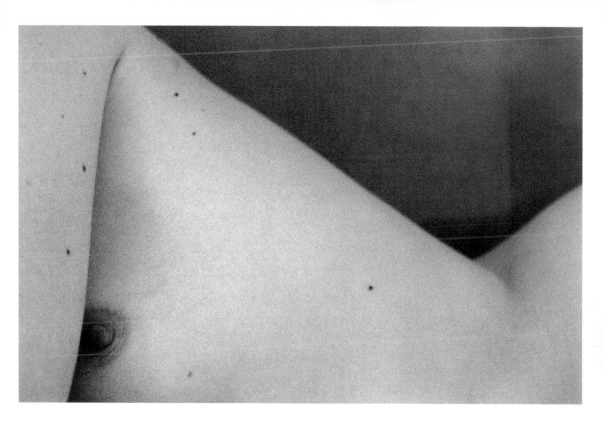

Till Leeser
Nude, 1976

The profession of photo designer, stemming as it does from the photography profession and yet as far removed from this profession as an electro-technician from an electrician, is in the budding rather than the blossoming (or even mature) stage. This explains why the process of societal, prestige-oriented and artistic/non-artistic status of the photo designer has formed the topic of such long-lasting debate.

Between the "You press the button, we do the rest" slogan coined by Eastman-Kodak and the intensity with which new, exciting pictorial worlds are exposed to us photographers there lies a wealth of transition-less possibilities for photographic expression and application which can fit any requirement and description. The professional image is documented in a way equally as transition-less as one of self-determination, overcoming one's self and self-realization. There is no longer any correspondence between usefulness and finding one's self.

Photo design is a special area. It ranges from the concept and productive new creation to setting the scene for a picture presentation, commission-related, largely pre-determined. A creative and artistic process can take place or not—in all areas, it does not depend on the specifications but on the quality of the operator with the camera. Perhaps there is so much debate about art in the area of design because so much artistry is expected of the photo designer: a staged pseudo reality, dramaturgy on stage with actors or a programmed pictorial composition. And you can tell that appearing natural is very exhausting. The photo designer becomes a location scout, props acquirer, director, set-builder, lighting technician, make-up artist. A one-man theatre. It is not smiles which are photographed but teeth bared from saying "cheese" and the scarcely concealable exertions of model training.

In the field of visual aesthetics photography has come to a certain standstill. Our eyes cannot retain the curiosity of the childhood age of discovery of reality. A new discovery becomes increasingly rare. We say "déjà vu" more frequently and "jamais vu" more seldom!

Our tortured eyes always consider a picture to be agreeable if it presents itself in a chosen, consciously selected, aesthetic form from amongst the unorganized photographic mash. During one and a half centuries of photography the perfect form has often been attained but it can hardly be surpassed. Although the quality of form and color can largely determine visual pleasure or displeasure it is not simultaneously able to touch our emotions.

We do not therefore need more pictures showing new style features or old form and color composition features but new <u>contents</u>. Copiers fail to reach any conclusions and do not impart any experience. They are unable to open up our own knowledge and our own experience and if one were allowed to simply have a wish, one would ask for pictures that touch our emotions, pictures full of energetic composure, full of the frivolous, lascivious curiosity of a voyeur, full of impending temptation, of serious humor. Pictures free of all earthly heaviness. Pictures that do not reveal where their magic comes from. Pictures of daydreamers or mad trolls. Pictures which do not only touch the outer layers of our skin but which get caught deep down in the crumple zones of our subconsciousness. Of course we must also learn how to see better and more intensively again.

It is not unusual for an individual to become bonded in a group where his activities and omissions can measured, examined, confirmed or changed. This is particularly necessary in a profession which is new and which only began to take on shape, become formed and formulated during the last decade. And in particular too because although small, this branch of the industry is an influential one representing as it does a group to be transported via the media which is still growing into new areas of responsibility which show society its opportunities, purposes and competence.

Fritz Kempe
"Time told in the faces" / Portrait of Prof. Dr. Otto Steinert, 1970 124

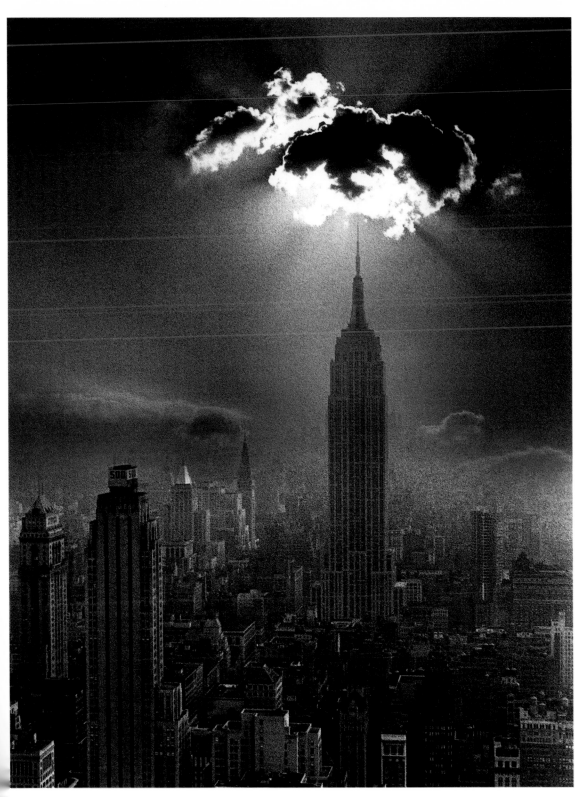

Walter Schels
New York / Cloud, 1968

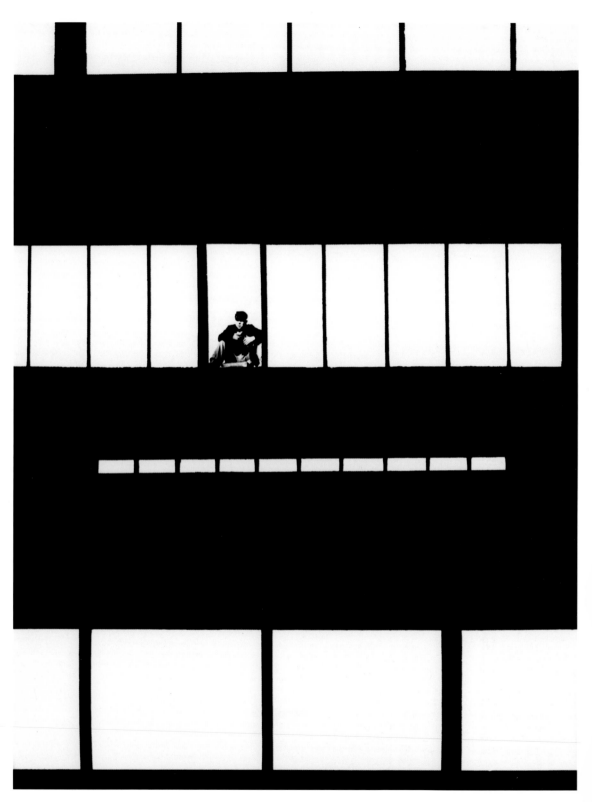

Lothar Klimek
The Sixties

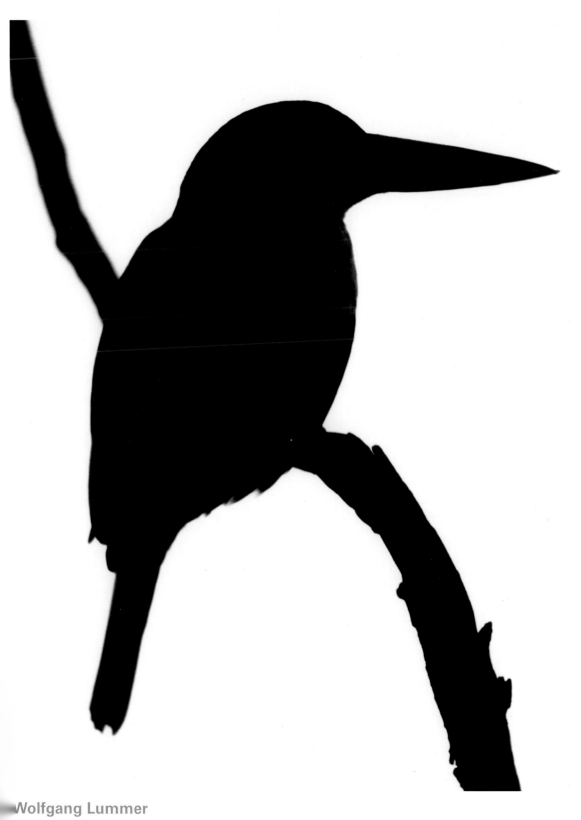

Wolfgang Lummer
Kingfisher, 1969

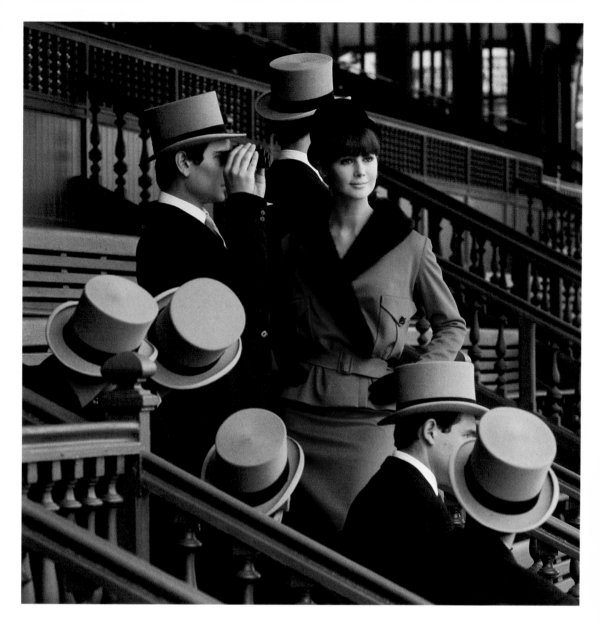

Walter E. Lautenbacher
Fashion at Longchamp / Paris, 1963

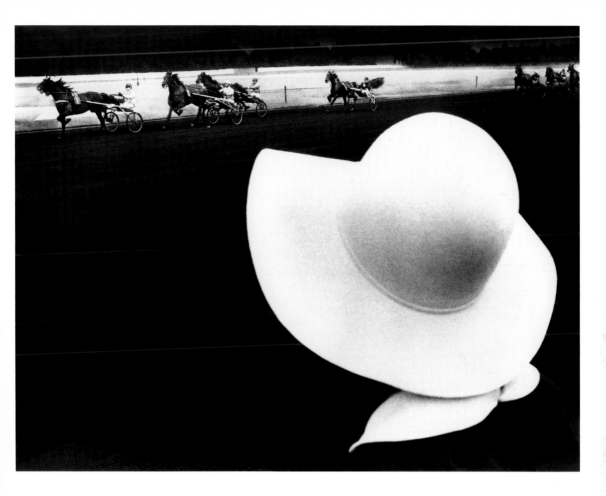

Robert Haeusser
At the trotting race, 1968

Robert Haeusser
J.R.5-9-70, 1970

Willi Moegle
1969

Willi Moegle
1972

Michael Engler
Flock of birds, 1979

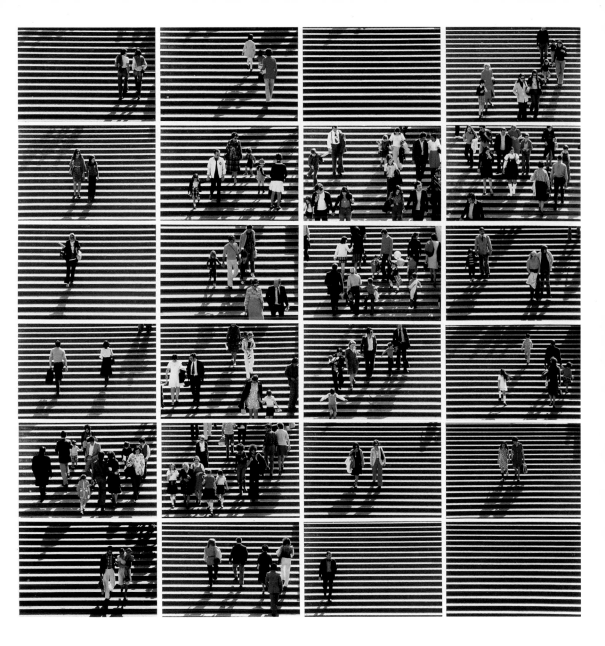

Harald Mante
Steps to the Seine / Paris, 1975

Rudi Meisel
Department store, 1972

Rudi Meisel
Department store, 1972

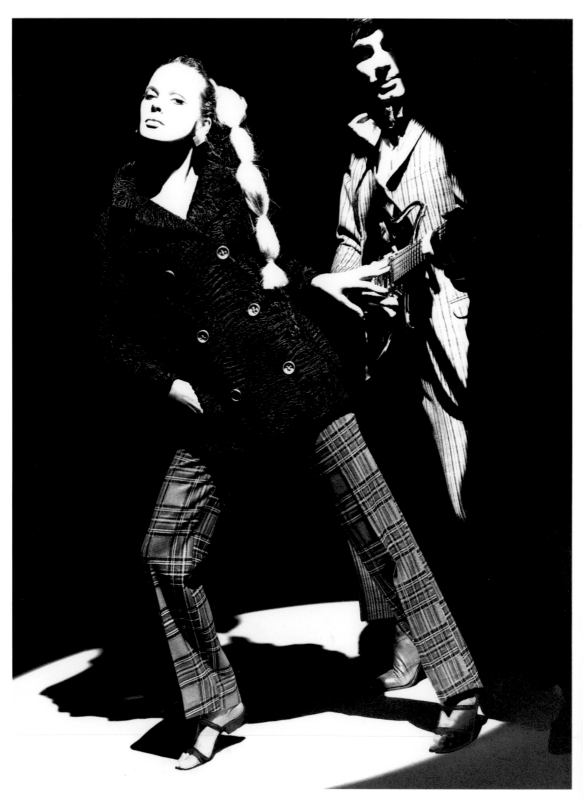

Ludwig von Khan
Sporty Persian lamb jacket, 1967

Ludwig von Khan
Triumph International, 1971

Charlotte March
Donyale with golden ear rings, 1966

Charlotte March
Trevor / Swimwear fashion, 1968

F. C. Gundlach
Op Art fashion / Gizeh Egypt, 1966

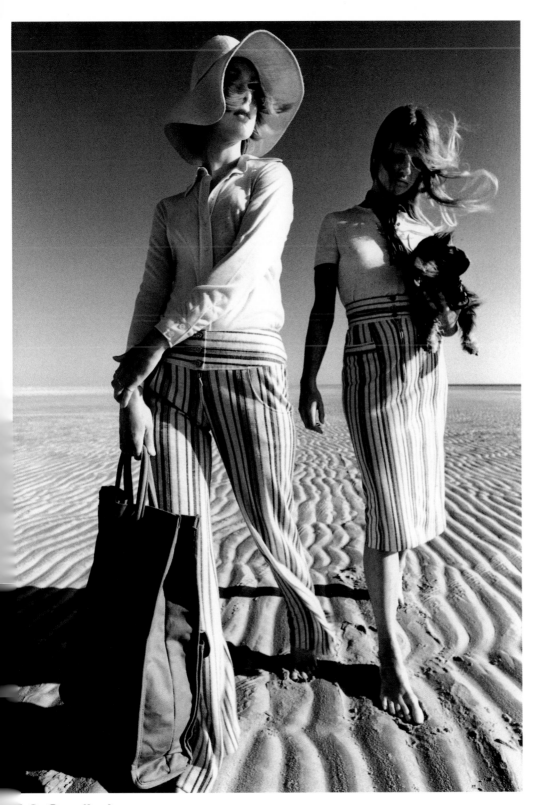

C. Gundlach
Sue and Francoise / St. Peter Ording, 1971

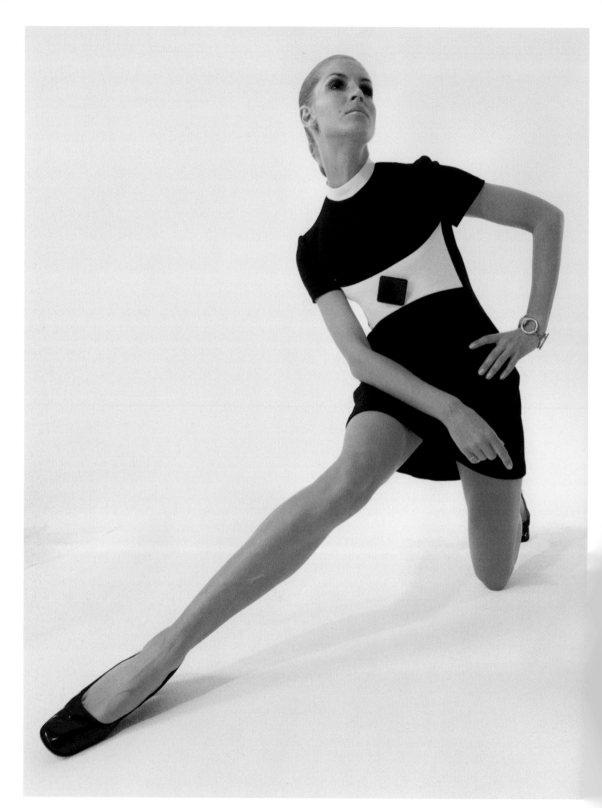

Goetz Eberhard Sobek
Courège, 1964

Goetz Eberhard Sobek
Nude—anonymous, 1966

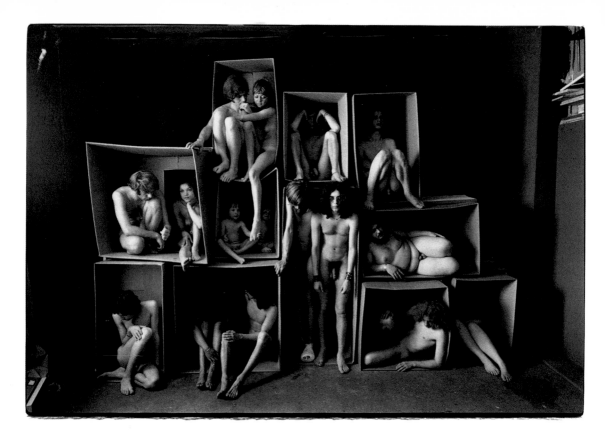

Will McBride
The house is full, 1968

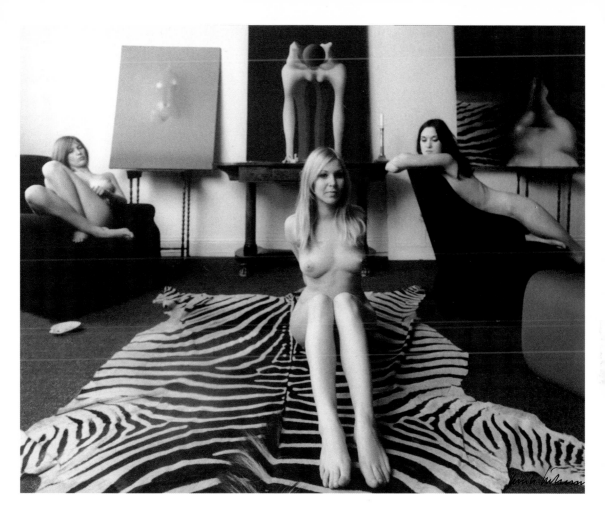

Karin Székessy-Wunderlich
Visiting P. W., 1968

147

Ernst Grasser
The four Jakob Sisters, 1969

148

Rita Kohmann
Two Girls, 1972

Ernst Grasser
The extended family, 1970

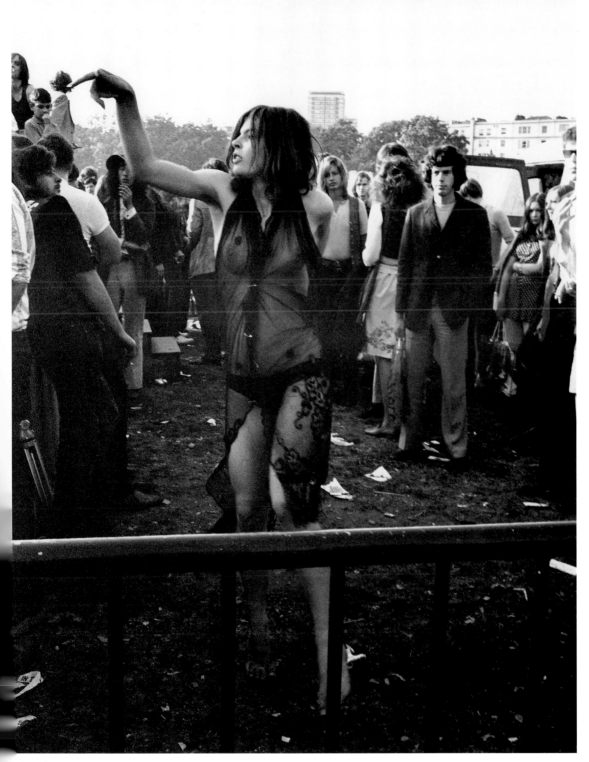

Wolfgang Volz
Hyde Park / London, 1969

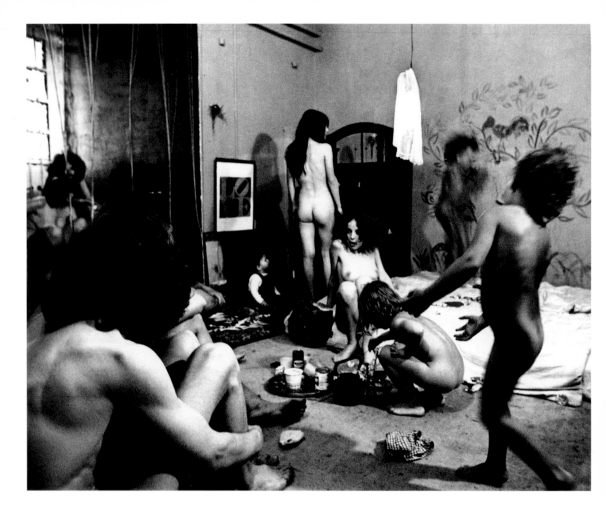

Rita Kohmann
Commune in Cologne, 1972

Volker Hinz
Fashion show in Paris Backstage Yves St. Laurent, 1972 153

Henning Christoph
Democratic Convention / New York, 1976

Henning Christoph (top)

Pensioners in Miami, 1976

Peter Thomann (bottom)

Black Disco-Soul / Provincial Disco in Muensterland, 1978

Horst Trebor Kratzmann
Barbara Trebor, Peter Roehr, Paul Maenz, 1971

Walter E. Lautenbacher
Veiled freedom, 1974

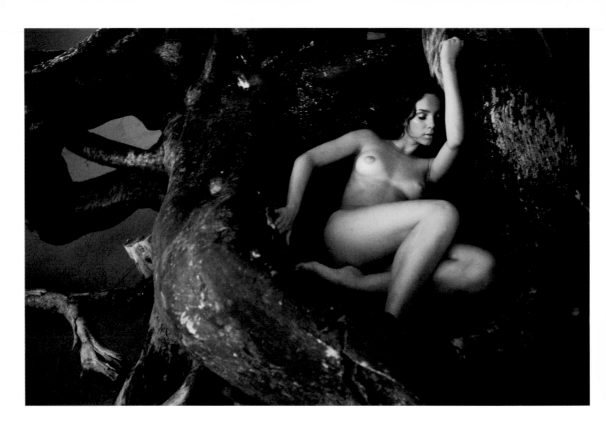

Guido Mangold
Maria, 1969

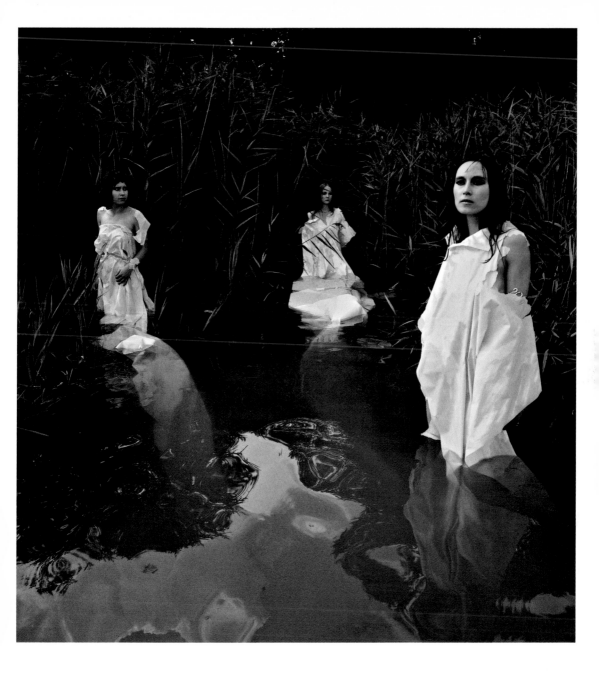

Thomas Lüttge
Paper and landscape, 1970

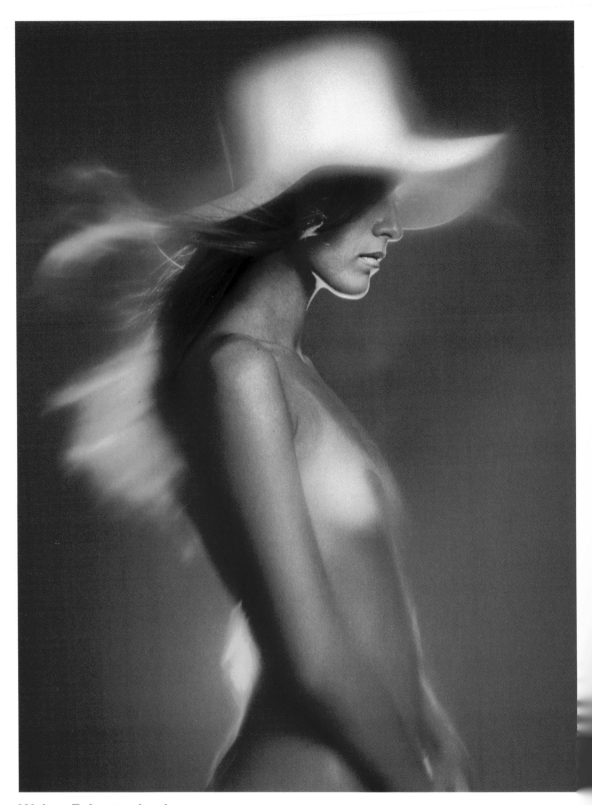

Walter E. Lautenbacher
Sonja, 1969

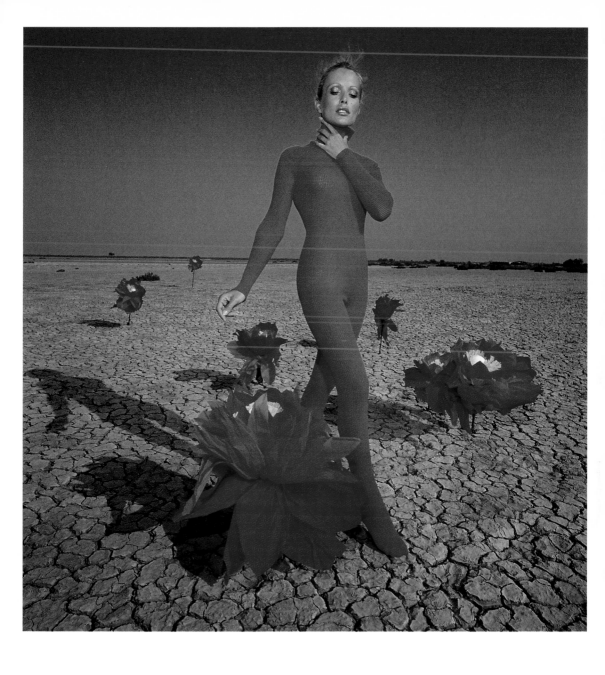

Walter E. Lautenbacher
Sylvie with artificial flowers, 1971

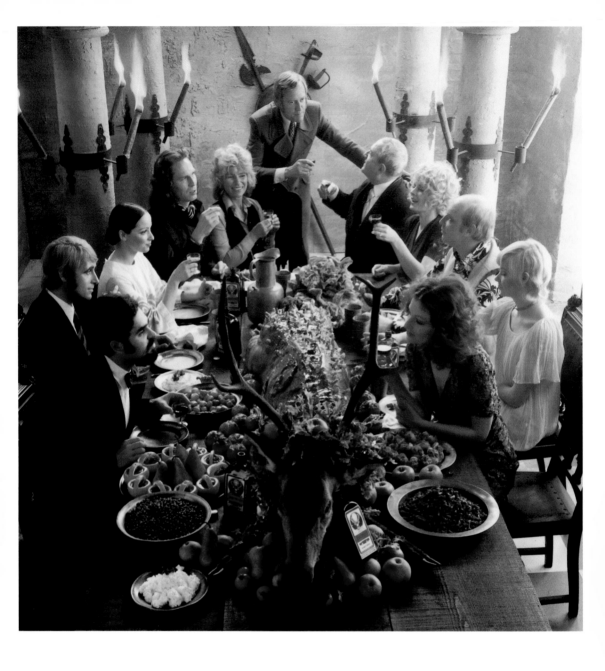

Reinhart Wolf
Jaegermeister, approx. 1970

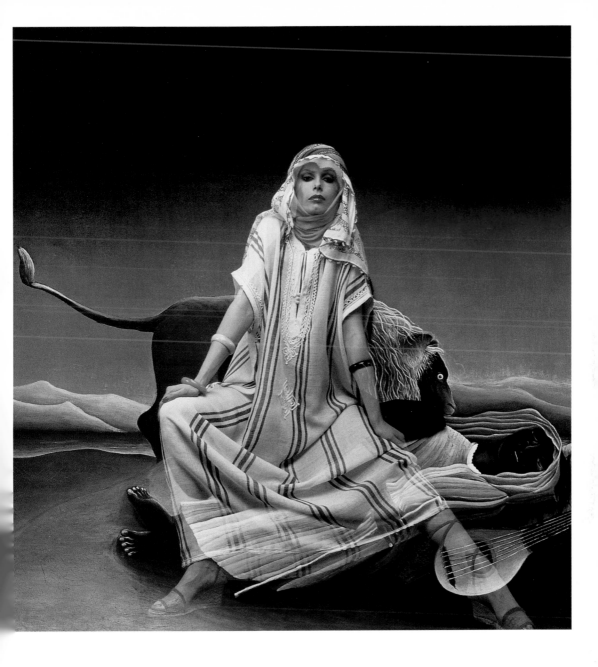

Regina Relang
Going to Rousseau, 1969

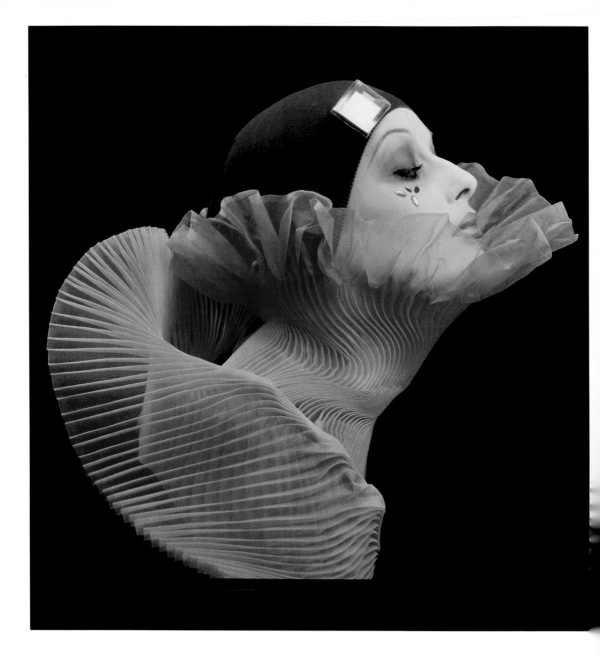

Regina Relang
Pink pleats, 1975

166

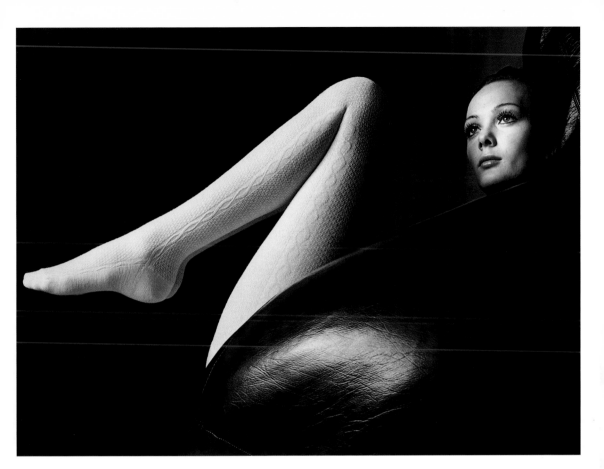

Fridhelm Volk
1971

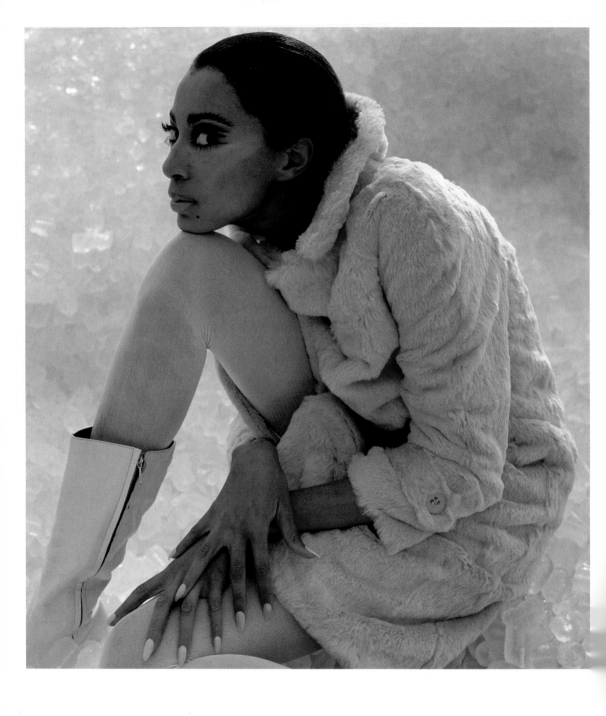

Charlotte March
Donyale Luna / Fur in the ice, 1966

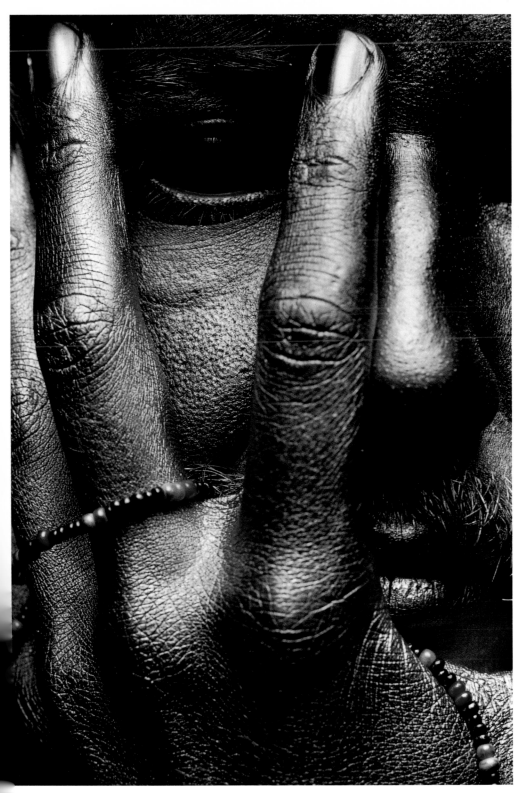

Peter Gauditz
Silver face, 1972

Franz Lazi
Handkerchiefs—hat, 1969

Franz Lazi
Ultraphan, 1971

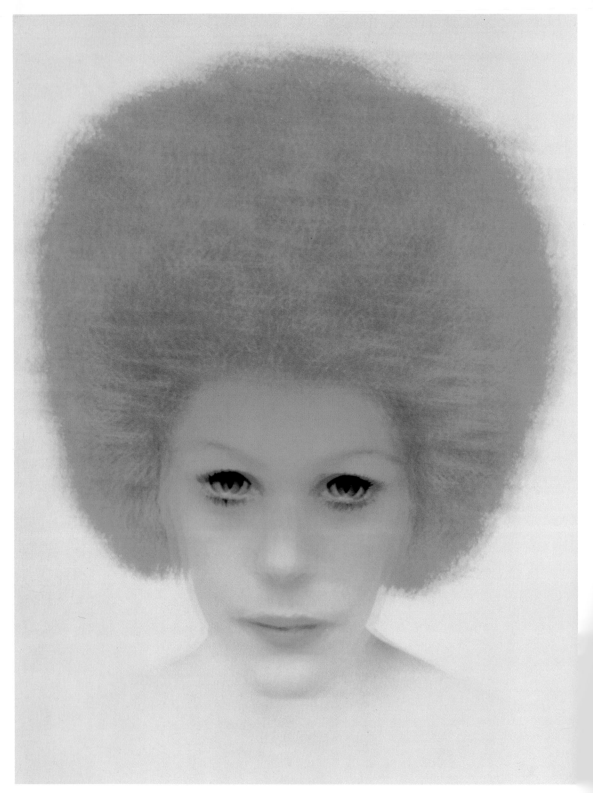

Rolf Herkner
Gaby, 1972

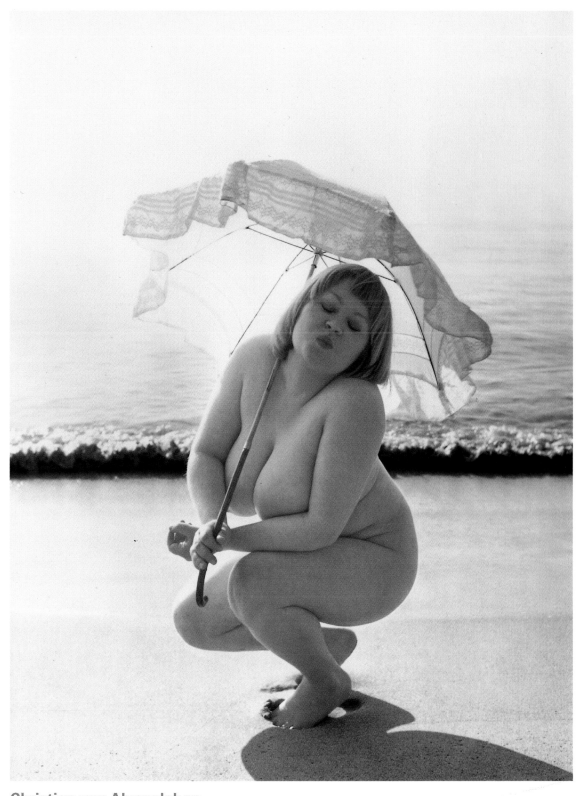

Christian von Alvensleben
Sunshine, 1972

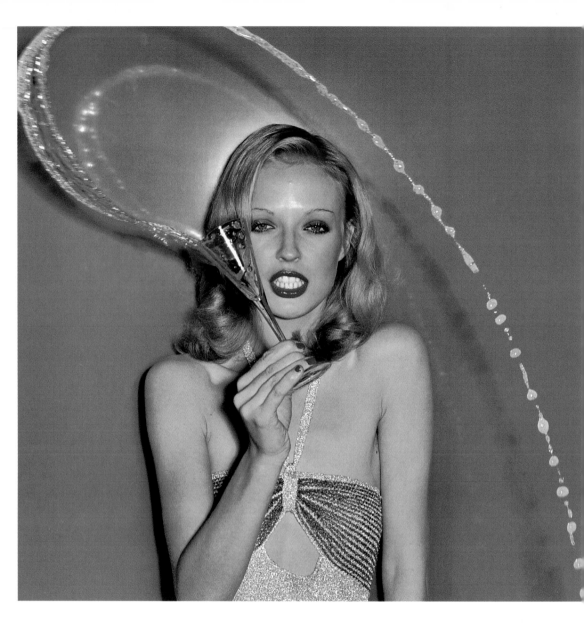

Jacques Schumacher
Food + Drink, 1973

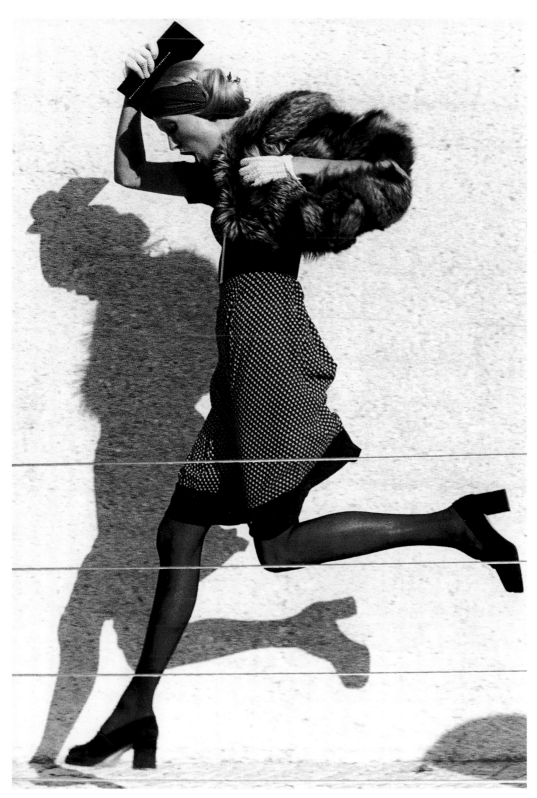

Kai Mahrholz
Gisela, 1976

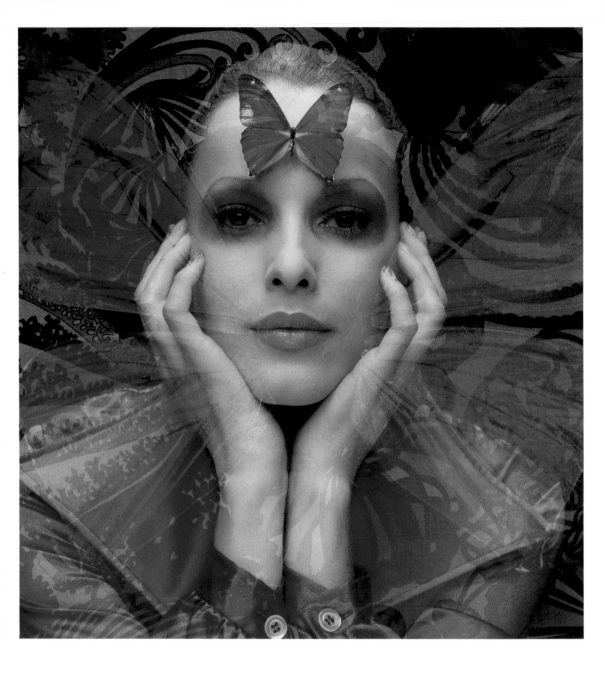

Regina Relang
Butterfly / blue, 1973

174

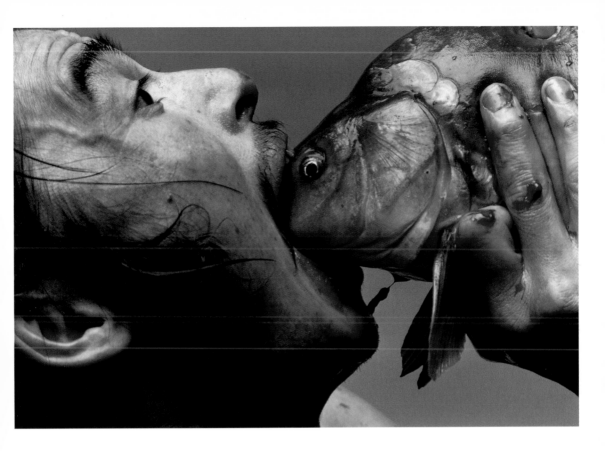

Christian von Alvensleben
Mitsutaka Ishi, 1973

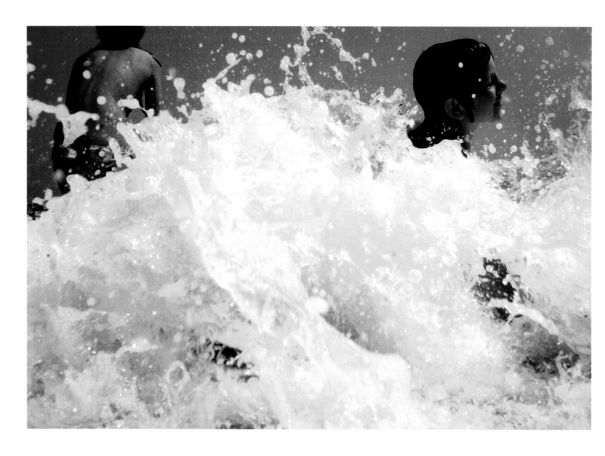

K. A. Vollborn
Holidays, 1978

Brigitte Richter
The Apollinaris glass, 1975

Brigitte Richter
Lobster for Lacroix, 1978

Till Leeser
Taken from the series "Spaces", 1979

Siegfried Himmer
Lufthansa menu, 1979

Guido Mangold
Finland, Lake Juari, 1978

Margot + Gero Kahlbrandt
Deep water / Hawaii, 1986

Peter Knaup
Alka-Seltzer, 1980

Rolf Herkner
Riesling—njet!, 1981

Jacques Schumacher
Self portrait using OM 2, 1982

Peter Knaup
My beautiful garden, 1982

Christian von Alvensleben
Hartmut Frielinghaus / Printer of Horst Janssen, 1975

188

Thomas Hoepker
Heinz Mack sculpture in the Sahara, 1976

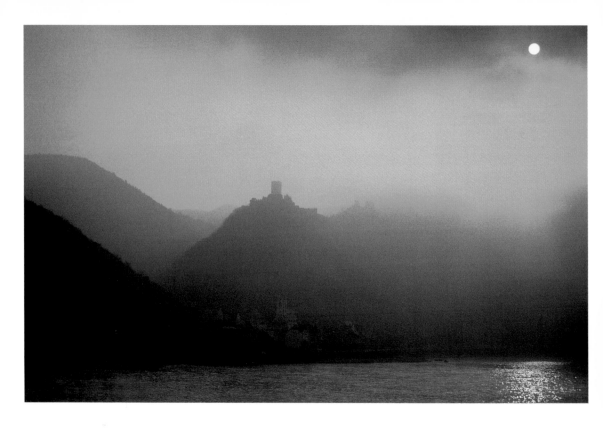

Siegfried Himmer
The country, the light and the dark, 1977

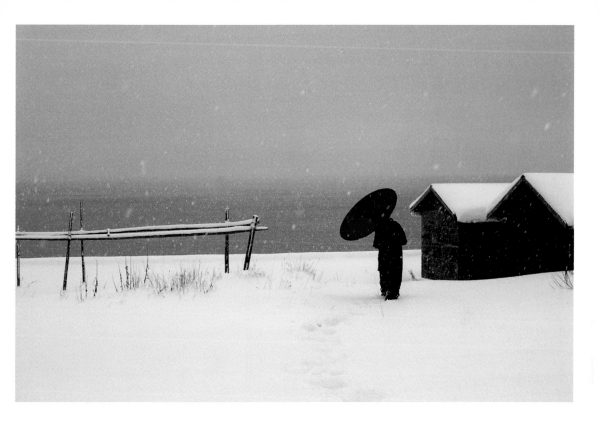

Eberhard Grames
Woman with red umbrella, 1978

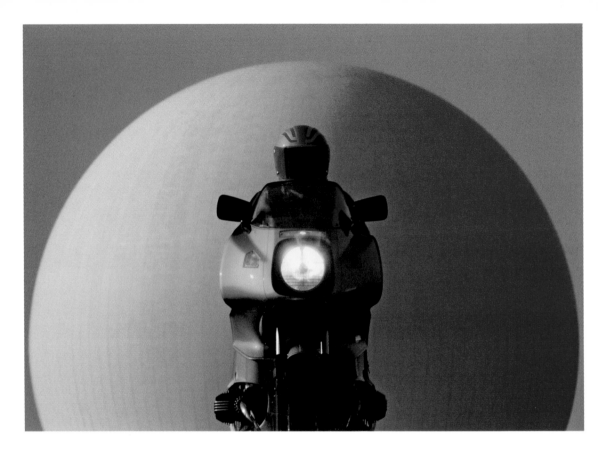

Ernst Hermann Ruth
BMW motor cycle, 1978

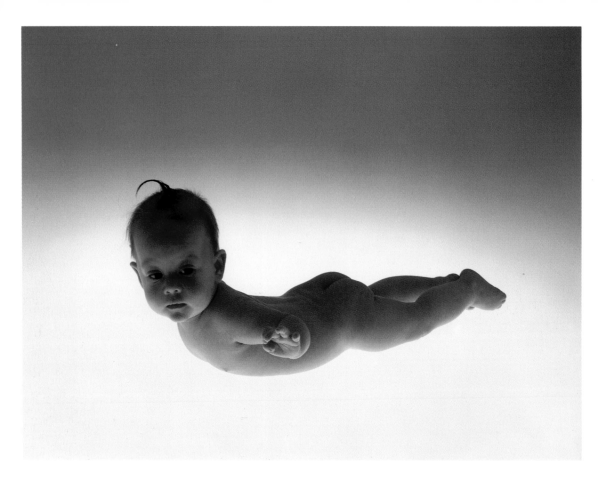

Hans Hansen
Baby, 1978

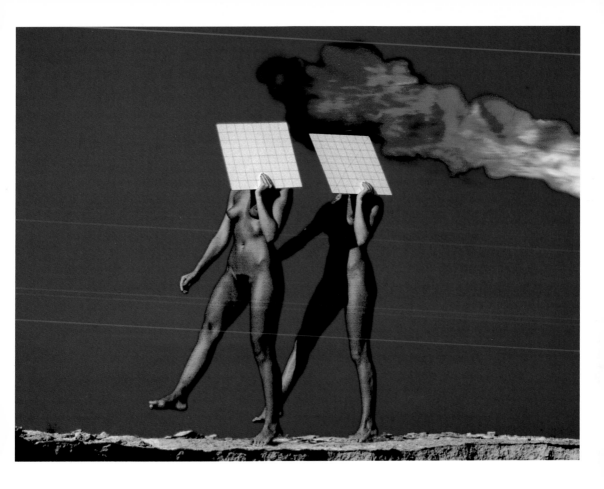

Gerhard Vormwald
1980

Christian von Alvensleben
Bather, 1980

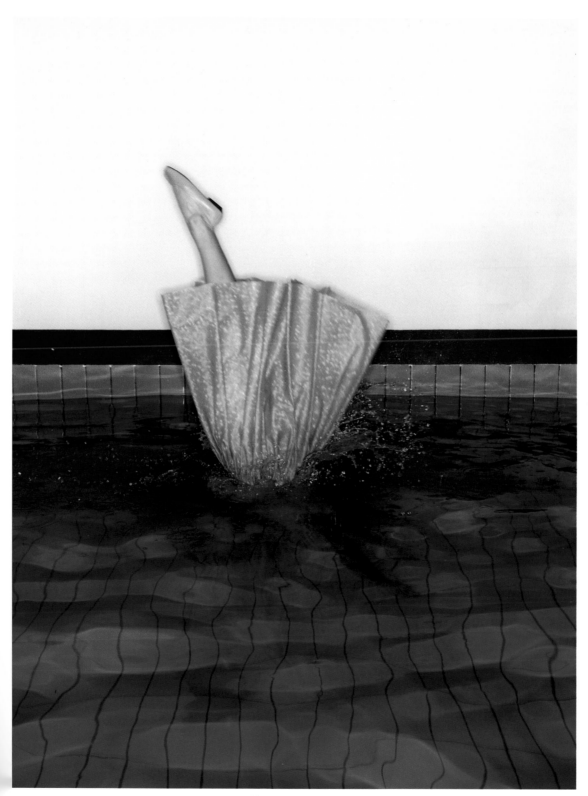

Christian von Alvensleben
Diving, 1983

Herbert W. Hesselmann
The jump, 1978

Conny J. Winter
Upwards, 1980

Dietmar Henneka
Record / Wega Concept, 1977

Lajos Keresztes
Knoll — chair series, 1984

Erich vom Endt
Two people working a hammer mill, 1977

Ernst Hermann Ruth
BMW motor cycle, 1977

Walter Schmitz
Boss race, 1980

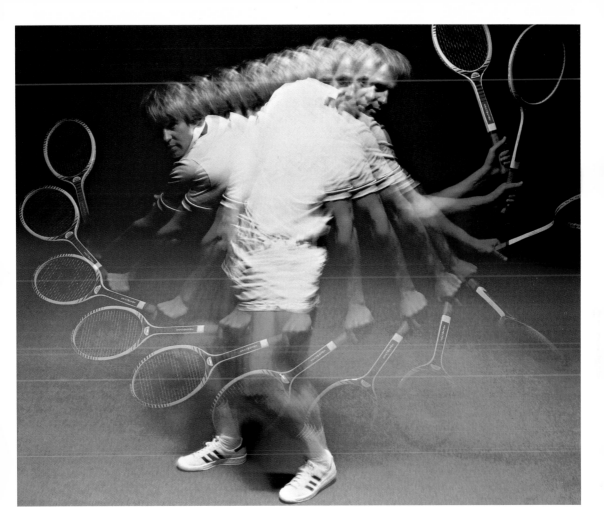

Ulrich Hohloch
Tennis player, 1980

Photo Design's worldwide fascination
and fascinating interpretation of the world
(Ruprecht Skasa-Weiss)

Nothing is more understandable, more forgivable, than the desire to relax from the impact of the mass media on our consciousness and travel into the horizons of a bright and shiny, unspoiled world of facts. Cinema spots, TV films, magazine reports, slide shows, the pictorial attractions of an advertising brochure with a clever layout: We are surrounded by the products of the illustration and description industry, by fiction and unreality. A traveler wants to escape from all of this. He wants to have something unadulterated and authentic, wants to break out of our artificial world, out of the back drop of the modern consumer society, of the fata morgana realities of all the existence-packaging artists and photo designers. But stop that now! That's enough of that! What we just said is not true, not in that manner, not for you and not for me—so for whom? And anyone referring to something unadulterated and authentic in connection with a travel destination must himself be accused of coining false concepts. Because reality, pure, unadulterated reality, cannot be dissociated from the media which reflect, design, change (manipulate) reality. No: these media have long since been shaping realities themselves, they belong to the reality of our epoch, to this one and to all future eras, world-wide and in every civilized country around the globe.

We want to admit this to ourselves and each other—call it a confession if you like. Because the insatiable craving with which you push and shove into every quayside alleyway and every crowded market hall and try to get as good a taste as possible of that foreign indigenous feel in every bar and bodega and allow yourself to be squashed into trolleys, tubes and clapped-out overland buses, just to gain that authentic "experience" of the foreign country is just the same as the craving—admit it—with which you stare at every manifestation of strange taste, at every page of a newspaper, every poster and every product of creative fantasy. Because you find them gripping; they give you an insight. And so if you wish to absorb the intellectual climate of a country then look at them, look at these papers, posters, book covers, look at all of these ideas which have become pictures, the cre-

ations of photo designers! They are also part and parcel of the material and, even more, of the ideal, intellectual reality of a time and country, they too define and characterize a nation, a zeitgeist, the taste of an era. And it is not only the products themselves which give us an insight into a country and the mental constitution of its inhabitants (because of course it makes a difference whether interests there focus on mainframe computers or sunflower seeds), no, more than this it is the way in which this product world is presented, the styling, the criteria for the sense of color and shapes, the degree of alienation, the flair? I love to flick through foreign magazines, I am attracted and enticed by any poster, any area show-ing creative design, it is a pleasure for me to study Italian, Spanish, Polish photo design. Because I am convinced in all seriousness that this enables me to experience more about the country, about its taste, humor, esprit and refinement. For instance it is not enough just to drink Retsina and eat Greek food in Crete. If you want to really experience this country and dis-cover this island in depth, you must also keep your eye alert to manners and fashions and to how their ideas are interpreted as a photograph; how needs, whether they be aesthetic or material, are optically manifested there, or even how they are "visualized".

A propos the national character—it may certainly be true to say that a good designer is also distinguished by his personal style—but nonethe-less his pictorial experience (as seen overall together with the experience of his compatriots and compared with the photographic creations of other nations) does not only reveal a personal style, but to a certain extent a national style too: the special sign of the sphere to which he belongs. Is this surprising? Hardly. Just as there is a very British sense of humor, a specifically Portuguese sadness (saudade), just as we have the categoriza-tions, "The Chinese find that funny", "That is considered to be chic in Venezuela", "In Beluchistan they think that is beautiful", we also have national idiosyncrasies expressed in pictorial form: in photo design.

And don't tell anyone that the world of photo design is artificial! Where are the character of a nation, its humor, rhetoric, jauntiness, and also its inhibitions revealed more openly and starkly than here, in those maga-zines, books, posters whose language we do not speak and yet

where we can "understand" the design, graphics, layout and photo design all the more directly? What we experience is more authentic and original than what a foreigner could tell us in our language. Why not? Because a (German, Portuguese, Bulgarian) photo designer really should know how to address his fellow citizens, how much elegance he can expect them to endure, how much subtlety? How much playfulness? How much impudence? How many jokes and what type of joke? Of course the performance standard of modern photo design also has an international standard. And of course some countries are ahead of others. Of course there are quite objective differences in quality. But there is a factor which has an even stronger effect, namely that it is precisely design questions which are dependent on very subjective moments, on changing contemporary taste, on changing trends and on recurrent fashions. And this is precisely the reason why, because we have not yet achieved a certain fashion (or have already forgotten it), because we have not become accustomed to the "new way of seeing" or have already become disaccustomed—this is why picture creations in other countries appear to be fresher and more gripping (the further away probably the sooner it happens). Just think of the fashions, of the intellectual and taste trends of the fifties (and also of the non-intellectual physical ones, the "wave of gluttony" for instance): and how many attitudes once overcome are recurring today, how many cast off designs are being rediscovered by our nostalgic longing!

Because our value system is not static and stable for all times, it vacillates: whereas it favors all geniality and comfort in one era, in the next it is sobriety and coolness and in the next but one perhaps a characteristic such as tenderness again. And so our human value system totters and falters over the course of time and it is precisely the photo designers who are the seismographs of this vacillation. They are the scouts, the avant-garde of the new taste, not necessarily opinion leaders, but quite certainly taste leaders.

Even the layman can sense the responsibility stemming from the designers' business. It is a business serving the world of ideas such as the consumer world, missioning, explaining and cultivating the (playing) field so to speak. Consumer world—that is easy to say, but before we can "consume" a thing, an intellectual product, it has to be performed and made

attractive and "consumable"—by means of the picture, through the appeal which the photo designers impart to us. And perception also has to be learned and therefore taught. Photo designers teach us to see. They are the "foreseers" of society. But of course I can already hear the objection, the severe question, "once tempted in this way do we then still buy the product, the actual idea? Or just the pretty illusion of it?" It is true to say that this pretty illusion has, in fact, often been treated as a heresy, as something just for show, as packaging, humbug and vain paraphernalia. But the pleasure surrounding colors and shapes and good design is legitimate, not just the design of sports cars and pearl necklaces but also of cognac balloons, cucumber slicers and clothes hangers. We often so aptly say that something is a feast for one's eyes, because culinary delights also include visual pleasure at the optical arrangement. But where is this not so? Even when we are smoking, slicing cucumbers and drinking cognac, our eyes are always involved, seeking "design". And design is, in fact, (almost) everything.

And so it certainly appears admissible—yes even almost a command if we are really serious about improving everyone's "quality of life"—to present a beautiful form, an attraction for the eye at its best by means of photo design; or if not at its best, then at its most dramatic. Because photo design can do more than any other product design, it plays with its subject, with the product, alienating the form created and relocating it in a superior way in new contexts, in alien ensembles, creating confrontation and harmony—unsuspected harmony. Creativity is experienced as "weightless" in photo design, here a super gag is possible at last, any perspective may be pulled apart, any material connection cleverly denied; photo design is pure supra design.

What would the world be like without all of this? It would be dull and grey, sheer Siberia. And there, in fact there really is no photo design and no advertising in those grey parts of a very eastern world—just as the "ground", the precondition for them is still very modest and very inadequate: the world of products, the produce of creative human intellect. Photo design manifests the refinements, the cultivation, the purified aesthetic taste and the feelings of a civilized society, of a cultural group, a nation—which has little to do with luxury and "decadence", but a lot to do with what makes life worth living.

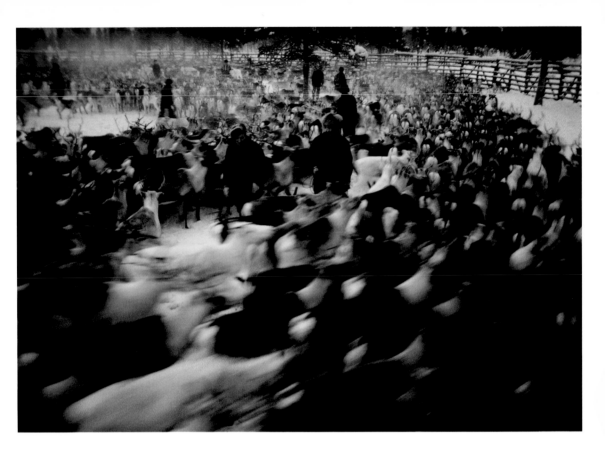

Guido Mangold
Finland / reindeer parting / Lapland, 1978 210

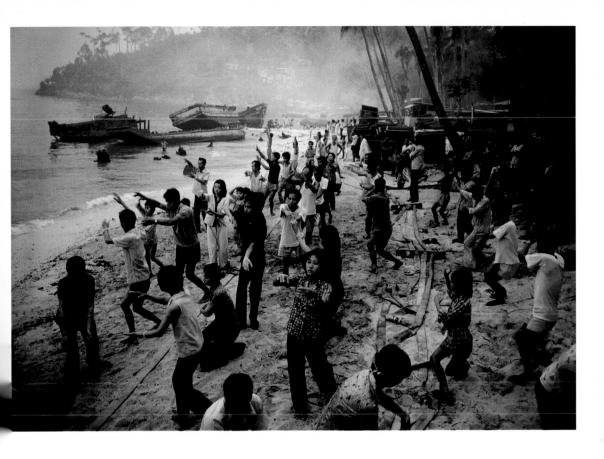

Hilmar Pabel
Boat people from Vietnam, 1979

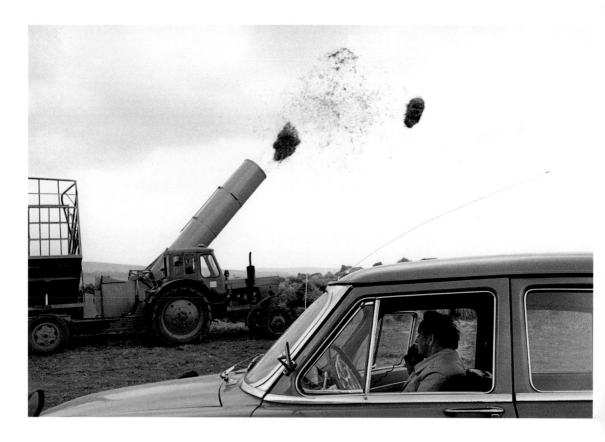

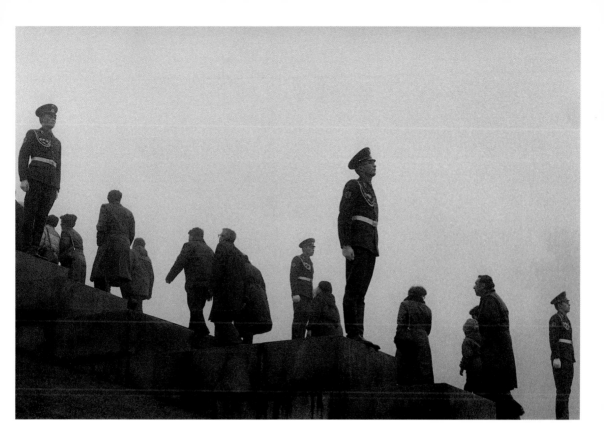

Rudi Meisel
Berlin Treptow / GDR, 1983

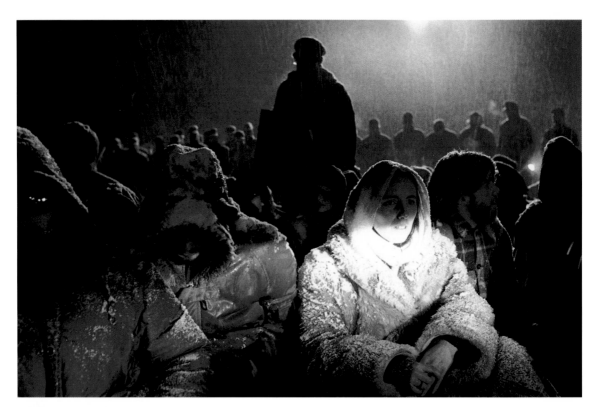

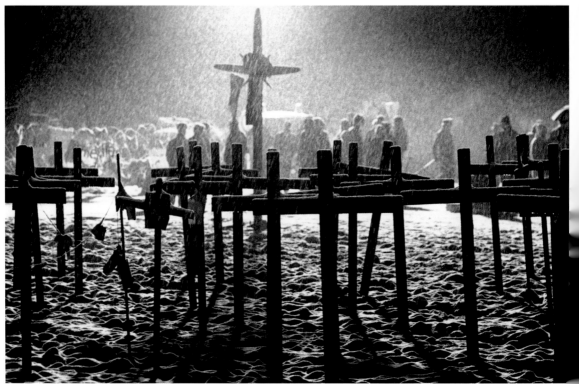

Thomas Pflaum
Mutlangen, civil resistance 83–87 / Winter blockade, 1983

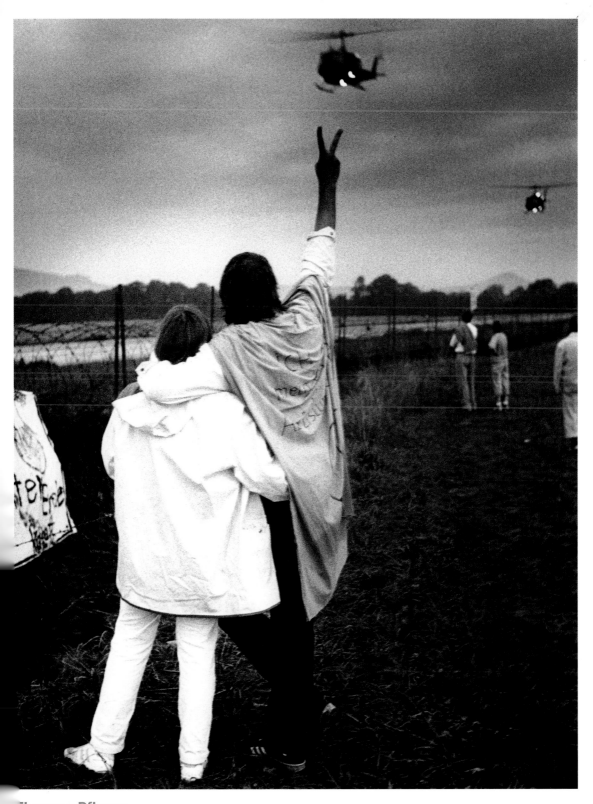

Thomas Pflaum
Mutlangen, civil resistance 83–87 / Blockade by celebrities, 1983

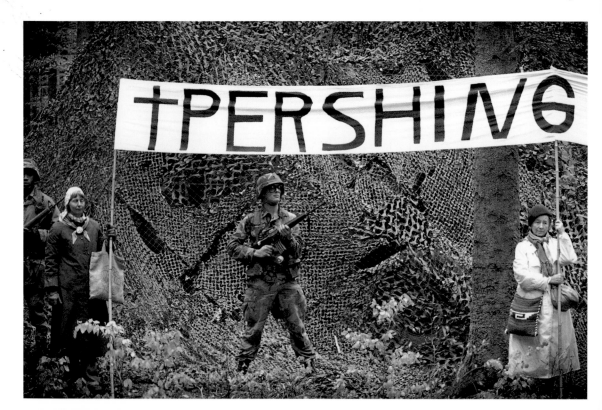

Thomas Pflaum
Mutlangen, civil resistance 83 – 87 / Spring and autumn manoeuvres, 1987

Dieter Blum
Initiation of Massai disciples, 1988

Volker Hinz
Cadet drill / West Point, 1985

Tom Jacobi
Artomobile, 1985

Volker Hinz
Aeid Flash, Area-Club, New York (top), 1986
Baltimore's Miss Jean Hill, Area Club, New York (bottom), 1985

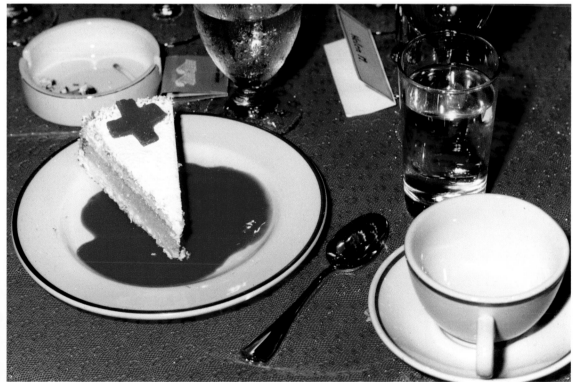

Volker Hinz

Ball Season / Palm Beach (top), 1987
Red Cross Ball / Palm Beach, (bottom) 1987

221

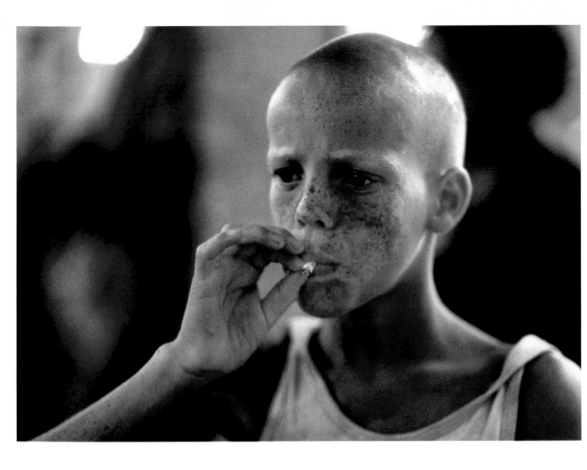

Hans-Jürgen Burkard
Street boy in Sao Paulo, 1982

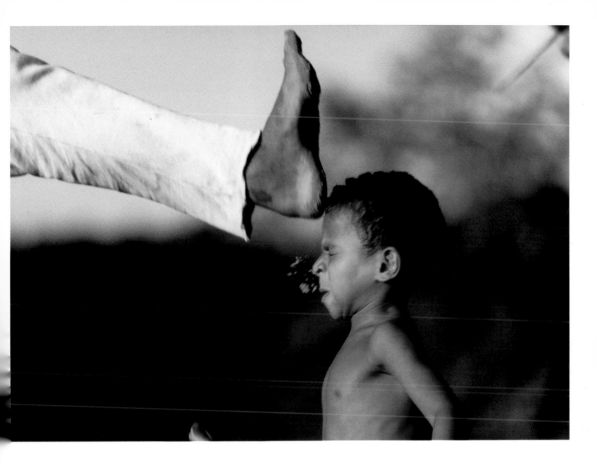

Walter Schmitz
Boy from Capueira / Brazil, 1986

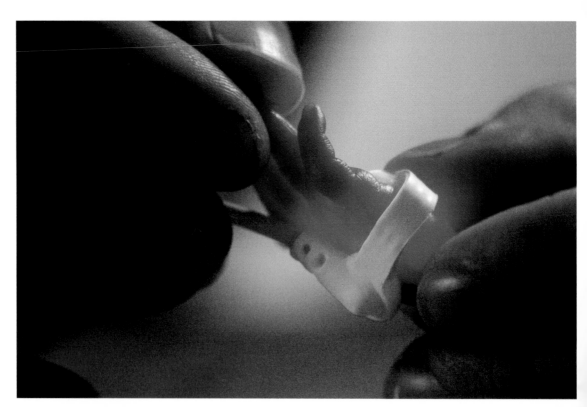

Thomas Stephan
A pulse oxymeter screens the hand of a new born child (top), 1987
Life without technology (bottom), 1987

22

Thomas Stephan
Taking blood from a new born child, 1987

Henning Christoph
Midday prayers in Gelsenkirchen, 1982

Thomas Hoepker
Man with blackbird in Peking, 1984 227

Dieter Blum
Herbert von Karajan and Seiji Ozawa / Paris Opera, 1981

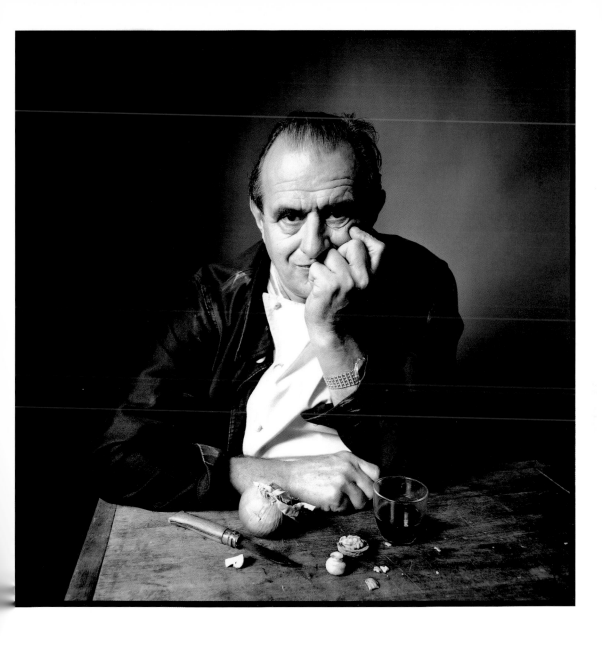

Herlinde Koelbl
Elegant people, 1985

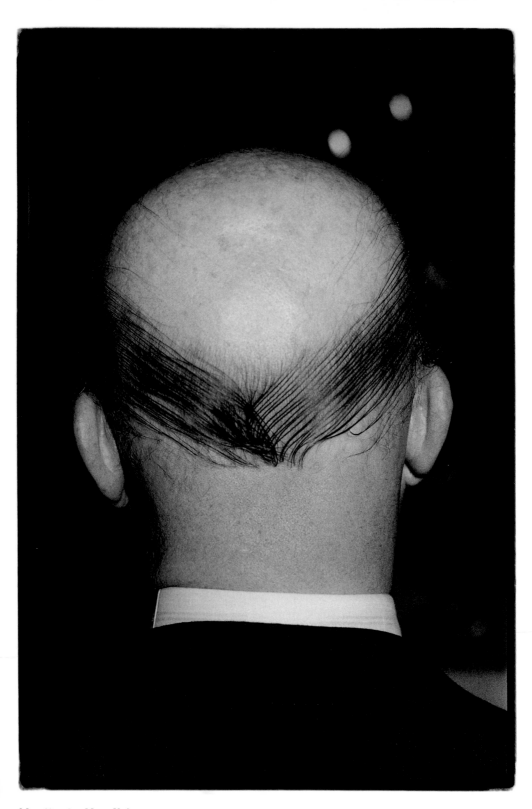

Herlinde Koelbl
Elegant people, 1985

Michael Dannenmann
Keith Haring, 1988

233

Erwin Fieger
Sadhu on Gangotri cliffs/India, 1981 234

rwin Fieger
ace of a beggar / Benares, 1981

The business of a photo designer cuts two ways. Anyone taking it up the wrong way risks getting cut—and not only financially. Professor Gottfried Jaeger attempted to define the area of a photo designer's activity and came to the conclusion that these photographers had to „prepare information using photographic methods for purposes of observation, acquisition and understanding". And this is already the first pitfall for professional users of photography: whereas designer colleagues have to co-ordinate functional and aesthetic requirements, whether they are designing an office chair or a kitchen grill, a photo designer does not work with the components function and aesthetics but with information and aesthetics. This applies to photo reporters and to advertising photographers. It is the information, the message which has to be put in the picture in an optimum way.

Unlike the design of a kitchen device where it is possible to define objective criteria for the functionality of the design alongside elements of pure taste, so that the quality of the design work can be effectively deduced from the object itself, the information in a photograph and the way in which it is portrayed is not an objective quantity. The contents which are allowed to be included in a picture and how they are to be placed are all factors which are generally determined by a body, whether it be called agency or editor's office, which turns the photographer into a mere (although important) recipient of orders. Has the problem therefore resolved itself? No-one can make a photographer responsible for contents which were not his. This short-circuited argument would not deserve any further attention were there not several photographers who are content with this abbreviated description of their profession. An irresponsible and dangerous contentment, because the products of photo designers' dark-rooms have more serious consequences than the work of other designers. Whilst their work is geared towards practical consumption, the work of the photo designer is not aimed at material but at ideal areas of life. These pictures and their messages are to find their way into our minds. One can say a lot about photography, but not that it is without any effect. A dangerous circumstance which professional users should really recognize rather than

others. And because photography is so effective and has such an important status in our society, it is imperative for professionals to attend to the matter. The arguments tabled by those artists who consider the combination of photography and design to be unworthy of and detrimental to photography, who do not want to accept that, problematical as the commercial area of photographic work may be, our society is now unthinkable without it, their arguments are not only narrow-minded but also short-sighted. They fail to see that photography finds its assignments and opportunities not by seeking its fortune in the floor polish-scented temples of the muses but precisely by facing up to the public (literally). The liaison made between art and commerce here is neither detrimental to the one nor advantageous to the other. If the sensitization which art has taken up as its cause is to become reality, then this must be a movement which takes hold of all areas of our lives. Anyone trying to exclude photography will do it a disservice. If one considers the flood of visual stimuli which our eyes are exposed to every day to be a worrying, perhaps even threatening fact and if one is initially prepared to accept this fact without retreating sulkily into an ivory tower, then it is a special, highly qualified type of photographer who is called for here. A photographer who does not understand his assignment as being only an aesthetic or craftsmanship assignment but also as a social one. Inadequate self-esteem often seems to put a stop to that. Photo designers, and this professional title is just ten years old, are limping behind a development which they (and not only they) recognized too late. The result of the realization that the entire commercial area using photography needs available and competent specialist photographers was that photo designers are now being hastily trained at technical colleges. It was only apparently the right conclusion that the emphasis was first placed on availability for too long and then on competence. Realizing that lost time had to be made up and in order to meet the demand for specialists, an effort was made to train photographers who fitted into the existing bodies of picture exploitation without any friction. This meant that it was possible to establish the photo designer as an important factor in the process of the commercial production of images, but the photo designers' own self-esteem should prevent them from being satisfied with this alone.

If the photo designer is aware of his responsibility and if he realizes what an enormous influence he has on the thoughts and actions of the world around him, then he must seek to strengthen his status. Not by means of decrees and laws but on the basis of his competence and commitment. The photo designer must reassume his part in the commerce and creativity team—the creative one. Over the past years there has been no lack of criticism and self-criticism surrounding the work of photo designers.

Dealers in taste, suppliers to a society of obsolescence, tempters—photo designers are pushing this negative image along in front of them. It demonstrates the problems which this new branch of the profession has with its work and self-esteem. And the problems which outsiders have in accepting these problems. If photo designers were to take up the offensive and face up to their responsibility in society, this would be the first step in the right direction.

Wolfgang Lummer
Fan dove, 1975

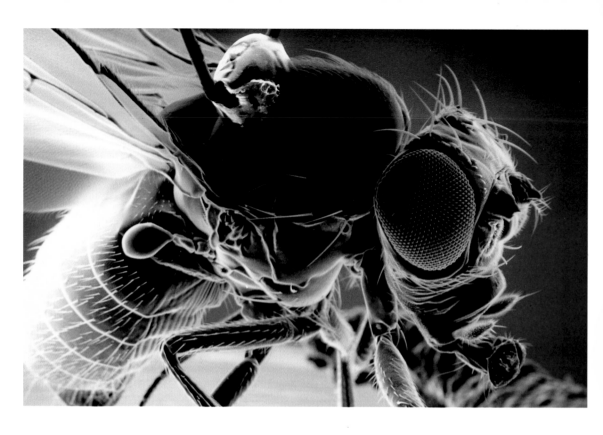

Manfred P. Kage
Fruit fly drosophila melanogaster, 1979

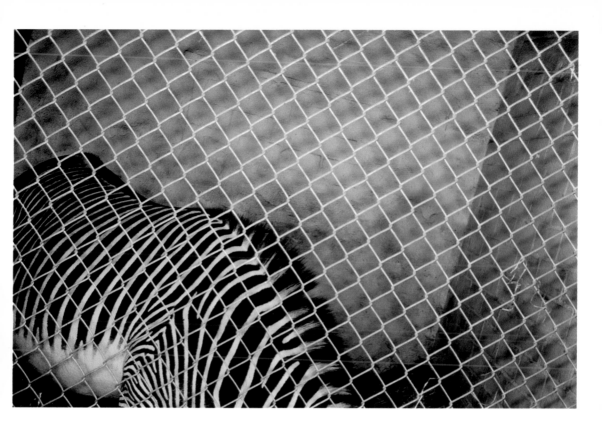

Till Leeser
Taken from the series "Zoo pictures", 1982

Axel M. Mosler

Monument Valley / Arizona (top), 1983
Death Valley, Zabriskie Point / California (bottom), 1983

Rainer Stratmann
Amish family in Ohio / USA, 1983

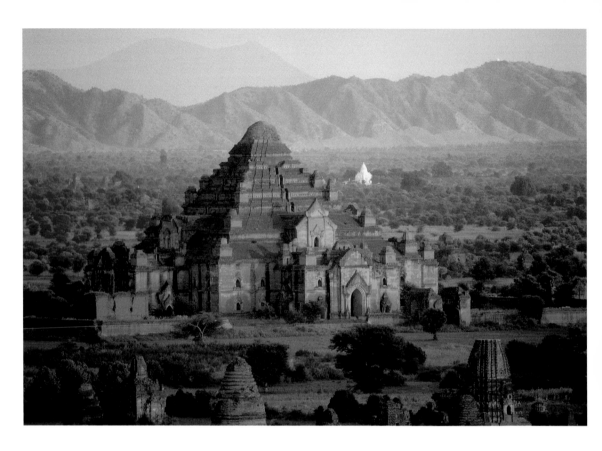

Peter Eising
Pagan / Dhammayaugyi Temple, 1984

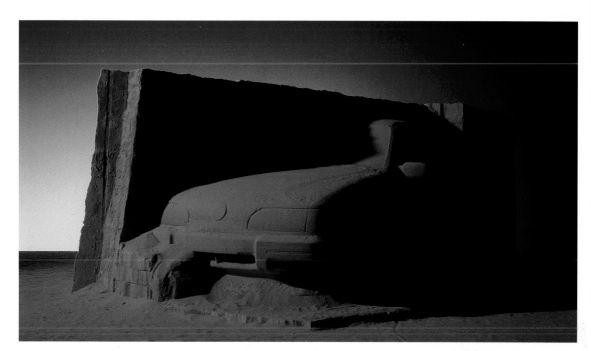

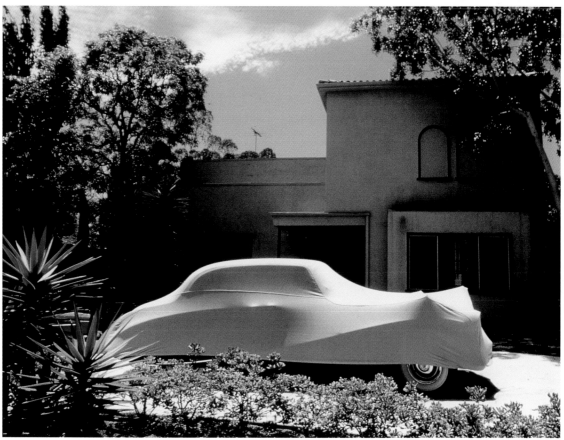

Iver Hansen (top)
New car in disguise, 1982

Volker Hinz (bottom)
Hollywood, 1977

245

Milan Horacek
Face-lifting in the dry dock, 1987

Thomas Lüttge
Paper and landscape, 1970

24

Wolfgang Volz
Christo and Jeanne-Claude: Surrounded Islands , 1983

Michael Friedel
The Philippines — Taal Volcano — Erosion, 1977

Reinhart Wolf
Fuller Building / New York, 1979

Reinhart Wolf
Waldorf Tower / New York, 1982

Dieter Leistner
Indoor Swimming Pool Elisabethstraße / Aachen, 1982

Hans Eick
Steel Dynamics, 1989

Peter Keetman
Cactus, 1985

Hans Hansen
Finnish glass, 1986

Bernhardt Brill
Airbag, 1985

Bernhardt Brill
Airbag, 1985

Karl M. Holzhaeuser
Landscape, 1982

Hansi Müller-Schorp
Black and white glasses, 1987

Hans Hansen
1983

Hansi Müller-Schorp
Dolls' eyes, 1984

263

Manfred Rieker
Audi, 1984

Gert Wagner
Glider, 1981

Peter Knaup
Fuji Chrome / Colors (top), 1989 / Lancaster (bottom), 1989

Peter Keil
Rowing boat, 1983

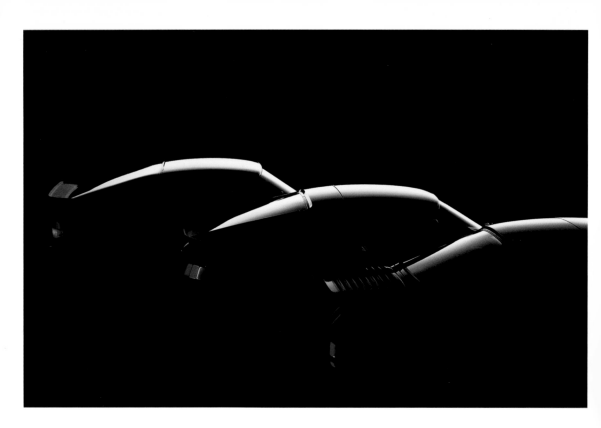

Dietmar Henneka
Porsche silhouettes, 1984

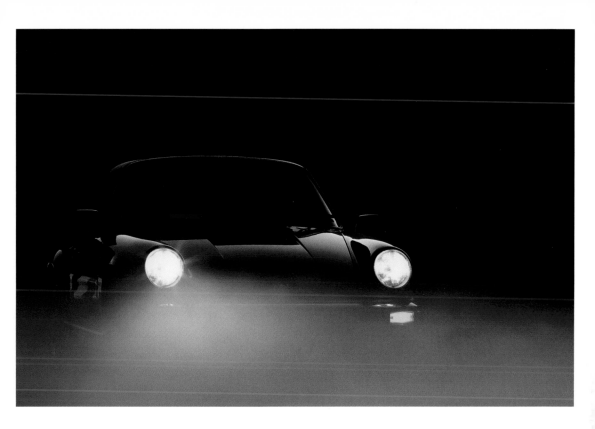

Dietmar Henneka
Porsche in the mist, 1983

Hartwig Klappert
1985

Dieter Leistner
Looking up 023, 1985

Dieter Leistner
Looking up 072, 1990

Dietmar Henneka
N-Cube, 1988

Tomas Riehle
Heerich on Hombroich / Tower, 1989

Christoph Seeberger
Power Plant, 1989

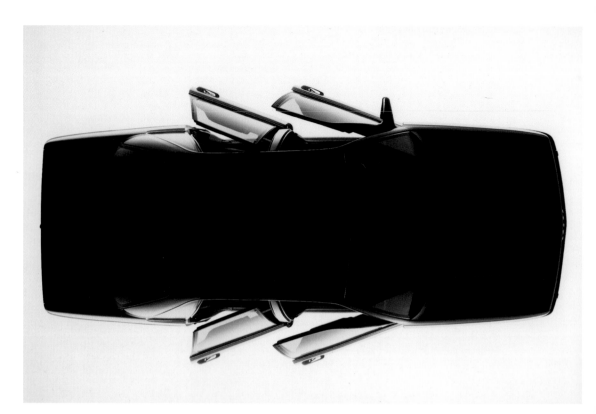

Manfred Rieker (top)
Audi, 1984

Wolfgang Gscheidle (bottom)
Champagne glass, 1984

Alfred Saerchinger
Maria's Steps in Atlantis, 1998

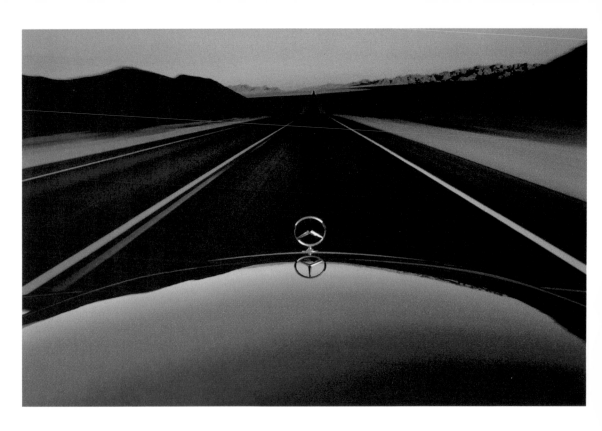

Peter Keil
Mercedes star / Nevada, 1985

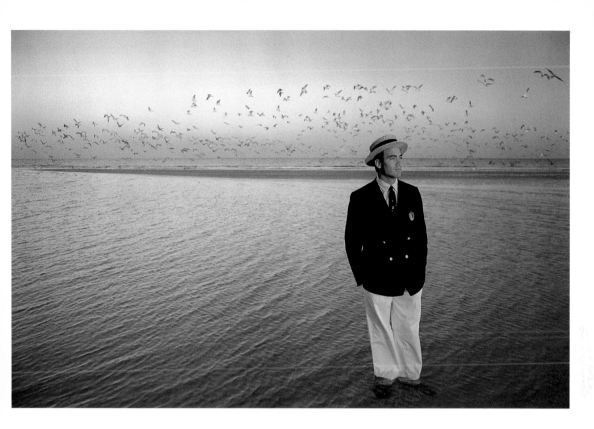

Conny J. Winter
Eurovision, Jorge Pensi / Spain, 1991

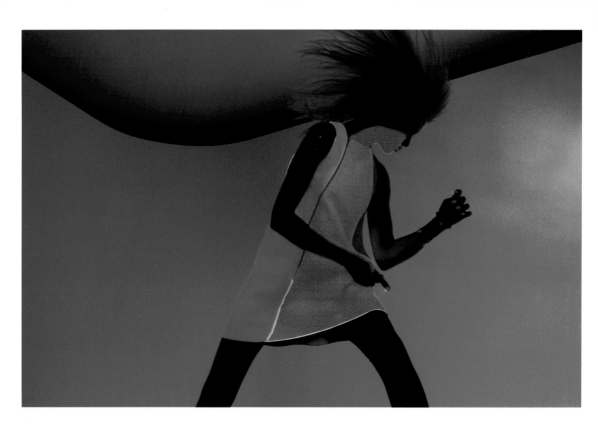

Tom Jacobi
Day-Glow, 1985

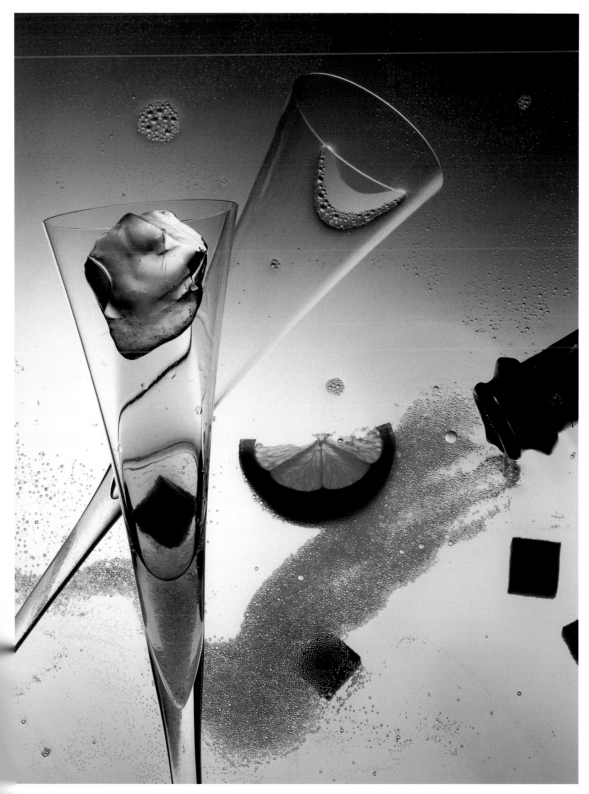

Bodo A. Schieren
Champagne cocktail, 1989

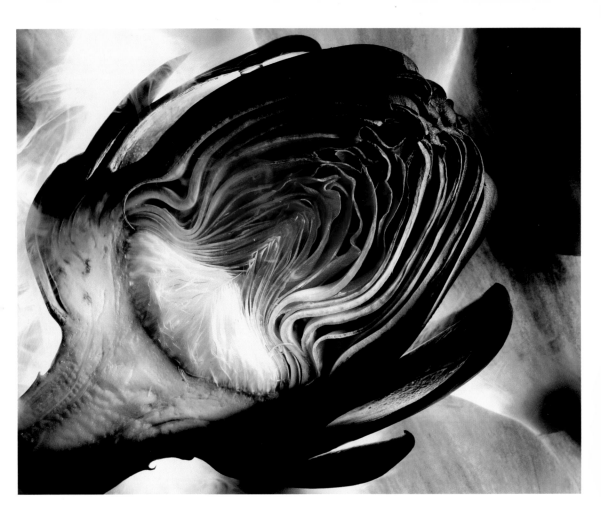

Jo van den Berg
Artichoke, 1987

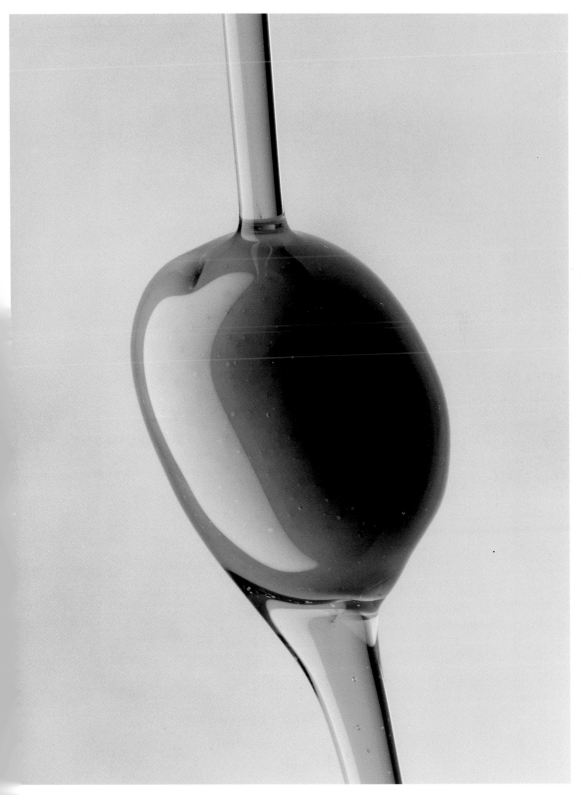

Christian von Alvensleben
Olive, 1988

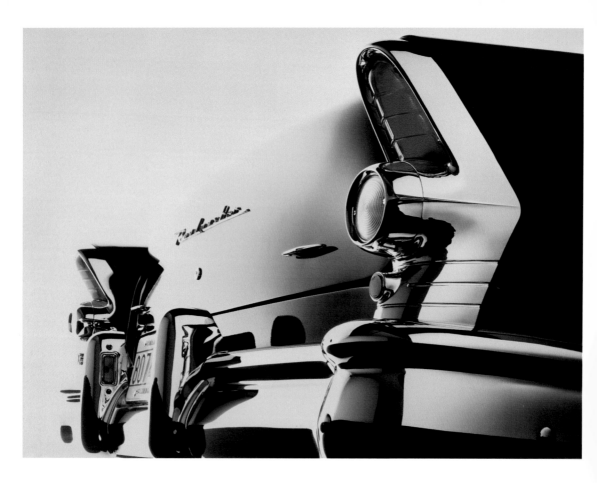

Manfred Rieker
Buick, 1985

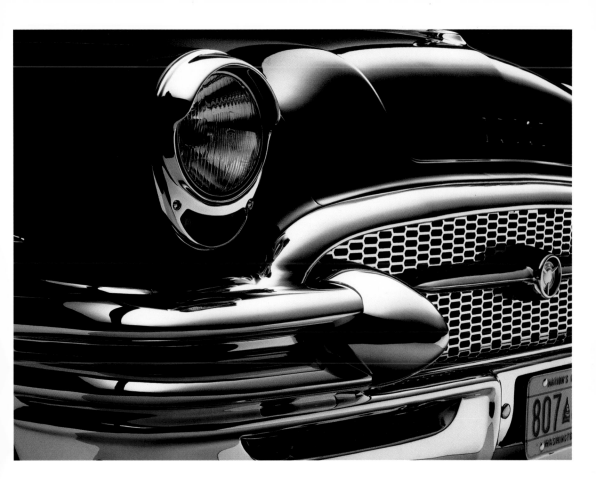

Manfred Rieker
Buick, 1985

Arnold Zabert
1987

Herbert W. Hesselmann
Sleeping beauties, 1983

Bernhardt Brill
Balloon exploding, 1985

Hans-Jürgen Burkard
Frank Hoffmeister, world record-holder in backstroke, 1984

Bert Brüggemann
1978

Gert Wagner
Flying a dirigible, 1980

Ben Oyne
Zeitgeist under the drier, 1973

Ben Oyne
Kitchen upside down, 1977

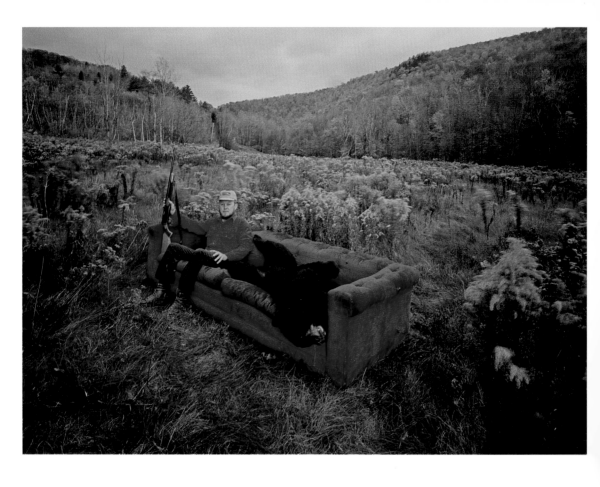

Horst Wackerbarth
Elmer Greene, Hunter / Beartown Valley, Vermont, 1981

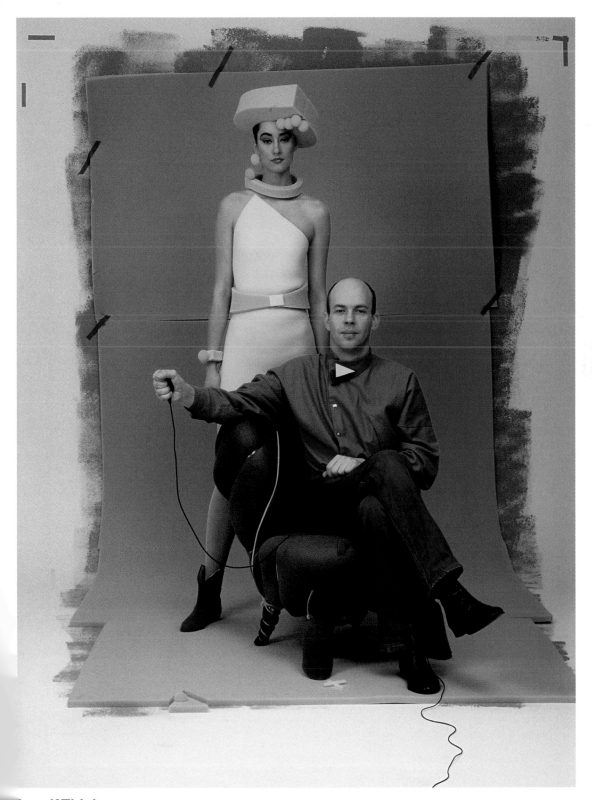

Ingolf Thiel
People of today, photographed by themselves, 1981

H. Ross Feltus
Three ladies from Hollywood, 1988

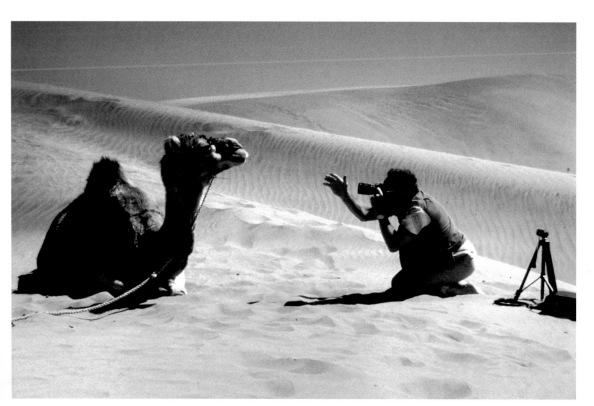

Chico Bialas
Photo Porst, 1980

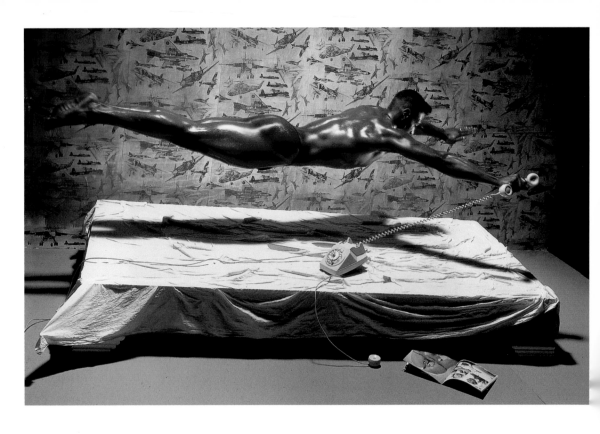

Gerhard Vormwald
The flying black man, 1983

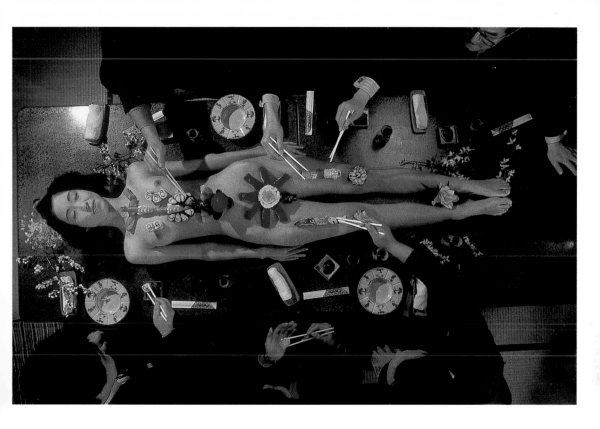

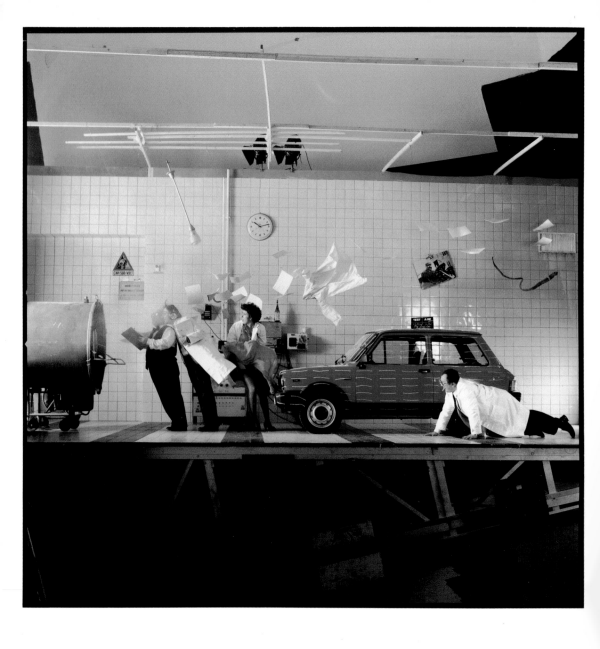

Ben Oyne
Air tunnel, 1983

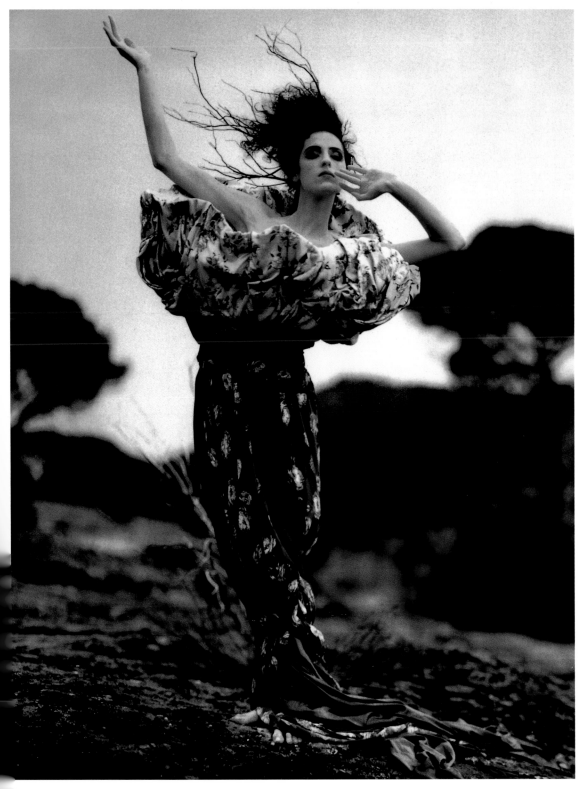

Peter Godry
1989

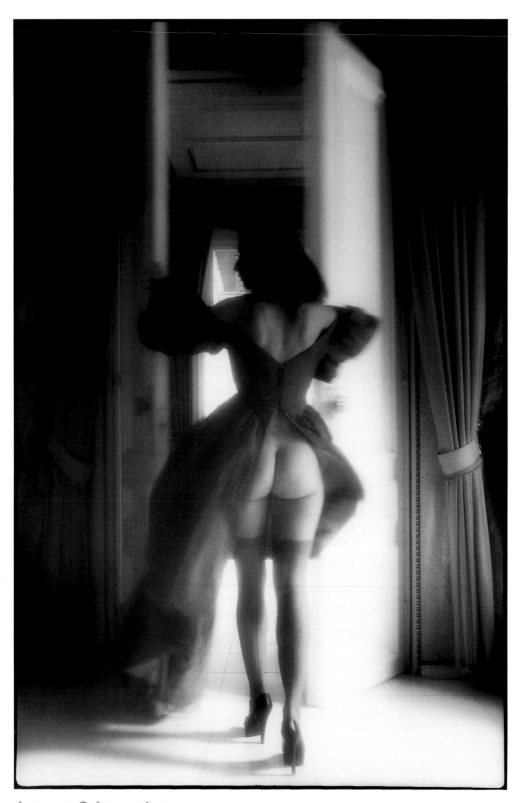

Jacques Schumacher
Lilo, 1980

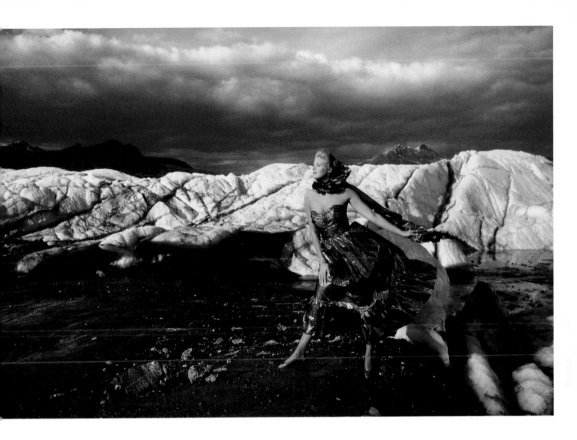

Jochen Harder
Evening dress on a glacier, 1990

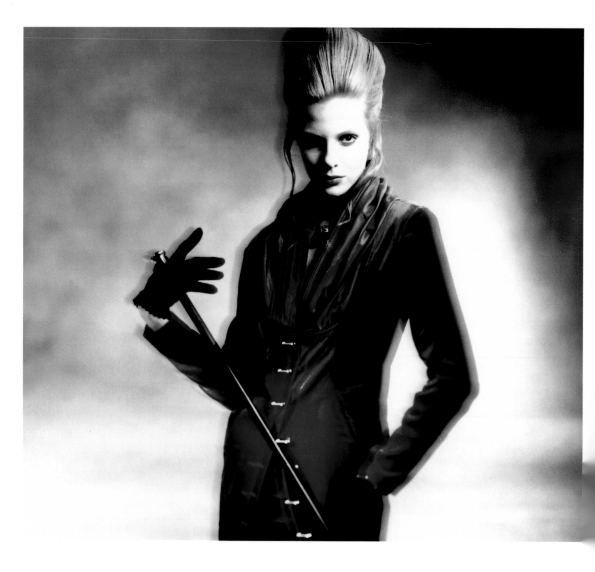

Peter Godry
1988

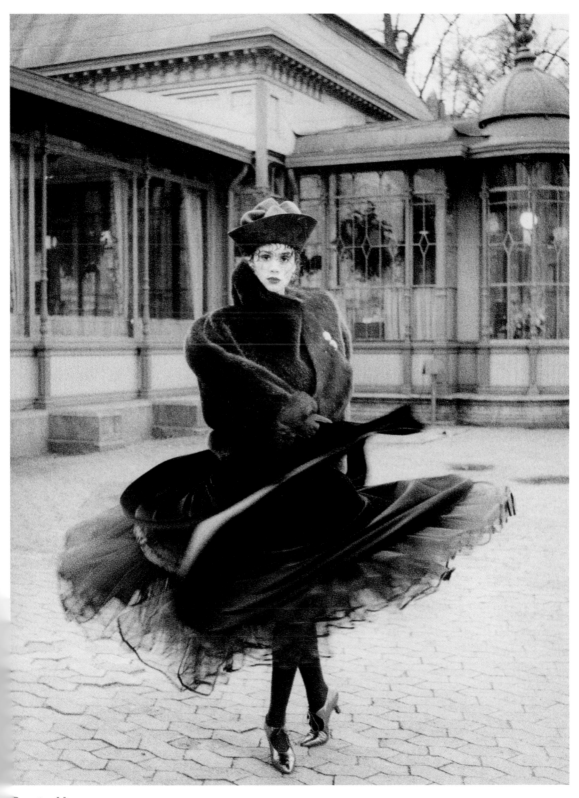

Beate Hansen
Noel en Finlande, 1987

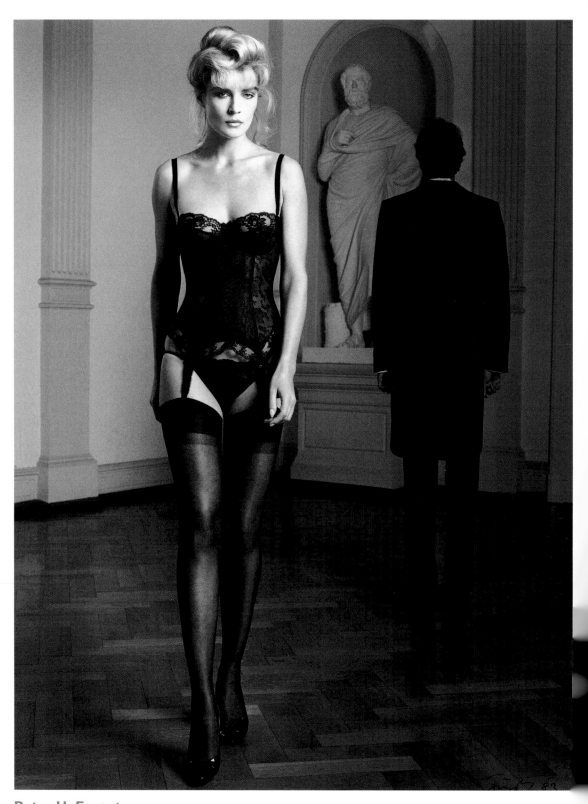

Peter H. Fuerst
"Danielle in black lingerie" Homage à A. Raederscheidt, 1983

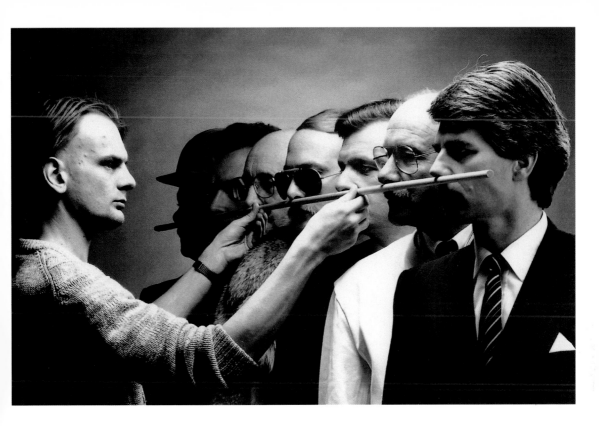

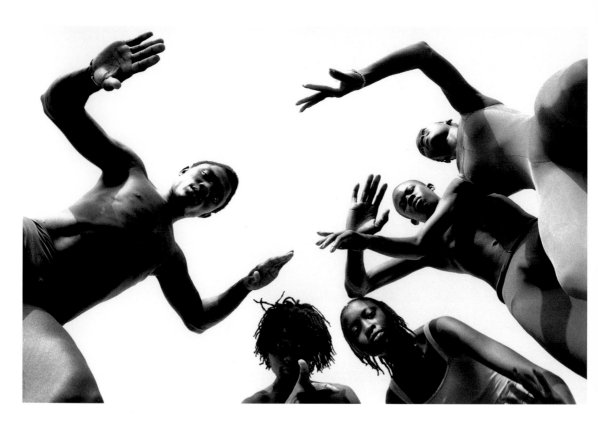

F. C. Gundlach
Dance Africaine / Dakar, 1980

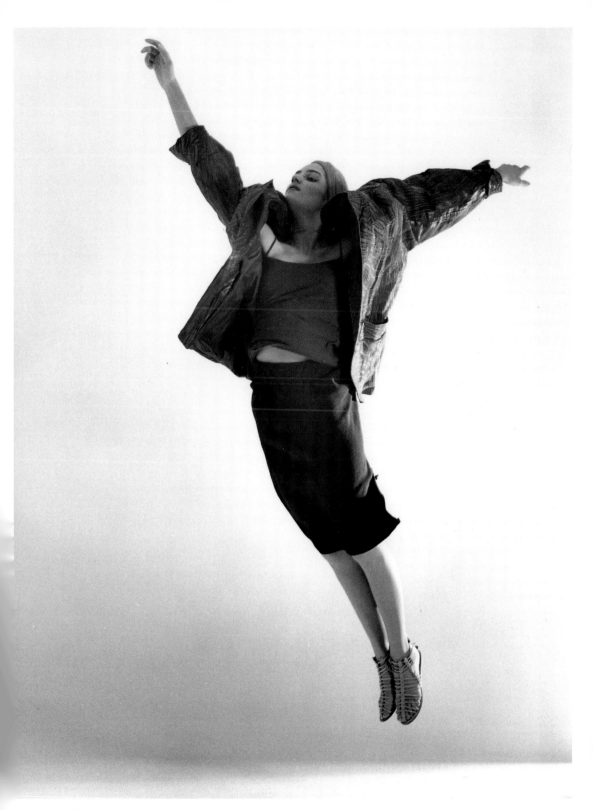

Uwe H. Seyl
1986

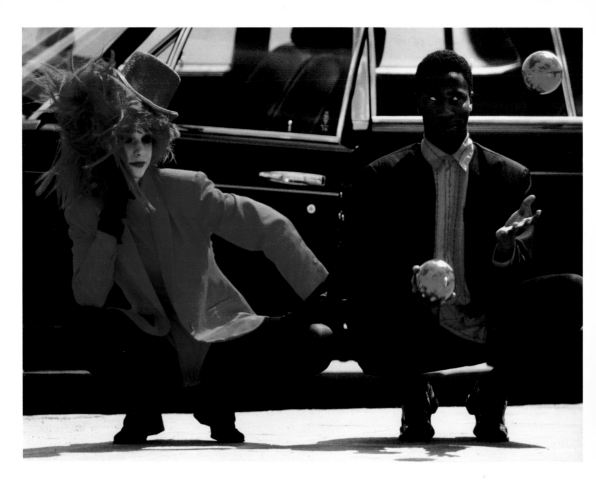

Chico Bialas
Mexx-International, 1986

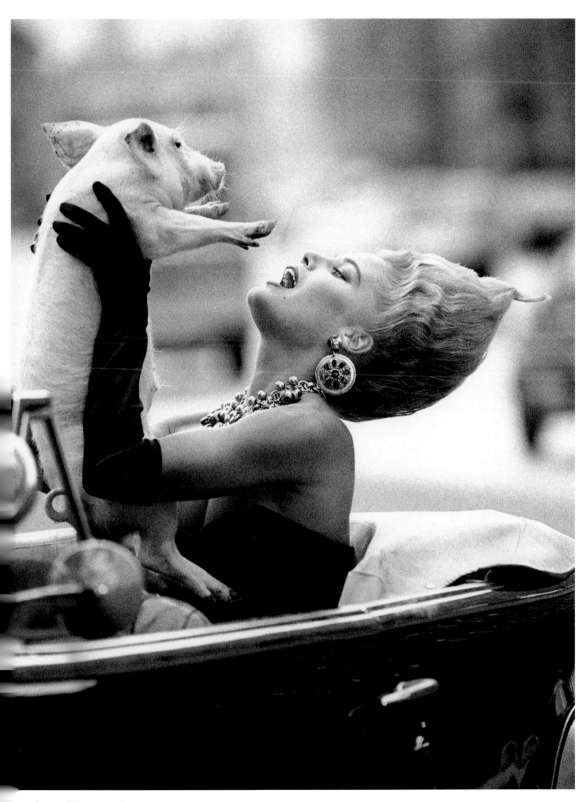

ochen Haunreiter
weet pig, 1986

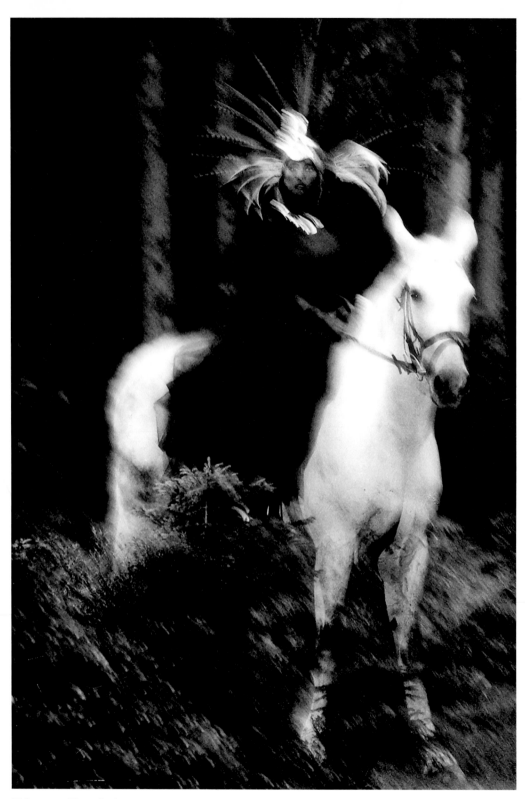

Werner Pawlok
Native American on a horse, 1986

Werner Pawlok
Vulture Wally, 1986

Peter Hoennemann
Michaela, 1988

Klaus Kampert
1990

Dieter Elsaesser
1988

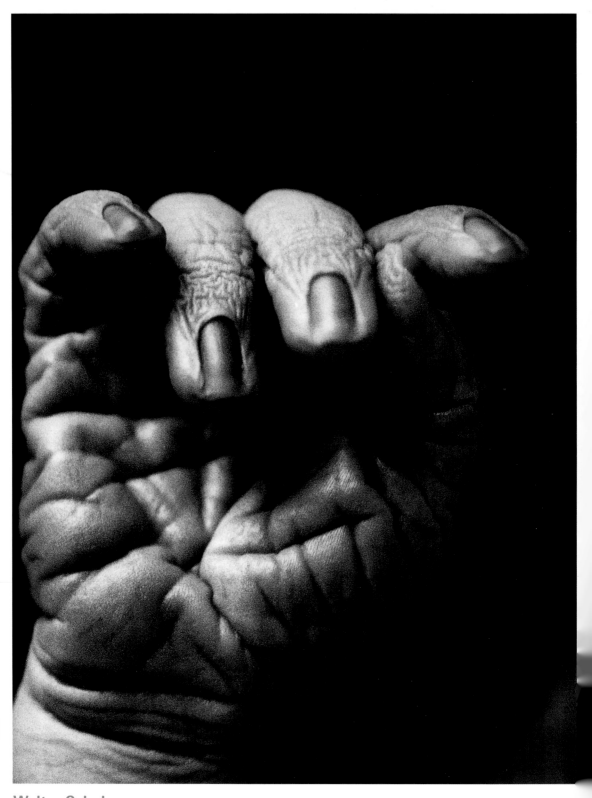

Walter Schels
Hand of a baby / approx. 3 minutes old, 1988

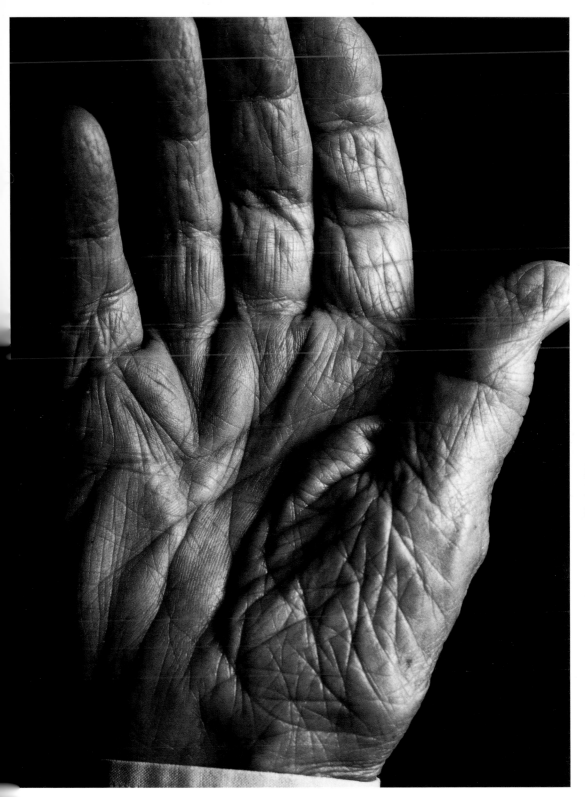

Walter Schels
Hand of a 96 year-old, 1988

Guenter Pfannmueller

A. Stankowski / Dr. F. Langenscheidt / P. Schmidt / K. Gerstner, 1989 32

Dieter Kahl
Piet, 1989

Uwe Christian Duettmann
Happiness, 1989

Uwe Christian Duettmann
ist, 1988

Hubertus Hamm
Finger Prints, 1990

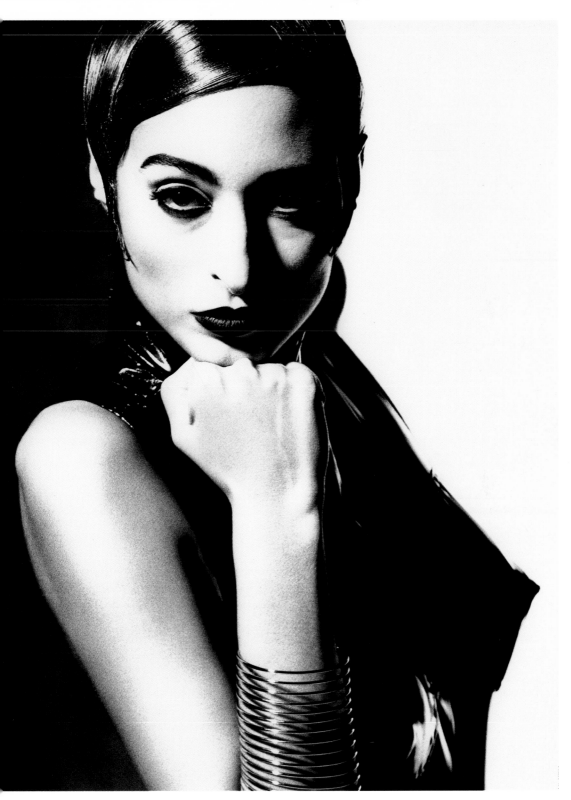

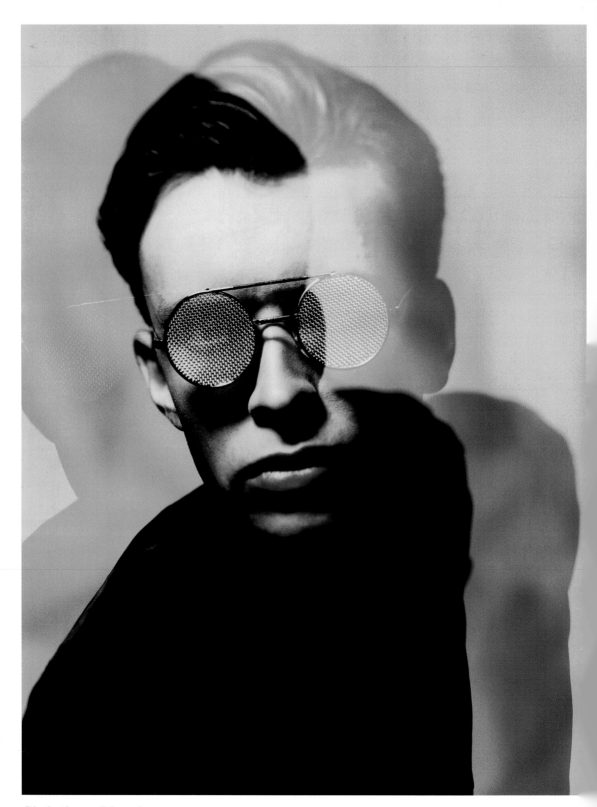

Christiane Marek
1989

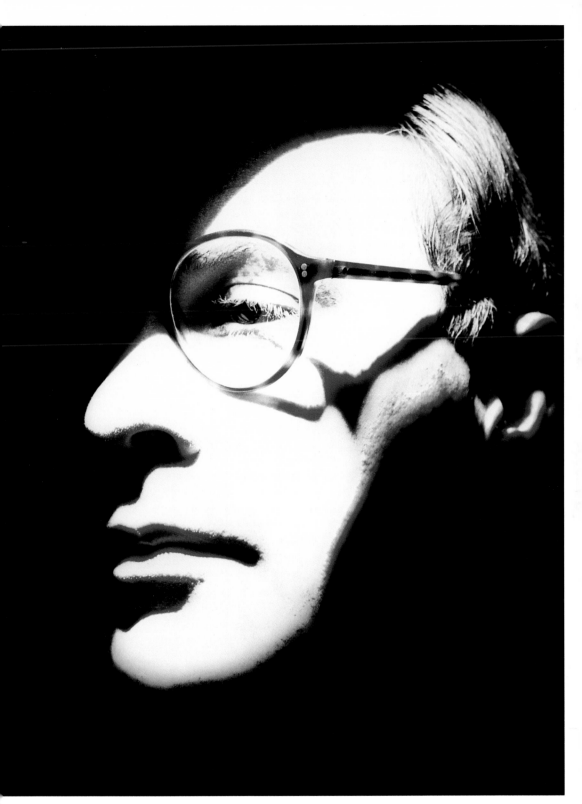

Uwe Christian Duettmann
Robert Wilson, 1992

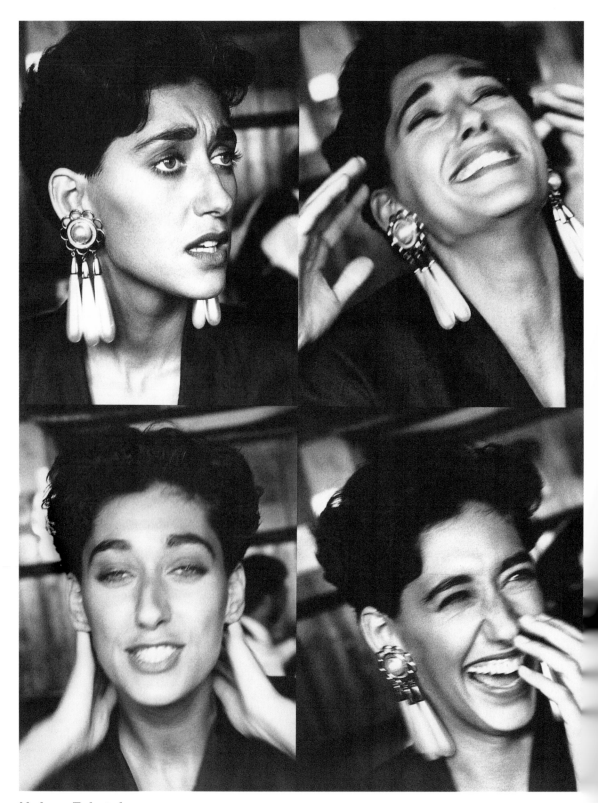

Holger Eckstein
Giselle for Toni Gard, 1991

328

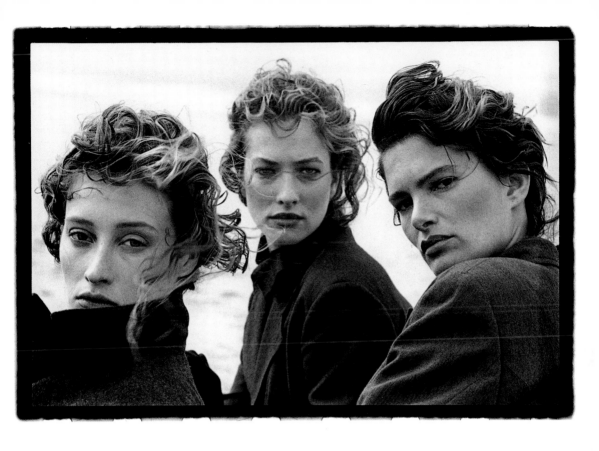

Kay Degenhard
Berlin Fashion / Joop, 1990

□ 199
Laura Gilpin (1891–1979)

'APPLE BLOSSOMS'

platinum print, hinged to mount, the photographer's
'Santa Fe, New Mexico' studio label, with typed title,
date, and the annotation 'A Platinum Print', affixed
to the reverse, matted, signed and dated by the
photographer in pencil on the mat, framed, 1926
9⅜ by 7⅝ in. 24.1 by 19.4 cm.

$8,000–10,000

*Unless otherwise stated in the description above, the photograph is a gelatin
silver print and is not offered as one of a limited edition.*

Marco Breuer
"1891–1979"

331

Sarah Moon
Audrey pour Comme des Garçons, 1998

33

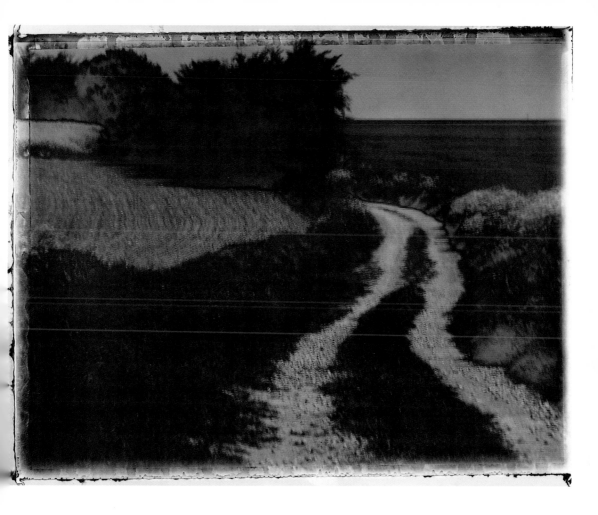

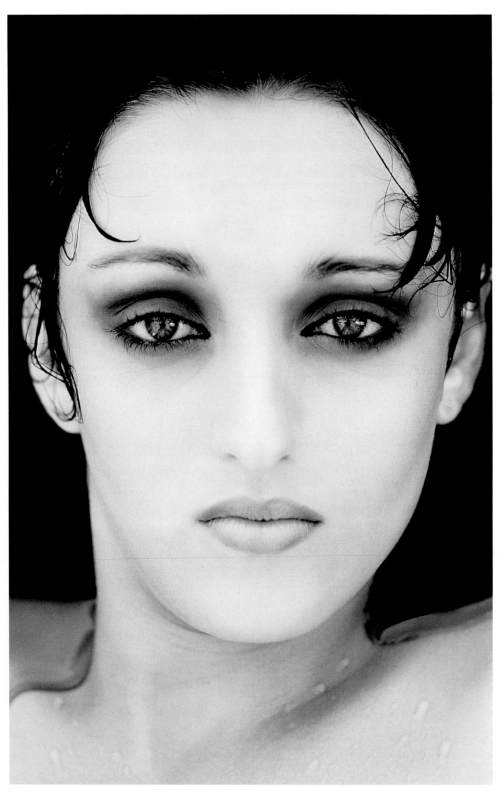

Thomas Kettner
True Lies, 1997

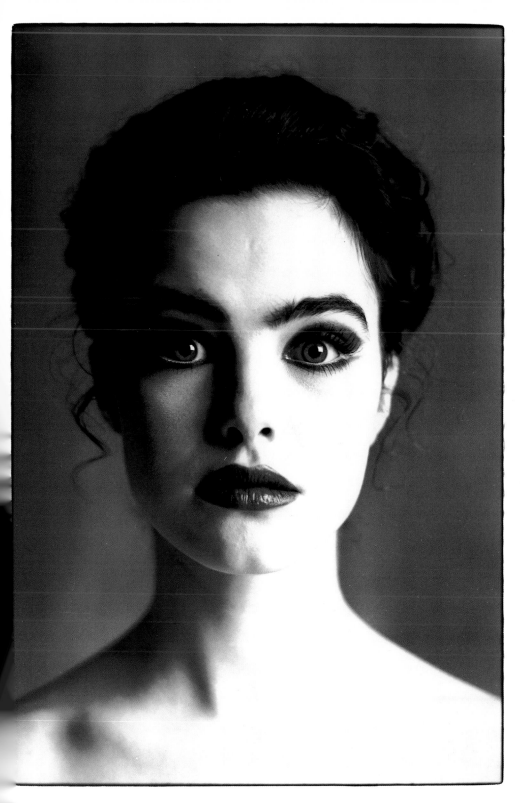

Sigi Hengstenberg
Anna Paula, 1991

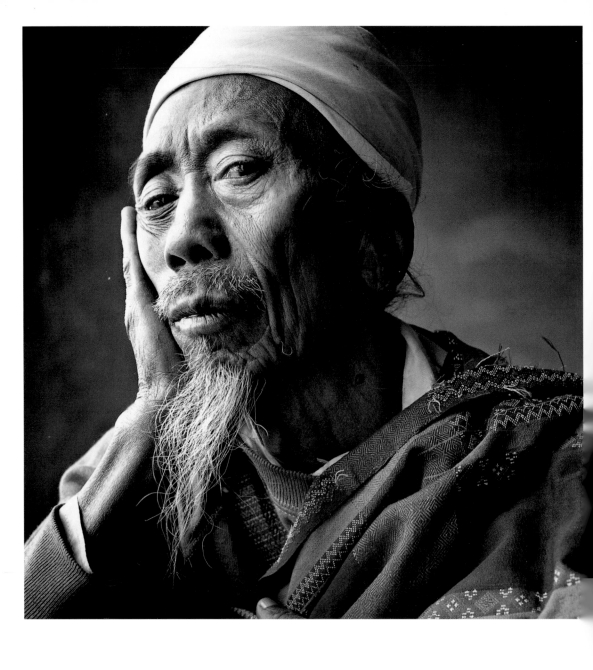

Guenter Pfannmueller
Farmer from the Chin tribe / Burma, 1995

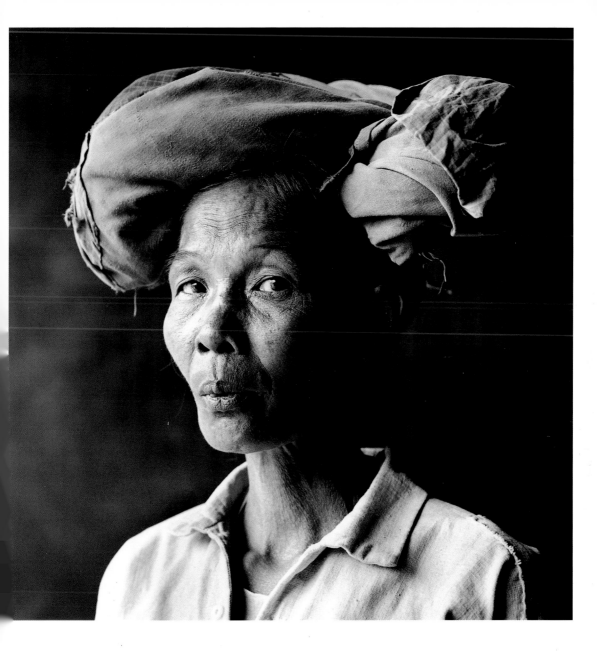

Guenter Pfannmueller
Woman farmer from Burma, 1994

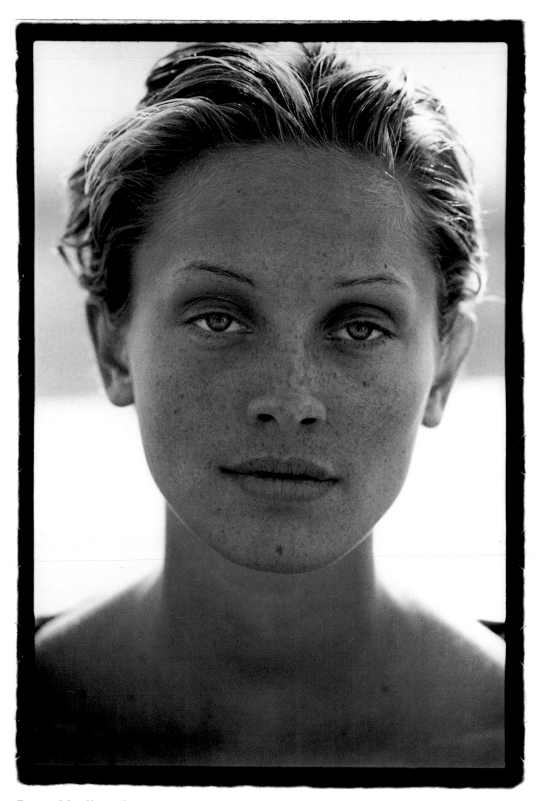

Peter Lindbergh
Berri Smither, 1993

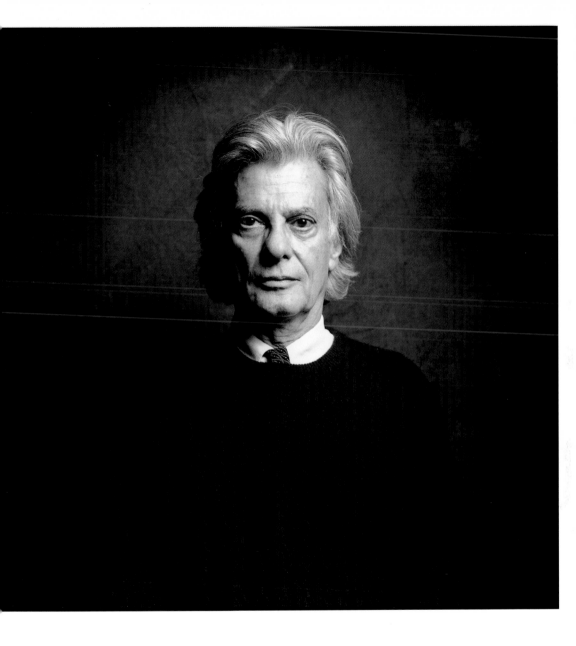

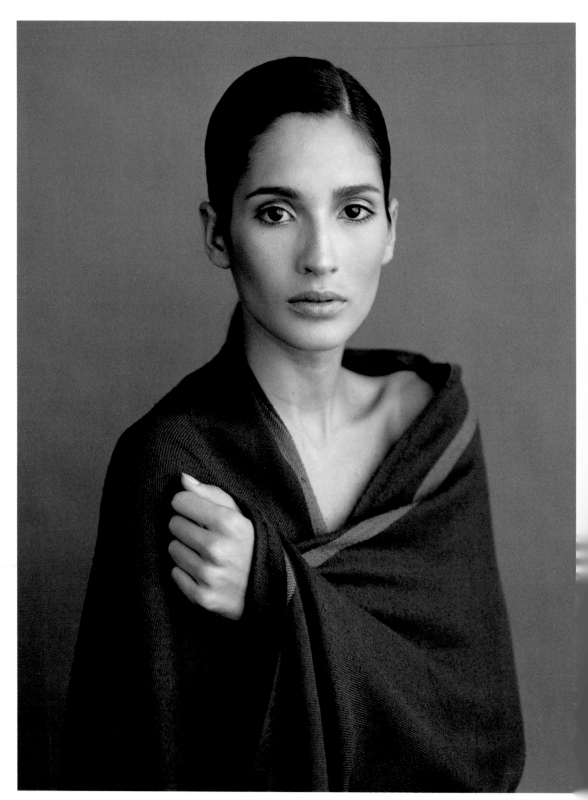

Peter Hoennemann
Astrid Muñoz, 1997

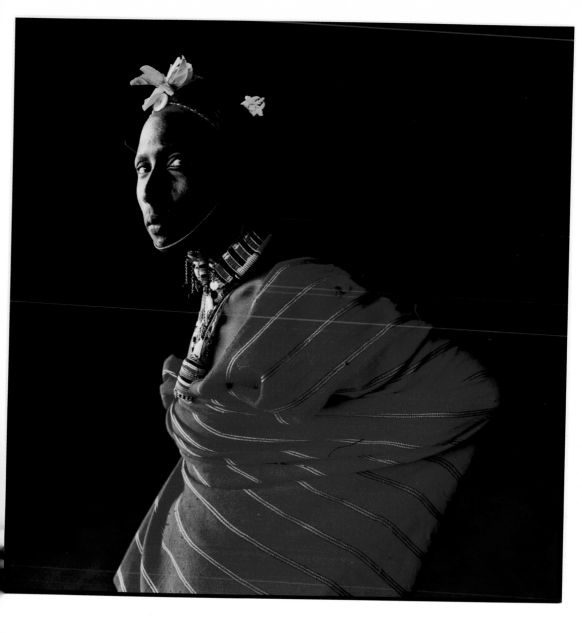

Guenter Pfannmueller
Samburu / Kenya, 1997

Beatrice Heydiri
Joy of life, 1997

Mats Cordt
Schnidder, 1996

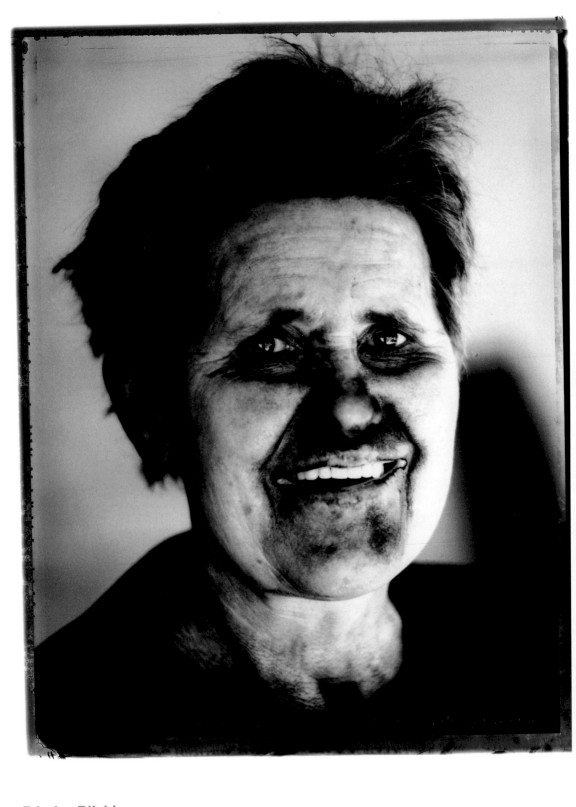

Frieder Blickle
The female charcoal burner, 1995

Nico Weymann
Thief, 1997

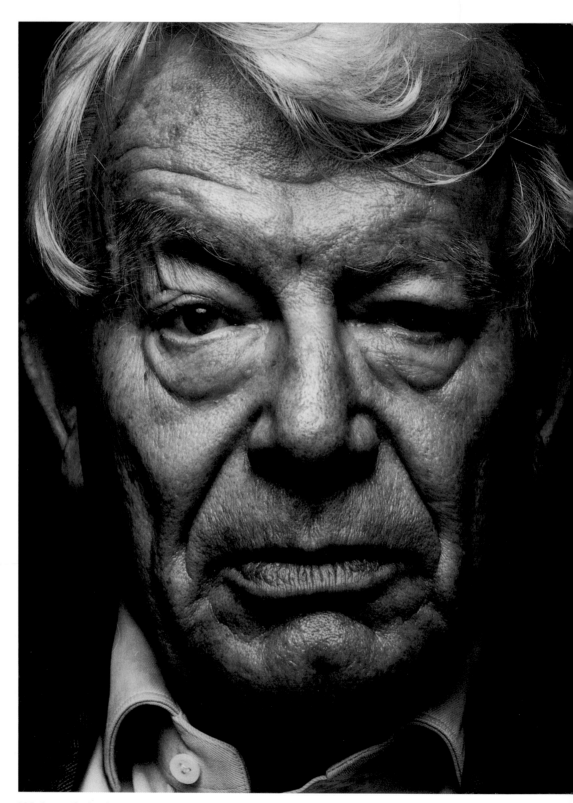

Walter Schels
Henry Nannen, 1991

Walter Schels
Dog's muzzle, 1991

Gerhard Linnekogel
1993

sad Cicic
blue nights", 1993

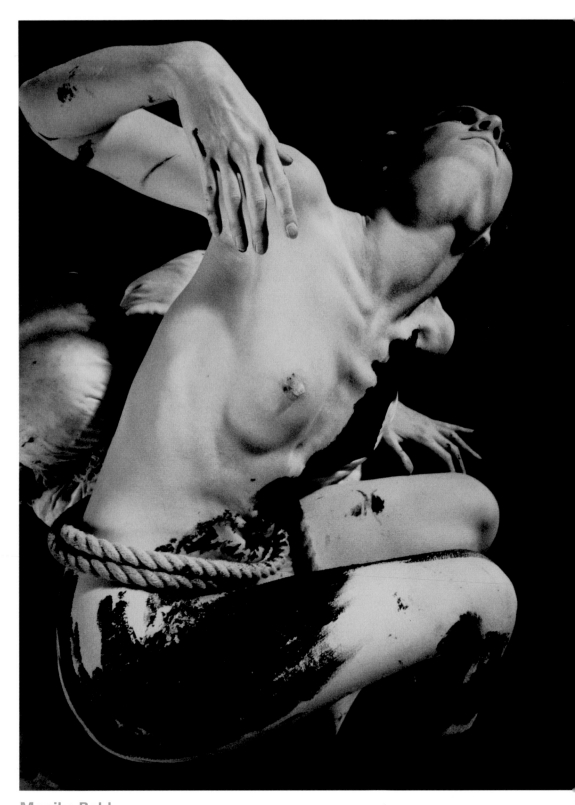

Monika Robl
Pictures of a dance, 1990

35

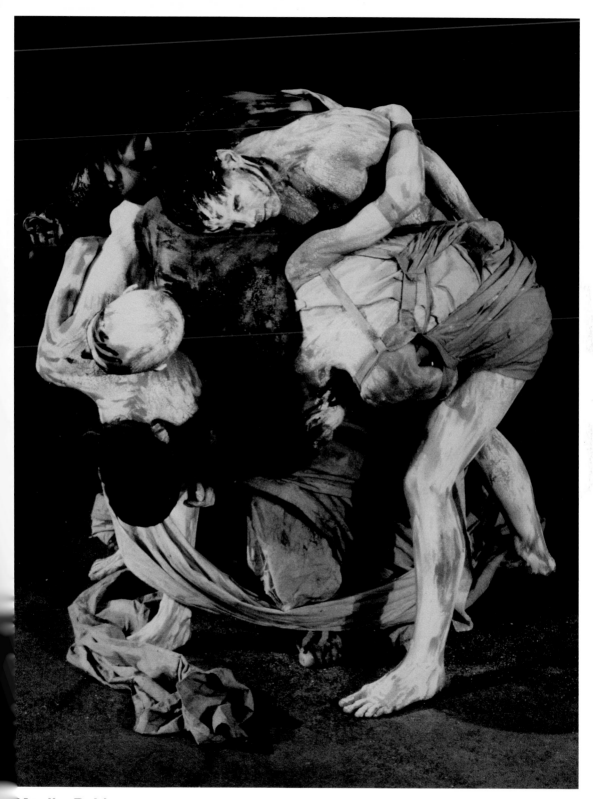

Monika Robl
Pictures of a dance, 1990

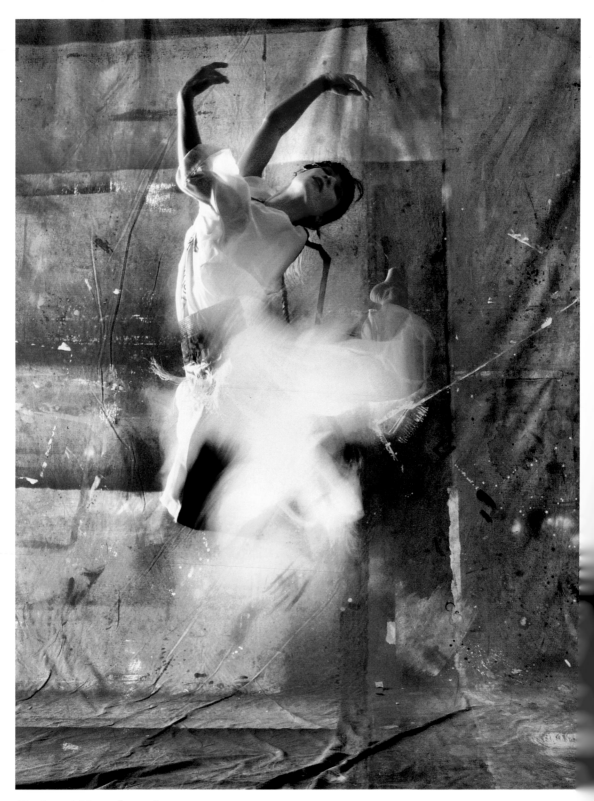

Gerhard Linnekogel
Verena Weiss, 1986

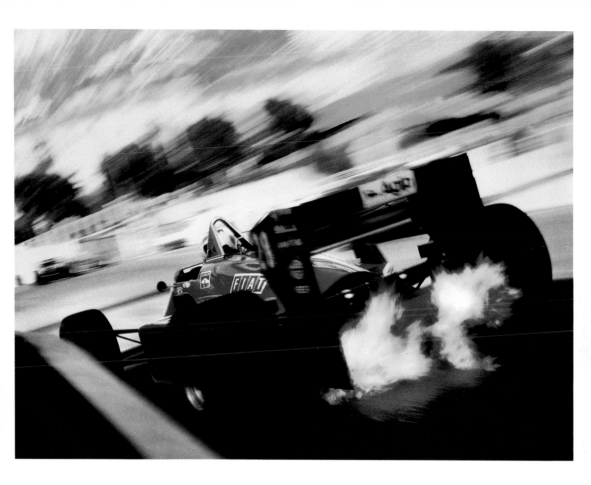

Rainer W. Schlegelmilch
Flames—Ferrari, 1985

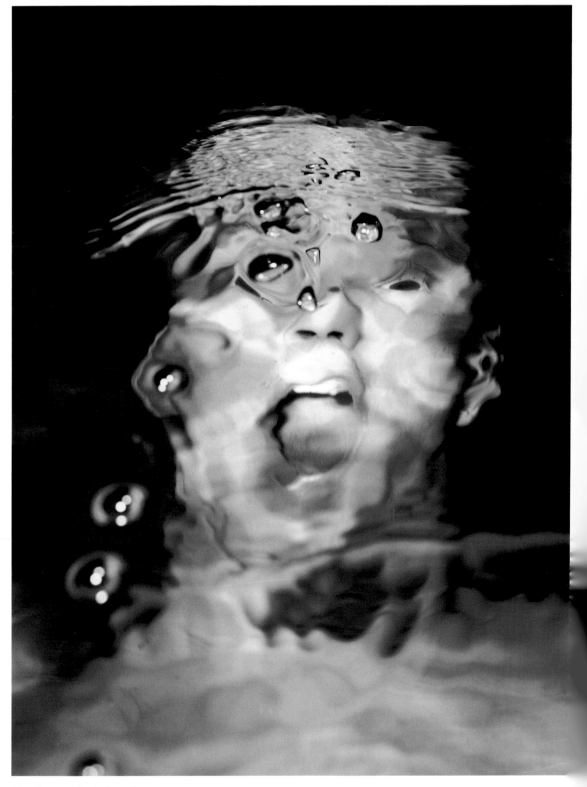

Andreas Dahlmeier
1991

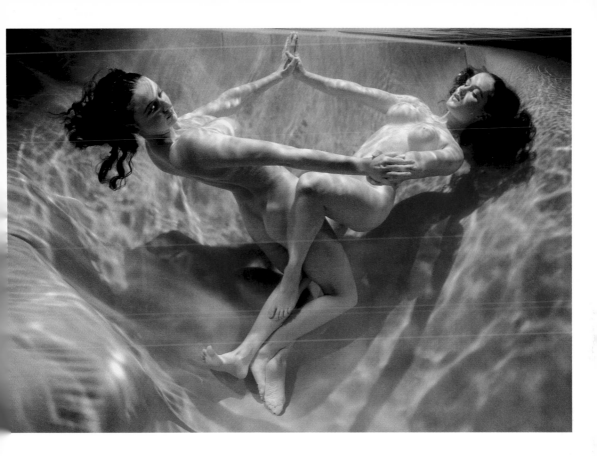

homas Kettner
wins, 1996

Beate Hansen
Mouth, 1996

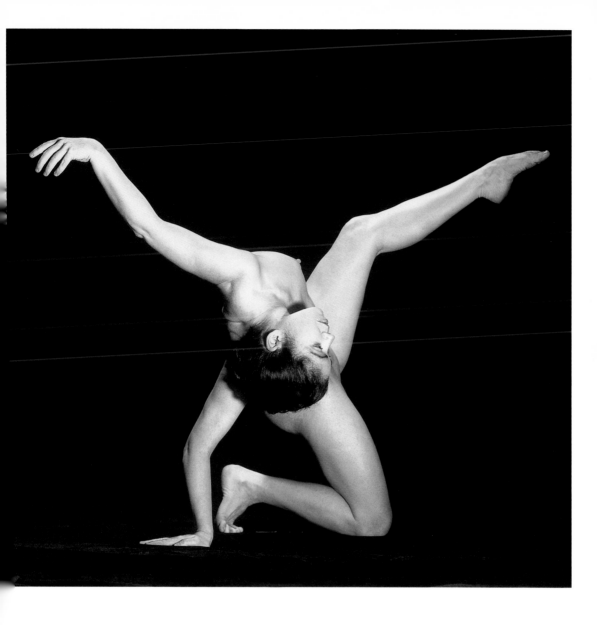

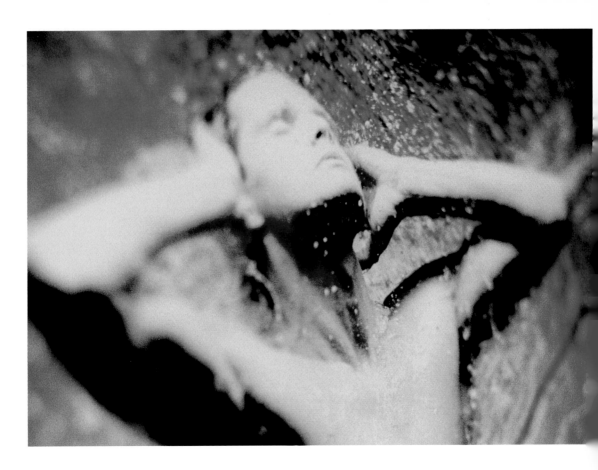

Hubertus Hamm
Aquarius, 1995

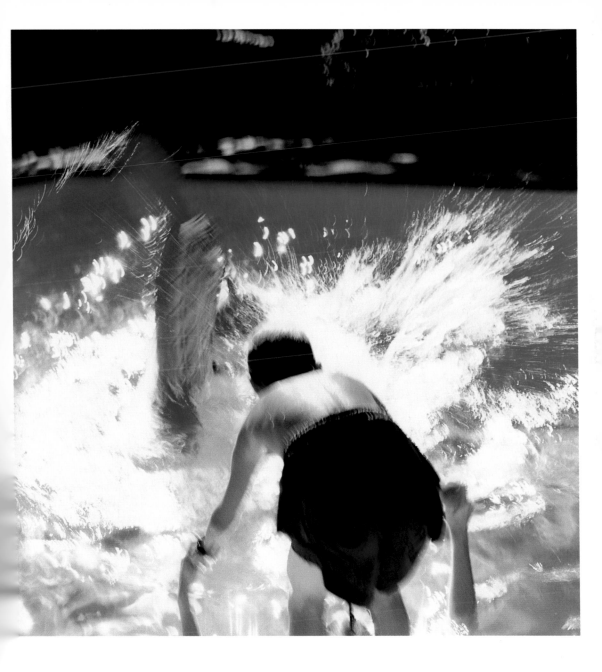

Olaf Hauschulz

997

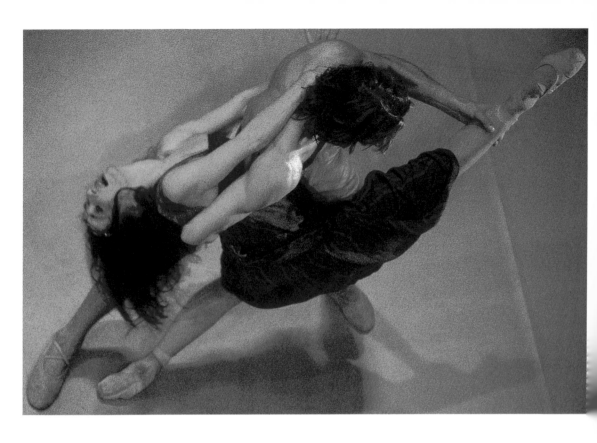

Dieter Blum
Marcia Haydée and Wolfgang Stollwitzer in Medea, 1989

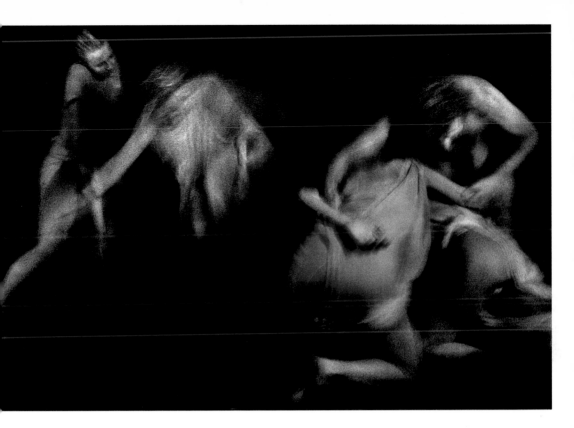

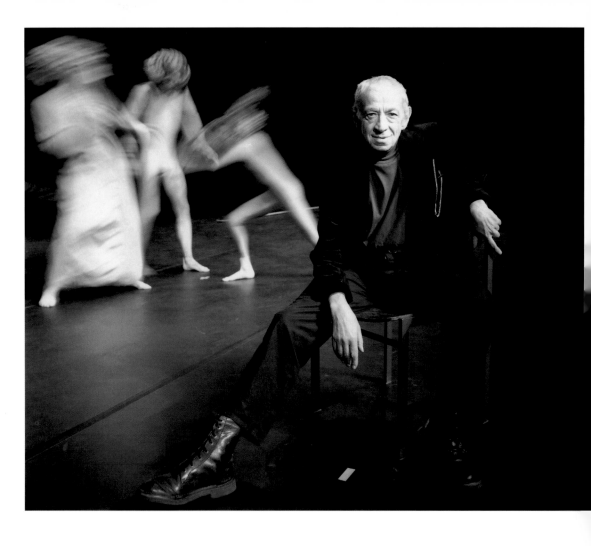

Joachim Giesel
Jean Soubeyran / Choreographer, 1990

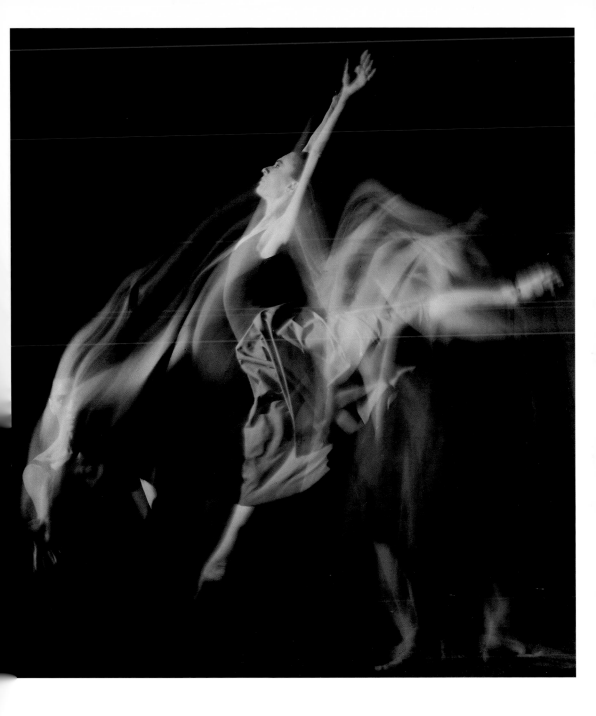

Joachim Giesel
Bolero 1, 1996

A.T. Schaefer
King Arthur / Purcell (top), 1998 / Rhinegold (bottom), 1998

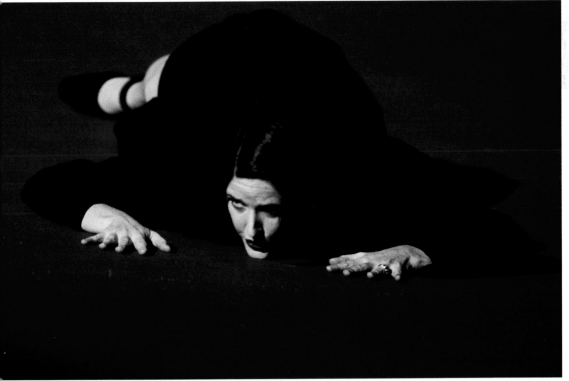

A. T. Schaefer
The silence of the sirens (top), 1994 / Salome (bottom), 1996　　　365

(Jacques Schumacher)

In essence, the answer is surprisingly simple: A good photo should make a stronger impact than television. Ideally, it sparks off the fantasy of the beholder, mobilizes his imagination for him to create his very own film in his mind. It also means, however, that a good photo has to send several signals simultaneously—in the absence of TV's sound and motion. Since photos only address one sense, they are silent by nature. We photo designers must amplify them in order to transform them into messages.

In technical terms this means: The use of strong colors or, for black and white pictures, of strong contrasts. More important still, a photograph must unleash emotions which conform to the beholder's own inner images to his dreams. Photographs which reveal their concept in the *new form* will invariably be accepted. They will never be tedious. Certain basic rules continue to apply to good photo design. The subject must always create a stronger impact than it does in reality. An effective photo documentary by a photo journalist necessarily results in an intensified depiction of the actual event. On the other hand, advertising photos must magnify and enlarge the essence of the product, positioning it in a pseudo reality aimed at satisfying the personal longings of the onlooker. As for fashion photographs, there is only one criterion—pictures have to be fashionable in the very essence of the word, fashionable not only in content but also in their photographic style. They must be totally immersed in the zeitgeist.

Good photo design also means a departure from pictorial concepts accepted in the past. Obviously such new pictures are apt to provoke criticism. But we are all well aware of the fact that creativity is invariably closely linked to courage.

Who protects us against the flood of pictures? Television, cinema, video and innumerable periodicals inundate us with pictures. And technical photographic possibilities are simultaneously on the increase: cameras with computer-aided sophistication, digitalized photographs on a screen or alienated laser copies. The multifarious new possibilities appear to be unlimited. As taking pictures is always getting easier, there should, as a consequence, be an increasing number of excellent photographs. But this is not so. A paradoxical state of affairs? No! Because completely new quality criteria are developing in photography. "Emotional values" play a considerable part. The search is on for photographers who enrich their photos with their own personal perceptions and animate them with feelings. I can see this trend in both contract photography and in free and artistic photography. In future, the photo designer who wishes to be at the top of his profession will have to keep constantly abreast of cultural currents and trends. He will have to keep his eyes and ears open in the artistic and in the cultural fields. Photography will play a considerable part in the 90s as it will fulfil a significant function as an important means of communication in an increasingly closely integrated Europe. Both in economic and cultural spheres. The future role of the BFF will be to build international bridges to other creative groups. A great but also very promising challenge to all BFF photo designers!

Uwe Christian Duettmann
Food, 1990

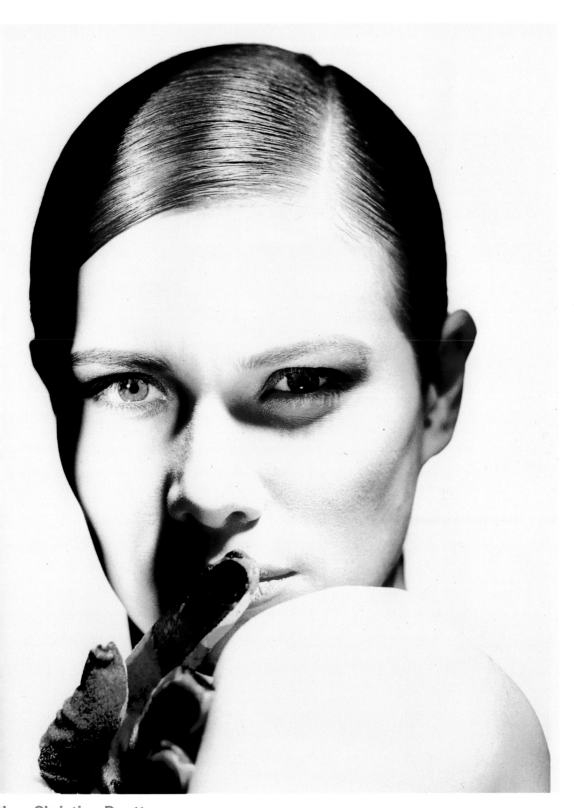

Uwe Christian Duettmann

fffffffff", 1986

Hubertus Hamm
Perfume phial, 1985

Jacques Schumacher
Olympus—0—Product, 1989

Hans Hansen
1980

Conny J. Winter
Two-Face, 1984

Dietmar Henneka

Kodak / Gondola in Venice, 1990

Thomas Pflaum
Our wealth is trashing itself to death, 1989

Michael Ehrhart
Country summer, 1991

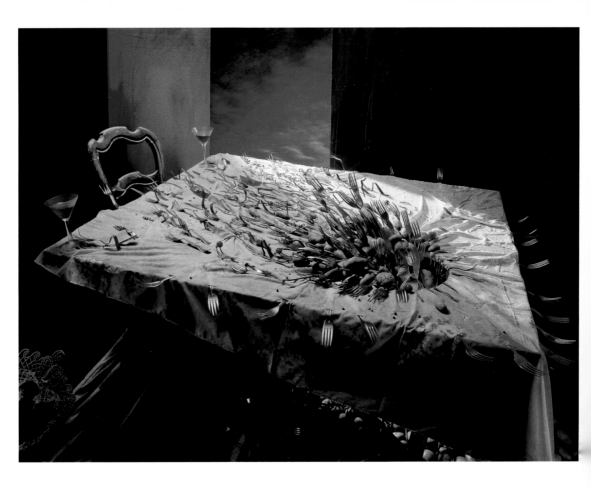

Gerhard Vormwald
The aggressive table, 1992

Gerhard Linnekogel
Wiegand Boning, 1995

Nico Weymann
Black, 1992

en Oyne
he victor, 1993

Werner Pawlok
Japan, 1989

38

Jochen Harder
Glaring bright fashion, 1989

383

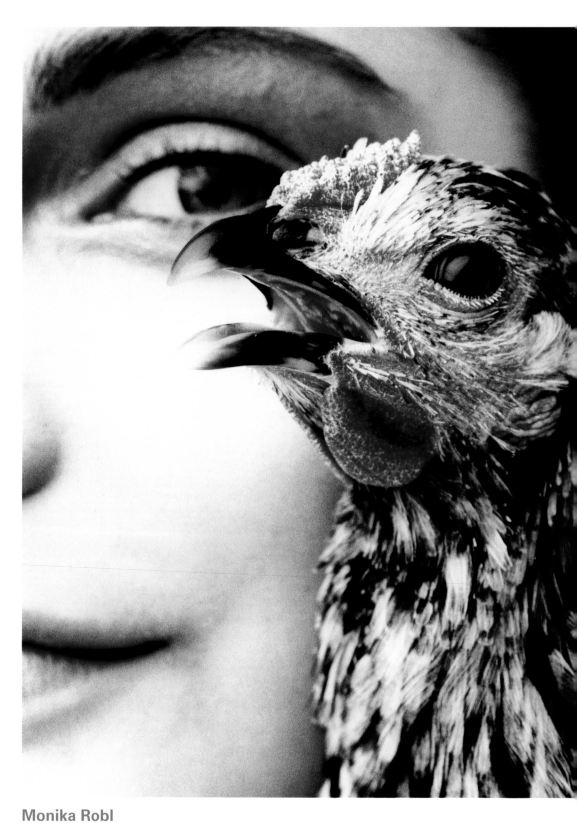

Monika Robl
Beauty series, 1994

Monika Robl
Beauty "sad eyes", 1994

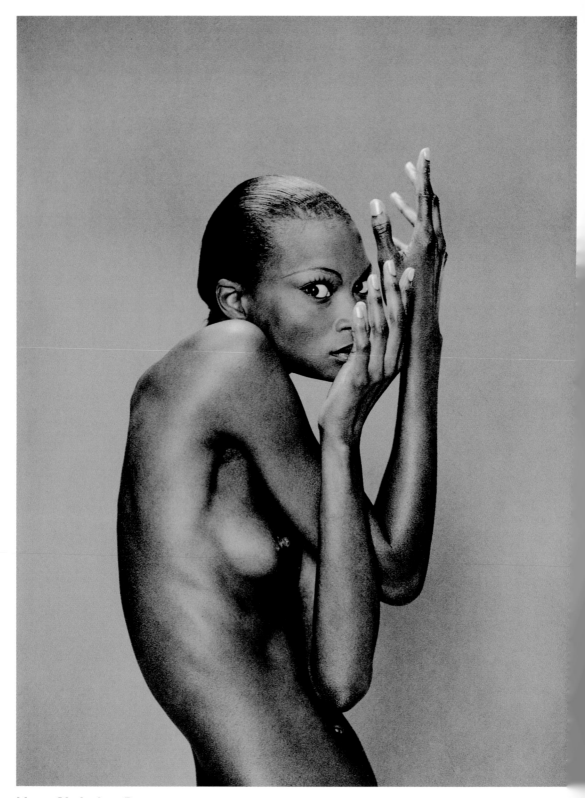

Uwe Christian Duettmann
"Yew", 1994

Guenter Derleth
Camera Obscura/ Ruta de la Plata, 1998

Alexander Haselhoff
1990

Hartmut Laube
1987

Erika Koch
Industrial portrait, 1988

Dieter Elsaesser
1991

Michael Wissing
Paper string, 1992

39

imon Puschmann
ologne Cathedral, 1992

Thomas Kettner
Unlimited Vision, 1992

Otto Kasper
Snow whisks in January, 1996

Bodo A. Schieren
Cauliflower, 1997

Hubertus Hamm
Water glass, 1997

Kay Degenhard
Bahama-Story, 1995

Martin Timmermann
Bartagame, 1996

Martin Timmermann
Rebecca, 1997

40

Bernd Sumalowitsch
Shirt collar, 1996

Conny J. Winter
Eurovision, Jorge Pensi / Spain, 1991

Rudolf Schmutz jun.
1992

Guenther Raupp
Twelve cylinders, 1997

Walter Cimbal
Forgotten vegetables / Black broad beans, 1997

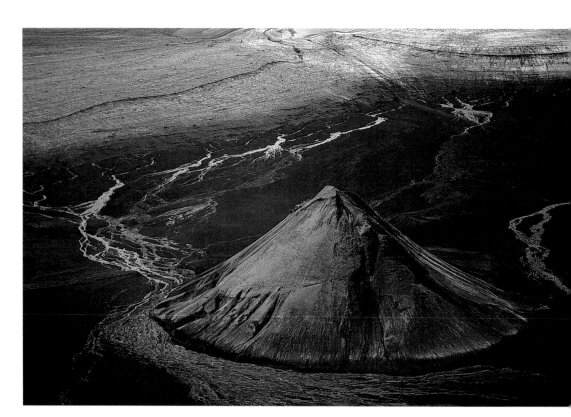

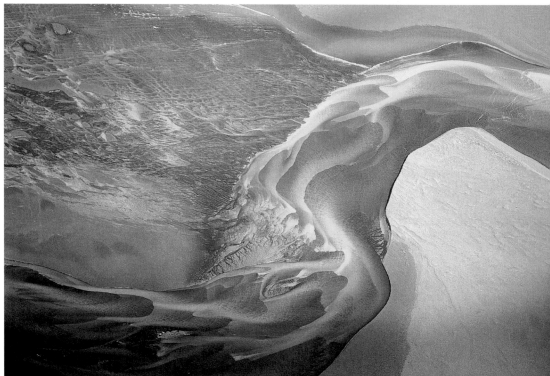

Klaus D. Francke

Maelifell at Myrdals Jökull (top) / Stream in Landeyjarsander / Iceland (bottom), 1991

Eberhard Grames
Iguana Lovers, 1990

Alexander Haselhoff
Mountain-Jogger, 1993

ake
avoy cabbage, 1993

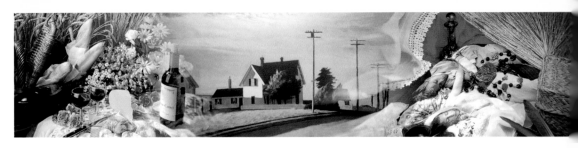

Heiko Preller
Breakfast—Liquor—Picnic, 1990

Tomas Riehle
Max Ernst / Island of Hombroich, 1993

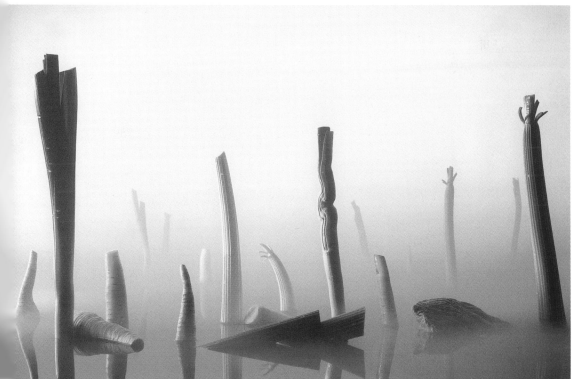

Hartmut Seehuber
Land of milk and honey (top), 1997 / Soups (bottom), 1996

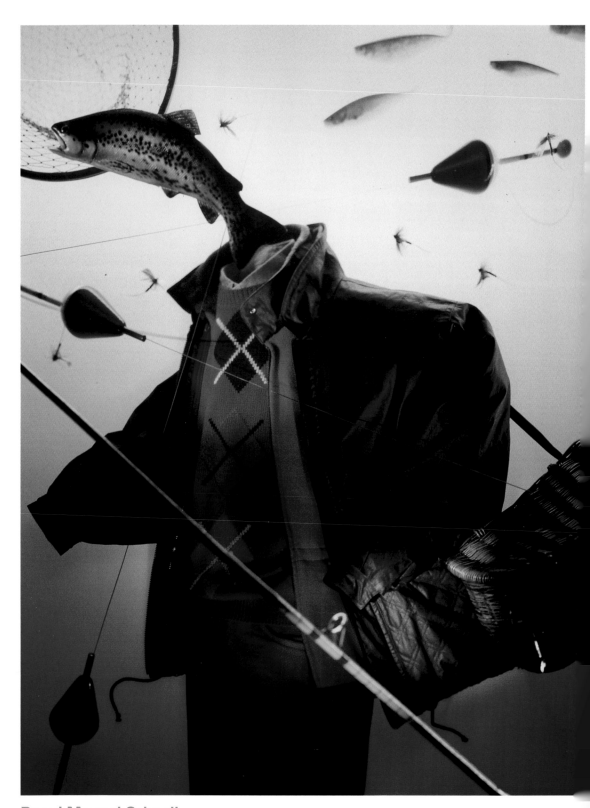

Raoul Manuel Schnell
Daniel Hechter, 1993

41

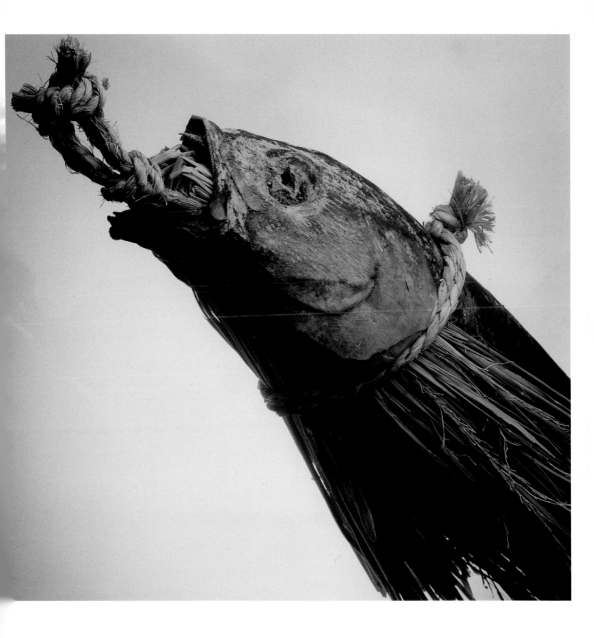

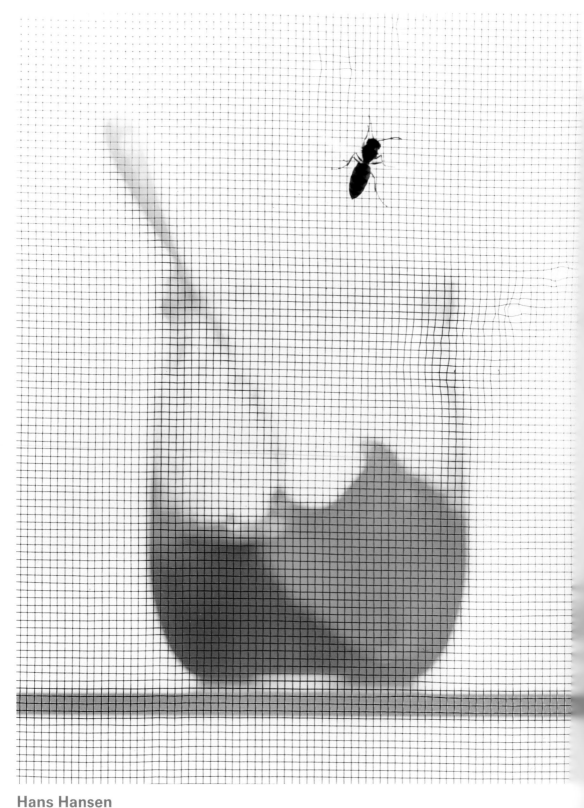

Hans Hansen
Jam / Stern food, 1994

Gerhard Linnekogel
Baywatch L. A., 1998

Julia Hoersch
Fish—Siebecks Summer Seminar, 1994

Michael Wissing
Cherry tomato, 1994

Christian Stoll
1996

Walter Cimbal
Basil, 1996

Edmond Laufer
Georgina II, 1997

Wolfgang Gscheidle
Thermos flask "Alf", 1994

429

Jan Kornstaedt
Lemon press (top), 1995 / Rump steak on a fork (bottom), 1995

an Kornstaedt
Mixer (top), 1995 / cucumber slicer (bottom), 1995 431

Christian von Alvensleben
Lobsters hate Christmas, 1985

Eberhard Beneken
Karafe, 1993

Hans Hansen
Viscose, 1990

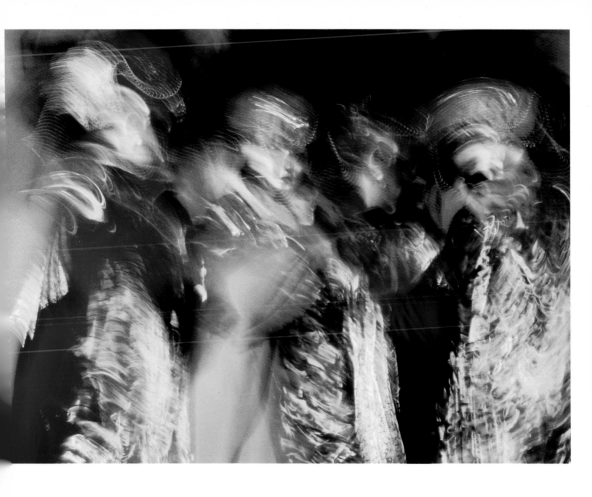

ieter Steffen
arnevale a Venezia, 1996

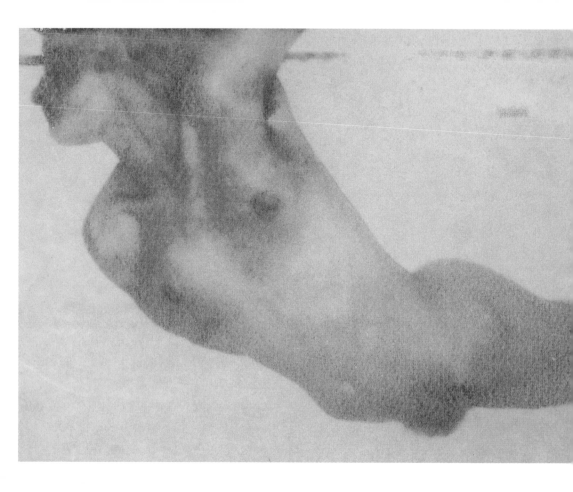

Bernd Fessler
Nude, 1989

Claudia Schiffner
Arab horses, 1998

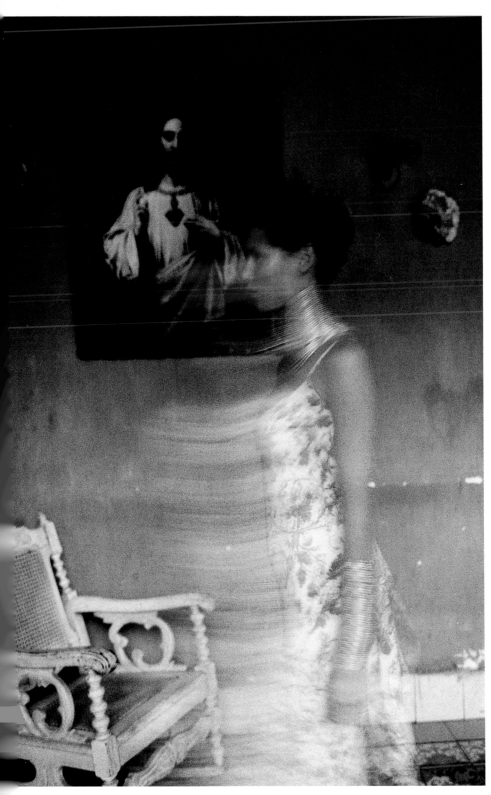

Esther Haase
Havanna, 1998

Florian Geiß
1998

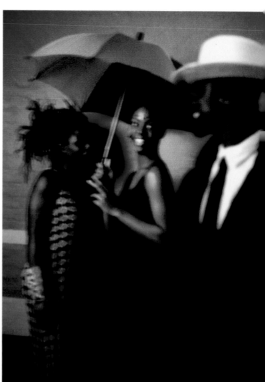

Manu Agah
Dance Café, 1997

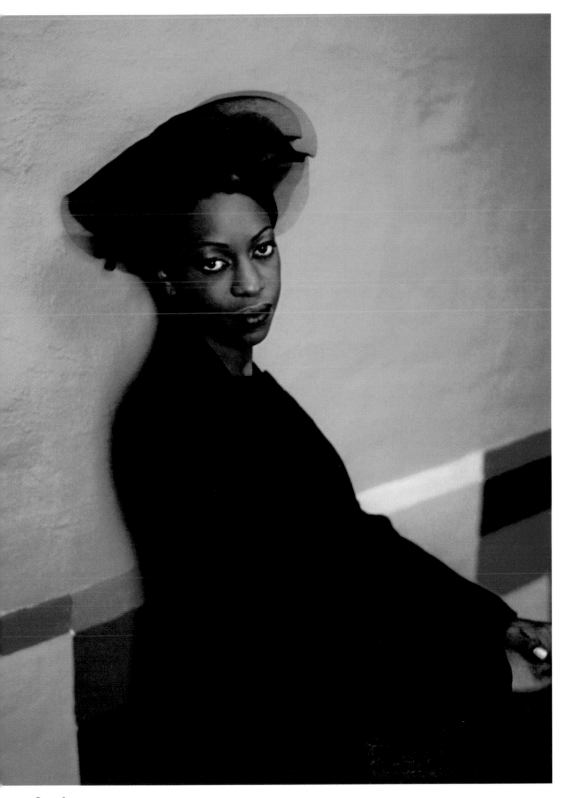

anu Agah
ance Café, 1997

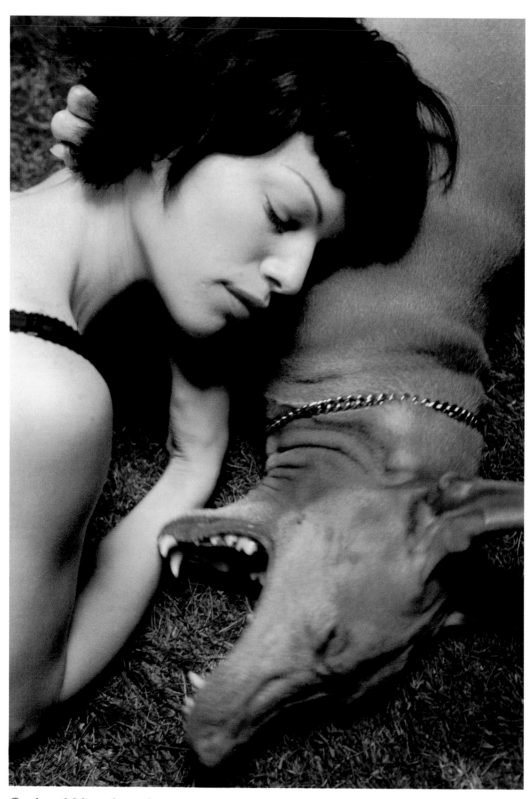

Gerhard Linnekogel
Casa la femme, 1997

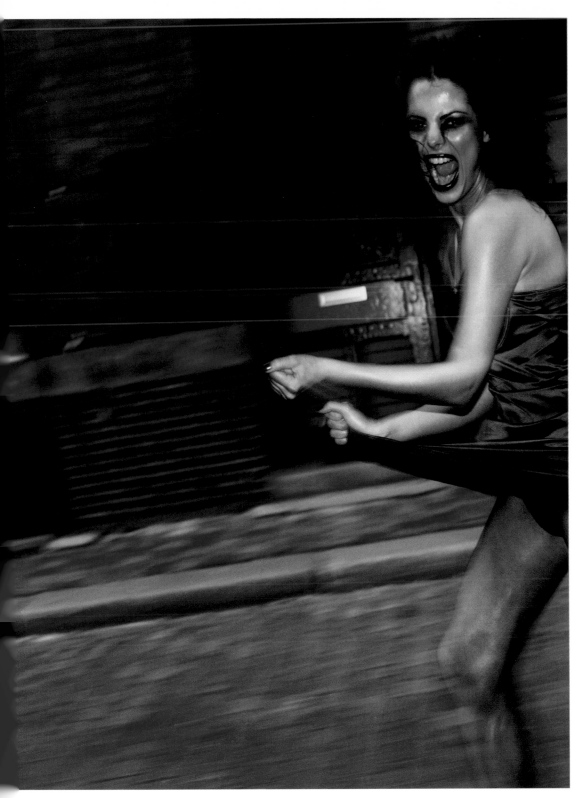

Andreas Dahlmeier
1992

ay Degenhard
ahama-Story, 1995

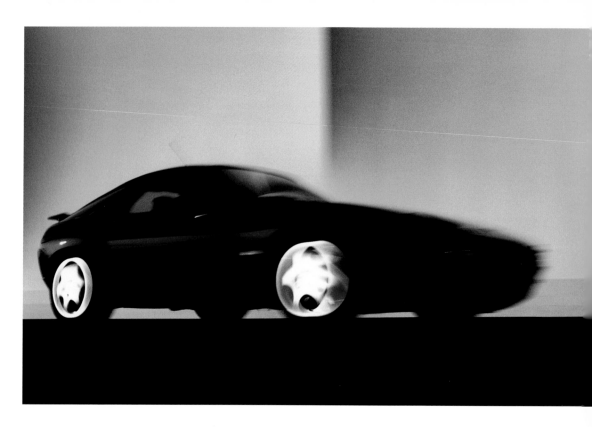

Uwe Christian Duettmann
P 928, 1995

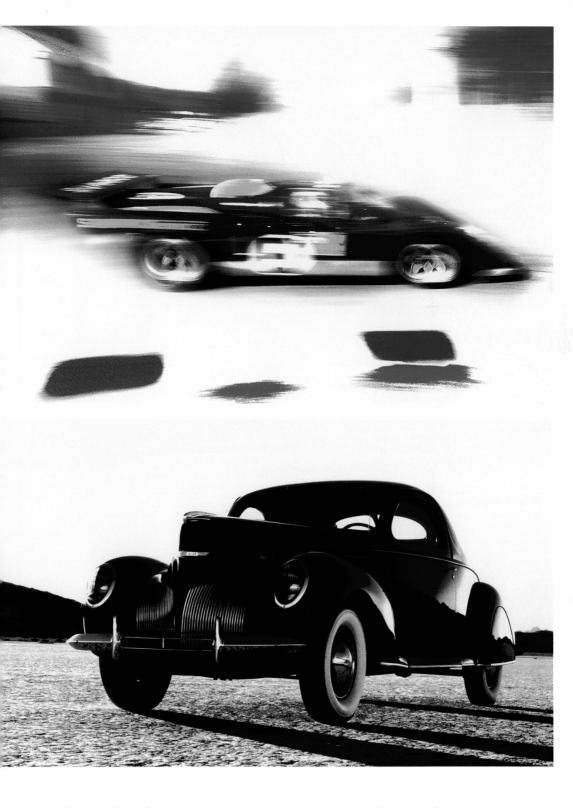

Gert von Bassewitz
1995

Markus Meuthen
1997

we Christian Duettmann
98

Frieder Blickle
Above Manhatten, 1996

Nico Weymann
Viper, 1996

"I'm just trying to picture it," someone says. But he does not mean a picture with a paintbrush or with a camera, he means in his reality and his imagination. Someone else says, "you didn't see that properly" and he does not mean that the person was looking at something definite, but that he did not "picture" the particular event, person or object correctly.

We live in a pictorial world of reality, illusion and imagination. On remembrance days in our current era of gloom we like to conjure up the crises of the day, whether they be social or ideological, political or ecological, artistic or philosophical—an elimination of the essence of life. They are said to be based on outmoded conceptions of the world in a world which is changing radically. Our design professions see, characterize, interpret and show these pictures of the world. We lay down signs of the time and capture instants. Is this done with sufficient responsability? In order to consider this, one must first bid farewell to speed, the spirit of the age, and slow down one's thought processes to compensate for one's own deficiencies. The composition of life and the creation of values cannot be shackled to cost/benefit philosophy. Slower thought processes give intuition a chance. We go from inspiration to understanding, through understanding to knowledge, thence to judgment and from judgment to values. From there we continue to greater understanding, to wider knowledge, to more mature judgment, more secured values and so on. It is these steps to control our own actions which prevent actionists from treading water. Because the speed and quantity of the things with which we are bombarded is not designed to be understood and digested but to be seen and forgotten. Here, however, no more clearly focussed images can be impressed on our retina. The assistants speed and quantity will run out of work. Wherever there is sufficient money and insecurity to keep pace with every new fashion at polaroid camera speed and to piece together a life style from glossy magazines it will be impossible to call a halt to the much deplored contemporary crises. Here one can only move within the prefabricated norms of consumer society and stay as flat as the paper on which the picture world has been modelled. Of course we need pictures of mouth-watering menus

radiantly beautiful clothes, of wanderlust evoking mountains, valleys and coastlines - aphrodisiacs. And these pictures should prove their unique and independent nature by teaching us how to differentiate and distinguish between "artistic and artificial, emotional and gushing, ceremonious and unctuous, enthusiasm and hollow Pathos". And we need new pictures generated from the mental power of understanding and the strength of the heart; pictures which seek to become liberated from the unrest of the heart and the confines of the skulicap. Pictures which can be found along the back of the Decalogue of the zeitgeist. Pictures which derive their inspiration from a state of irritation. Pictures which shy away from collective content. And something is not only new just because it can dispense with beauty. The professional photographer's window frame way of looking at the outside world can, on the one hand, serve to limit his store of ideas or, on the other hand, result in his perspective becoming concentrated and exact, thus enabling the actual picture to come into its own. As Cezanne put it, "The path to truth does not allow for any detours." When a painter pushes his thumb through his palette, he is not yet aware of the verbal opacity which his picture will have. When the photographer releases the shutter he has already experienced his picture's address. And the language must be forceful enough for the beholder to follow it somewhere he did not even want to go, somewhere that he knew nothing about. Anything else is mere copy, at best a clever feat, but by no means a work of art. It is not important to count the number of films a person has exposed but the number of eyes he has enlightened. But this does depend on the values of the beholder; whilst one person merely sees something, another has perceived something and gained understanding. Photography is a static medium. A picture shows neither past nor future. Decisive people are required. People with telescope eyes and individually targetted shots who outclass the photographers with the machine-gun mentality who do not see what they have shot until after it has happened. Nor does the significance of photography lie in darkroom cosmetics, touching up, montage or collage. Art has accomplished all of these things better and normally earlier too.

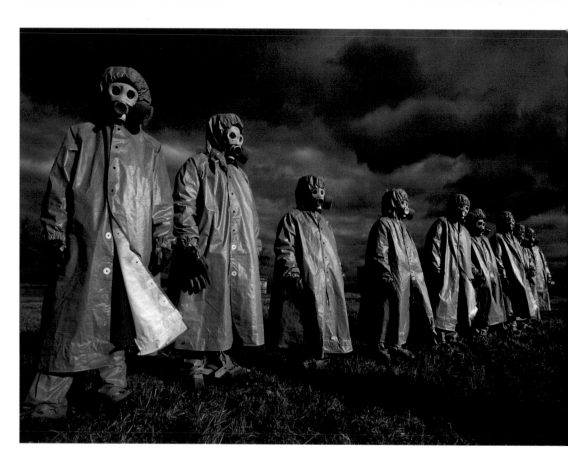

Hans-Juergen Burkard

Training for atomic, biological and chemical warfare »Kantemirow«, 1990

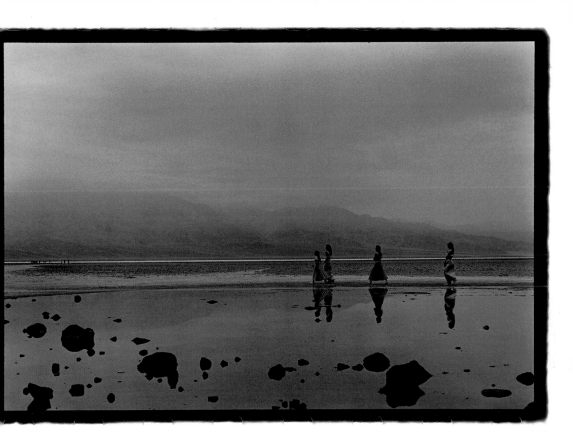

Peter Hoennemann
Landscape, 1994

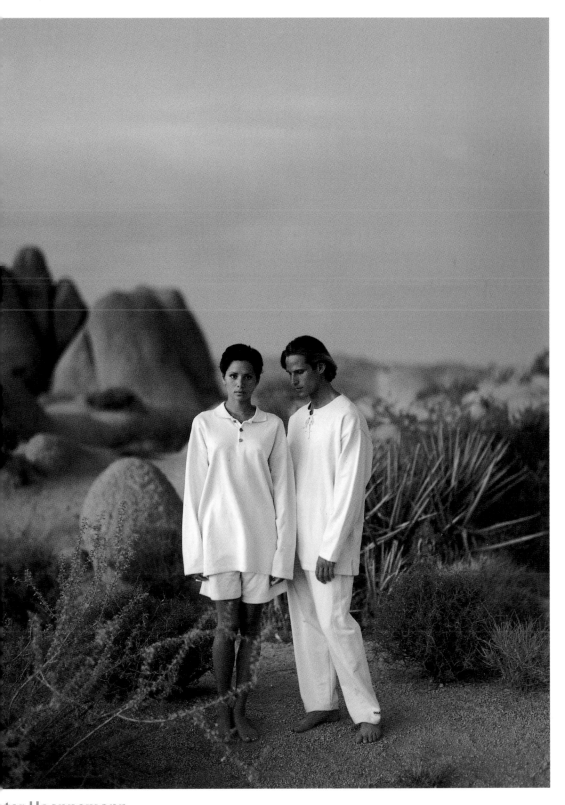

eter Hoennemann
shua Tree / California, 1994

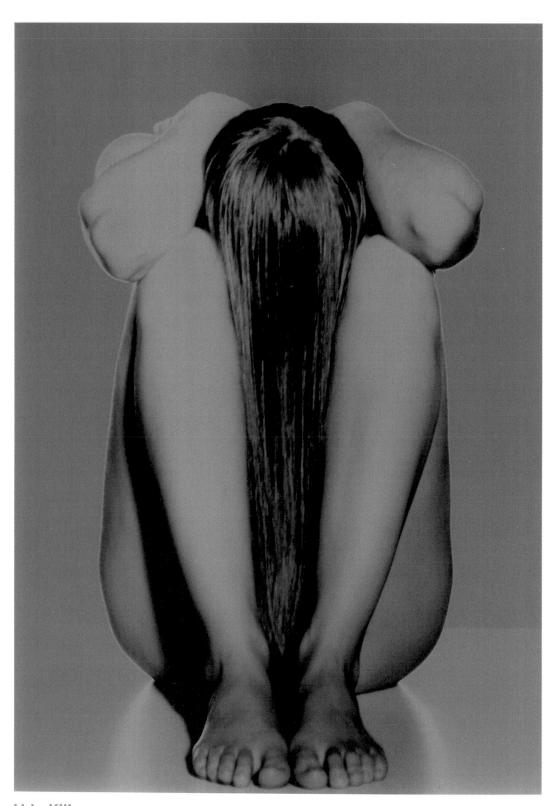

Udo Kilian
Aline, 1998

4

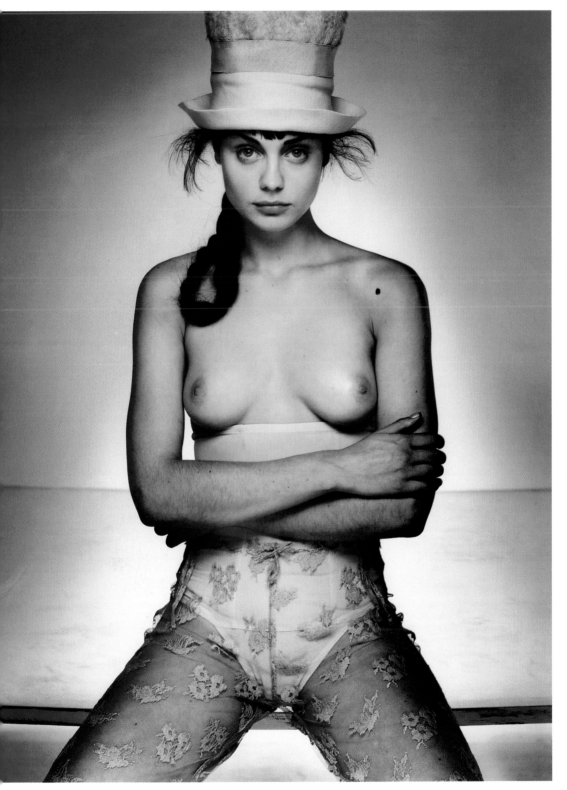

Edgar Lissel
Rooms / Photographic deconstructions, 1997

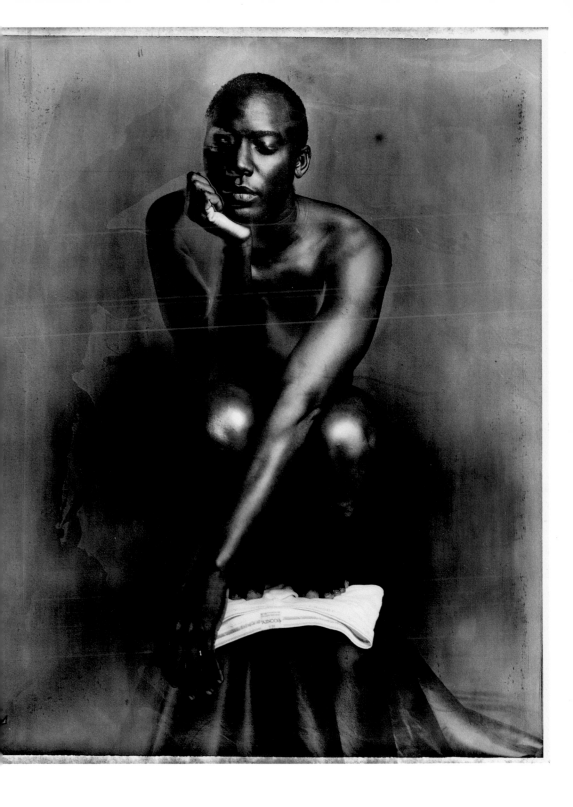

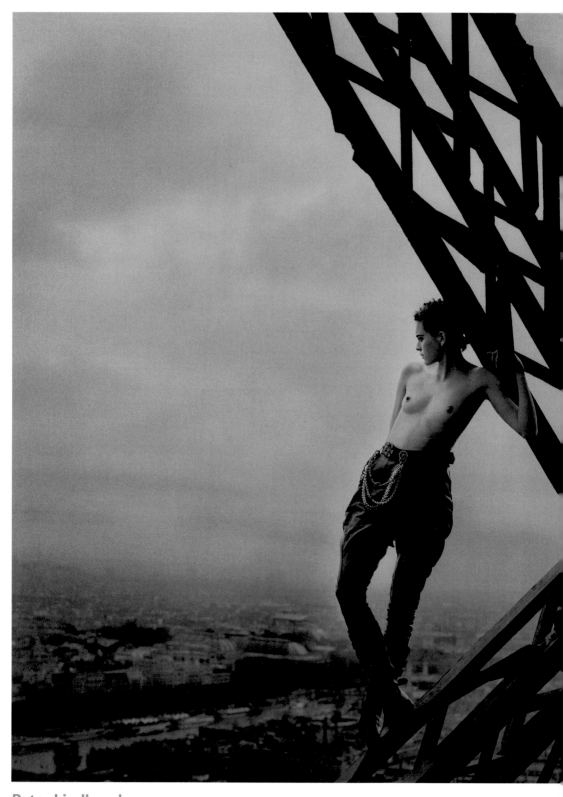

Peter Lindbergh
Mathilde on the Eiffel Tower / Homage to E. Blumenfeld and M. Riboud, 198

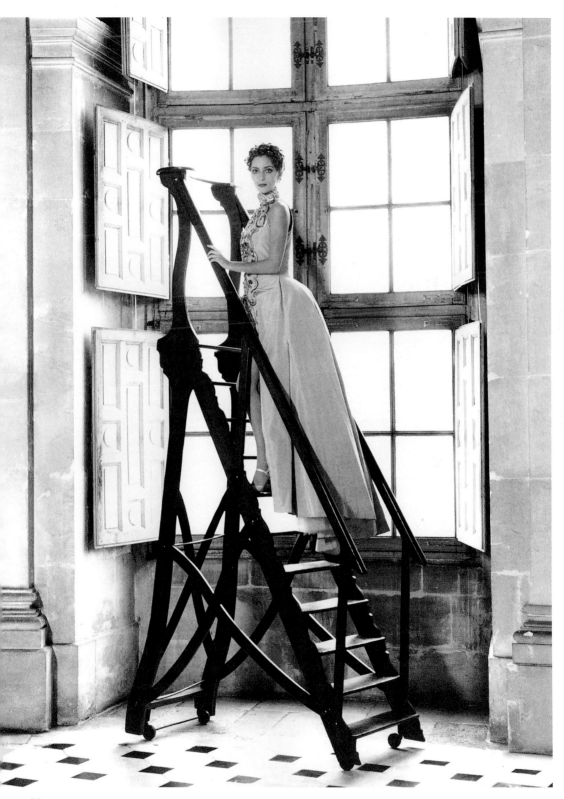

Peter Hoennemann

...cie de la Falaise, 1991

Tom Nagy
1997

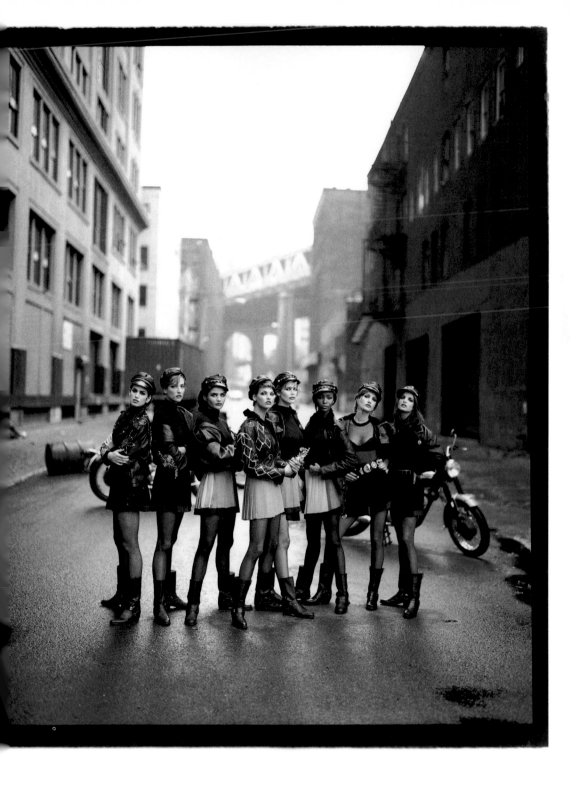

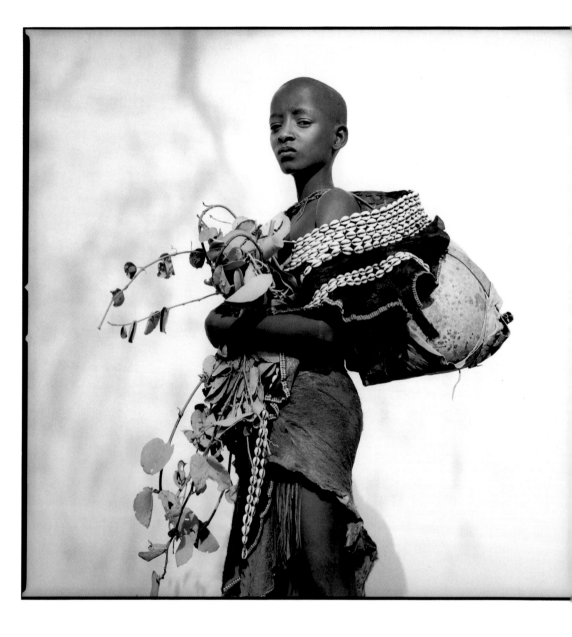

Guenter Pfannmueller
Zamai woman / Southern Ethiopia, 1996

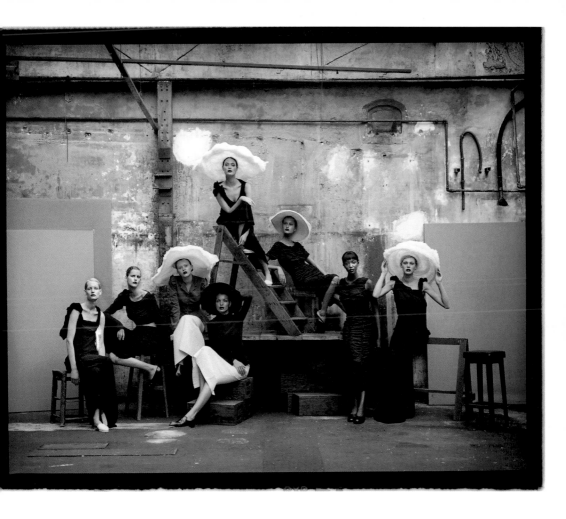

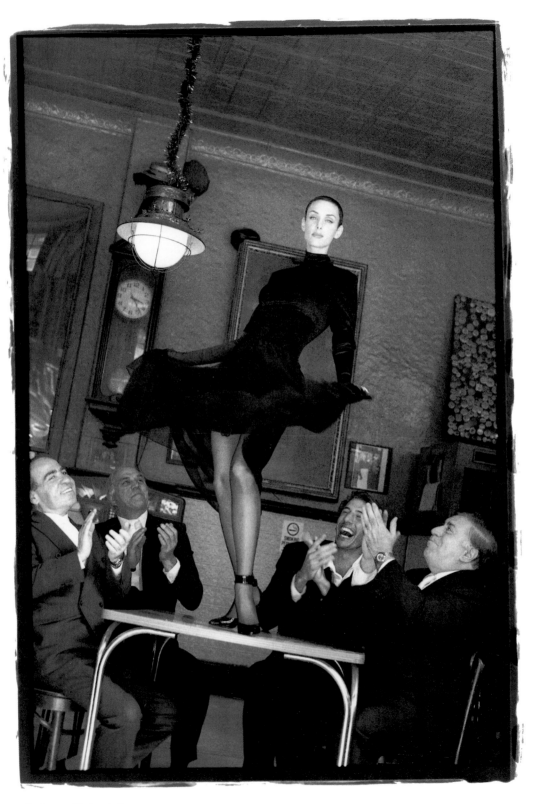

Holger Eckstein
Dancing on the table for Comma, 1994

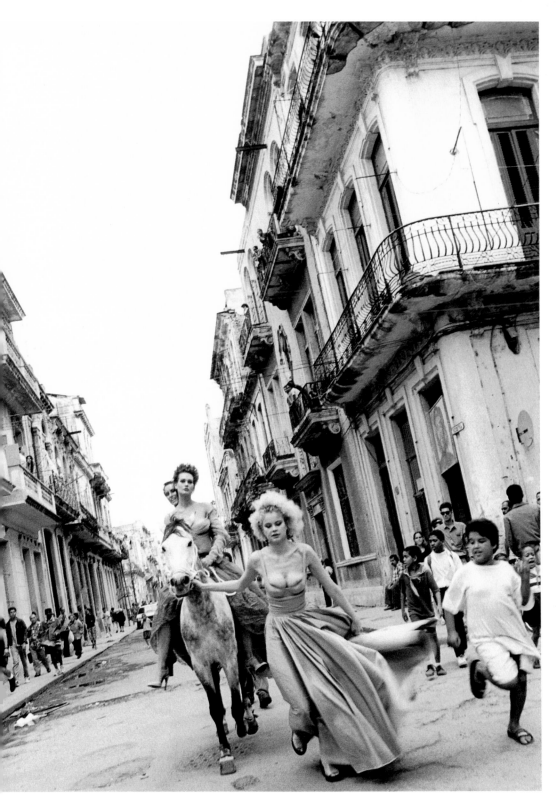

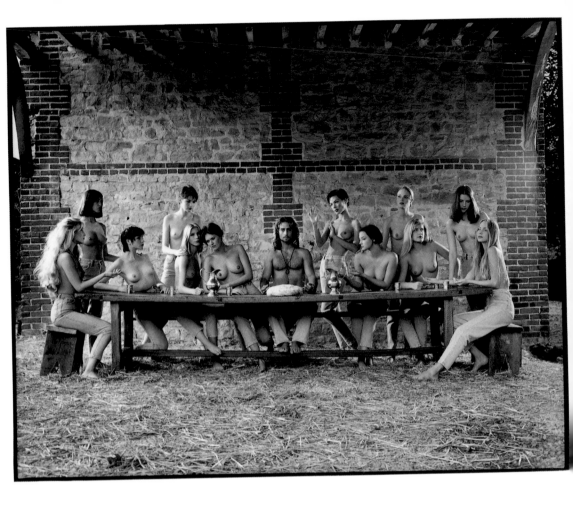

Horst Wackerbarth
The last supper (female) / Lisieux-Normandy, 1993

47

Conny J. Winter
Zodiac, 1993

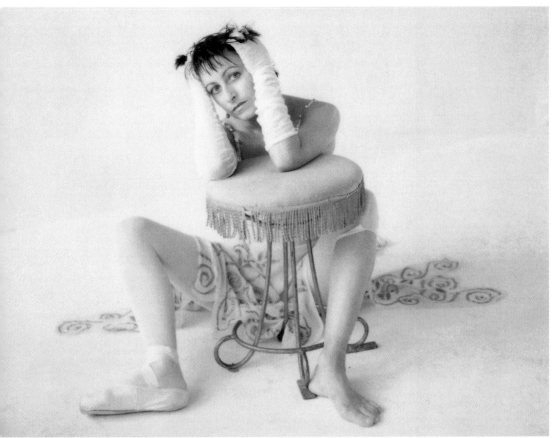

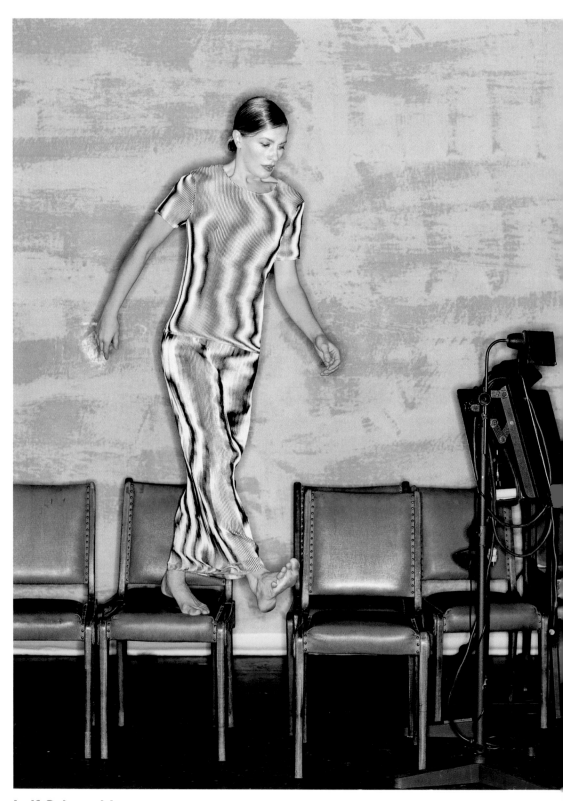

Leif Schmodde
Fashion by Issey Miyake "danced" by Christal, 1996

4

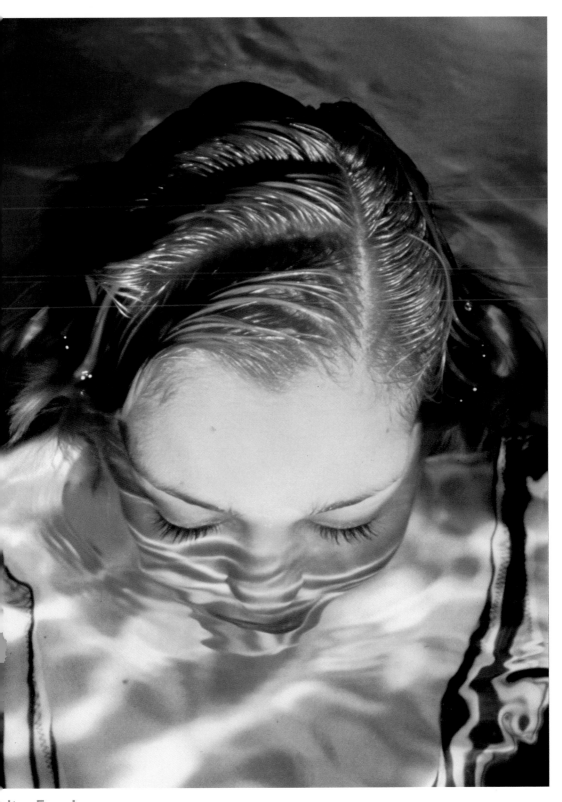

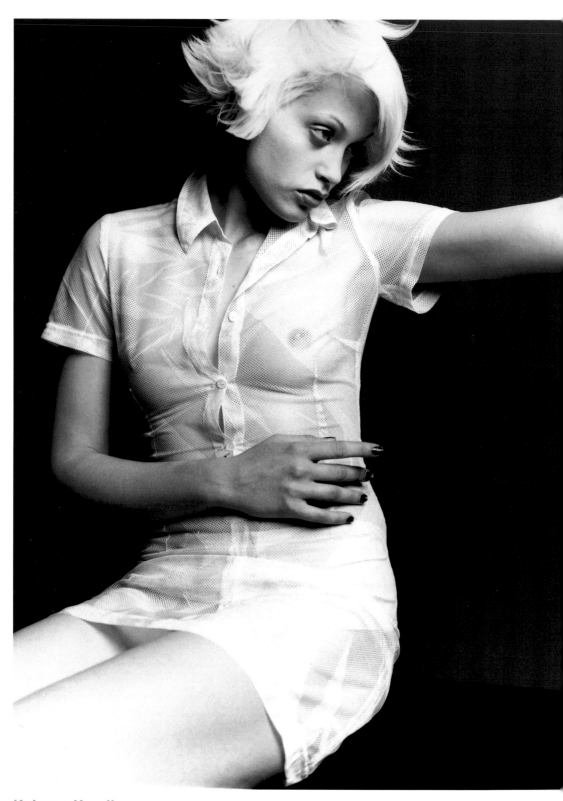

Kajetan Kandler
Leslie, 1998

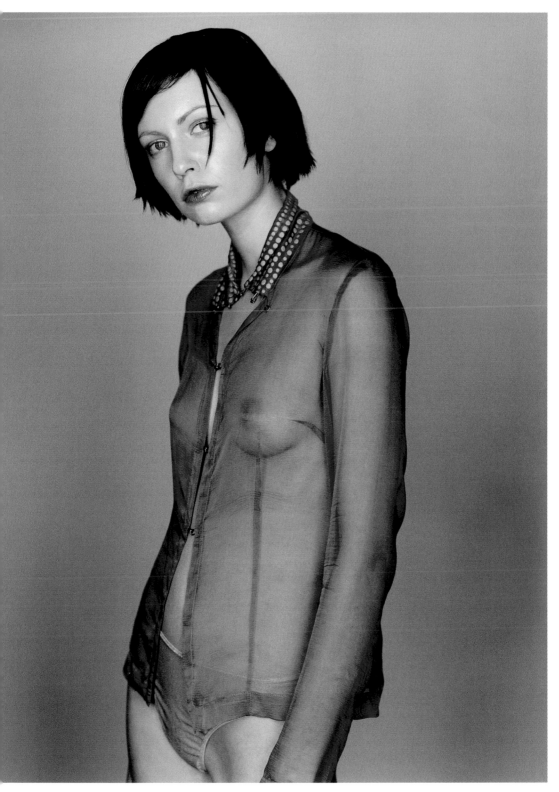

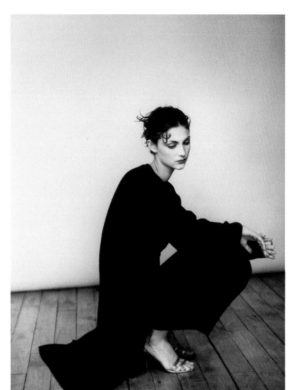
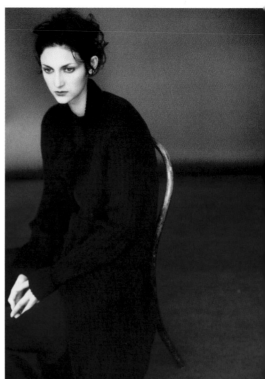

Esad Cicic
1997

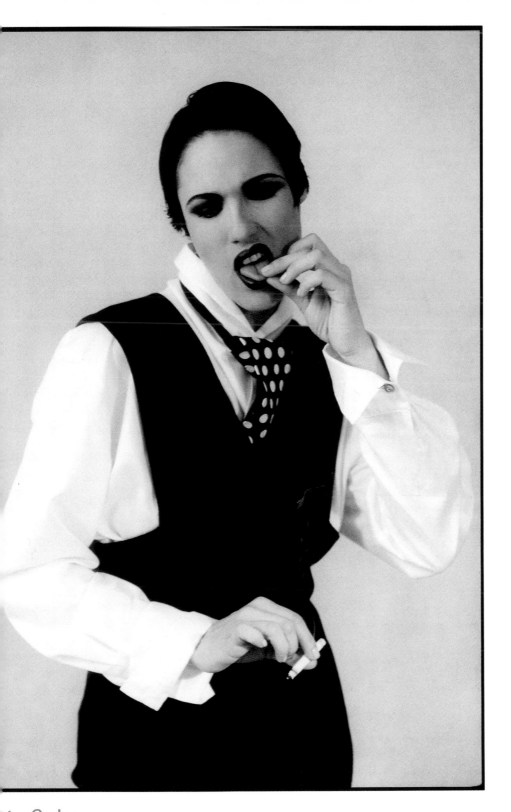

Peter Godry
Smoke, 1993

Peter Godry
1990

Andreas Klehm
Princess, 1997

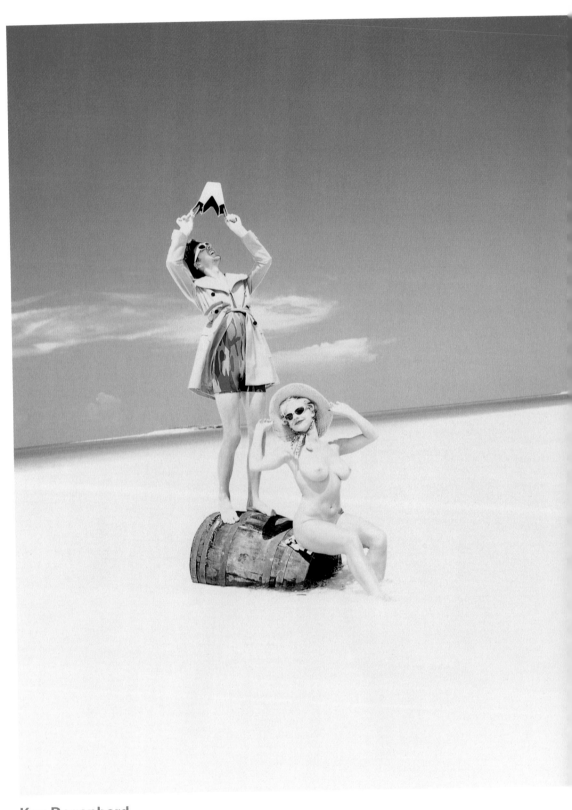

Kay Degenhard
Bahama-Story, 1995

Michael Dannenmann
The sheep, 1997

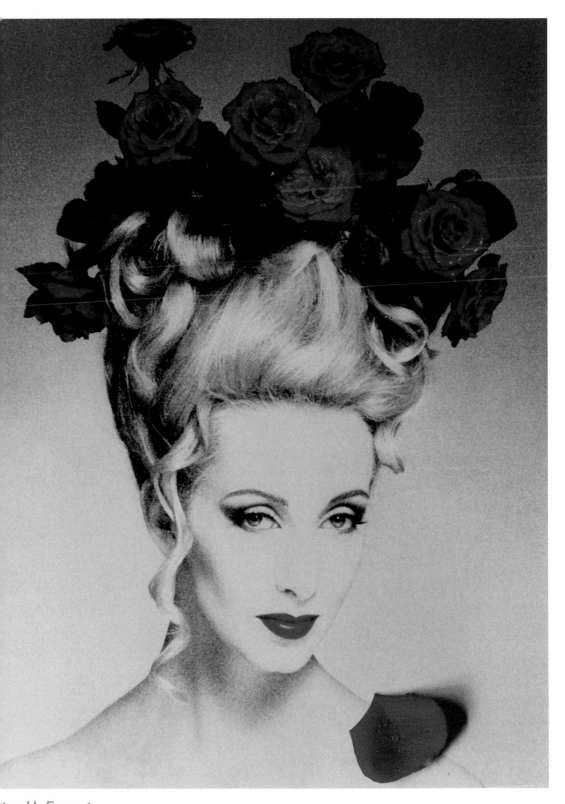

ter H. Fuerst

a Rosière" Photo Installation, 1995

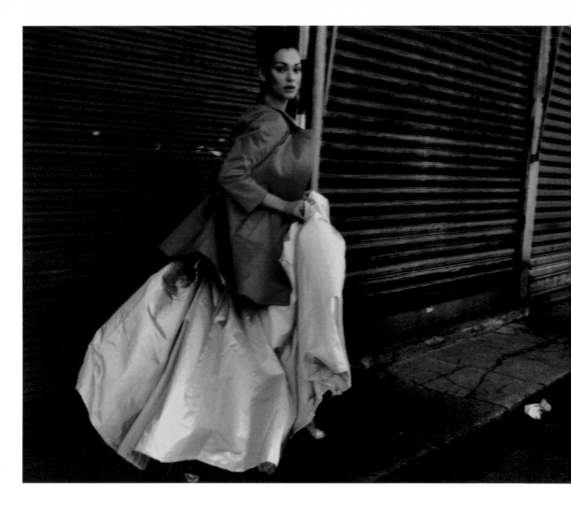

Chico Bialas
Clignancourt, 1997

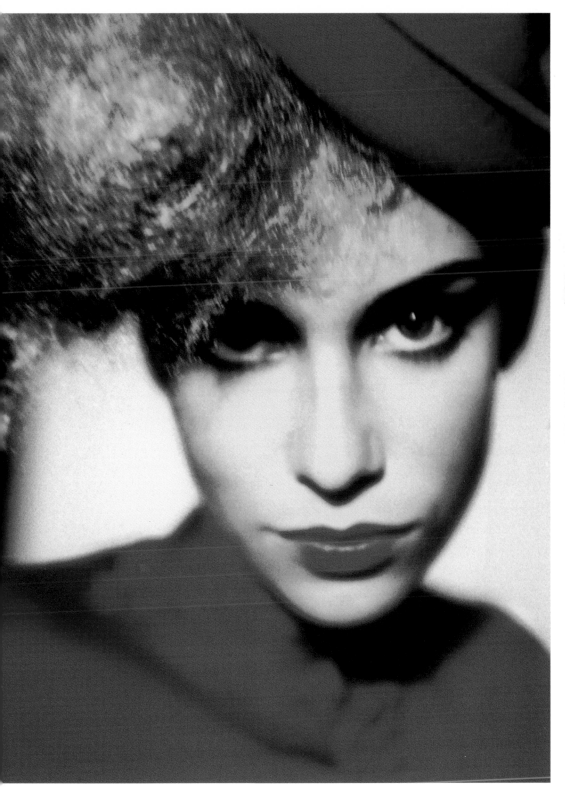

erhilde Skoberne

ed, 1997

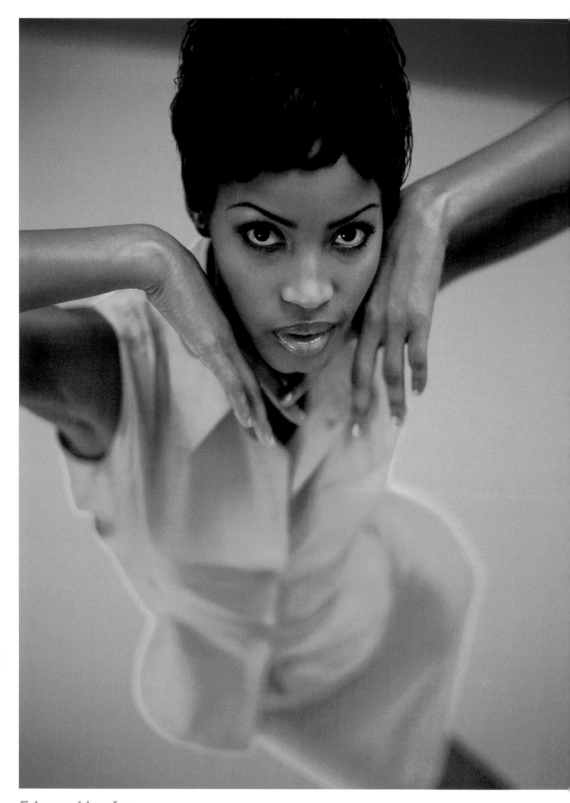

Edmond Laufer
Georgina I, 1997

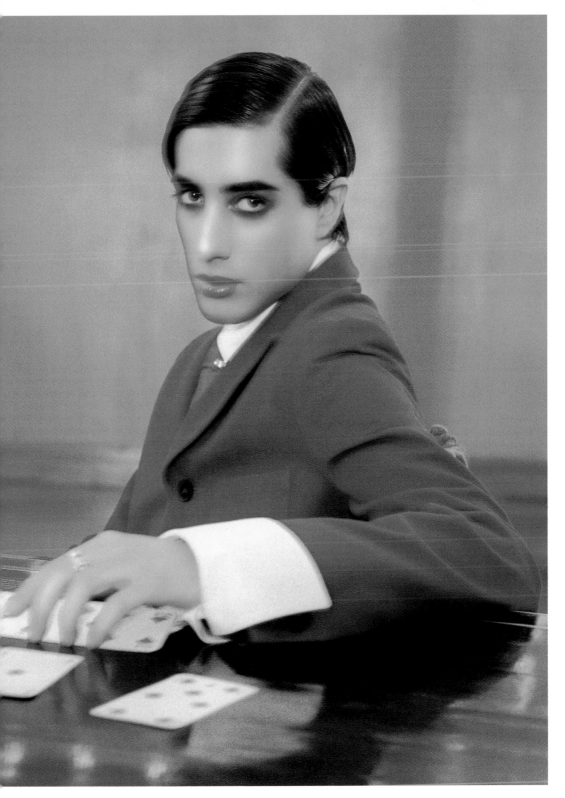

Juergen Altmann
1996

Juergen Altmann
1994

Gerhilde Skoberne
Blue, 1997

Iver Hansen
Chrysler, 1998

Peter Keil
Zeppelin S. F., 1997

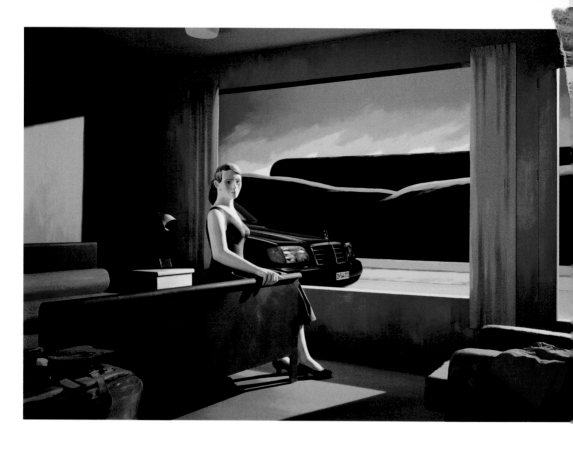

Dietmar Henneka
Western Motel / Homage to Edward Hopper, 1991

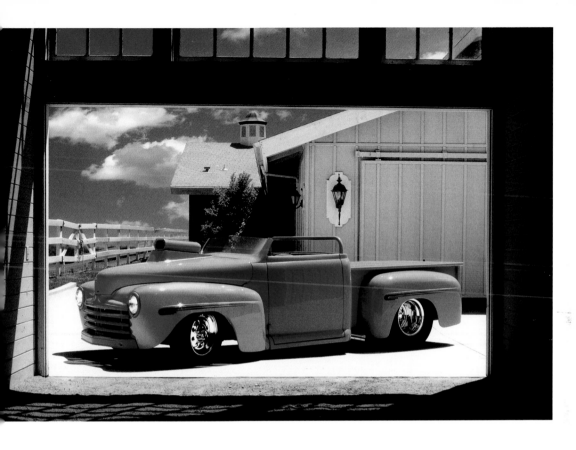

Christoph Seeberger
Vitra, 1996

alph Richter
on maiden, 1998

509

Wolfgang Schwager
Cultural worlds, 1993

er Hansen
ord Custom Cars, 1995

Christian von Alvensleben
Hare (from the apocalyptic menu), 1992

5

ainer Stratmann
ndscapes in Anatolia, 1995 / 1993

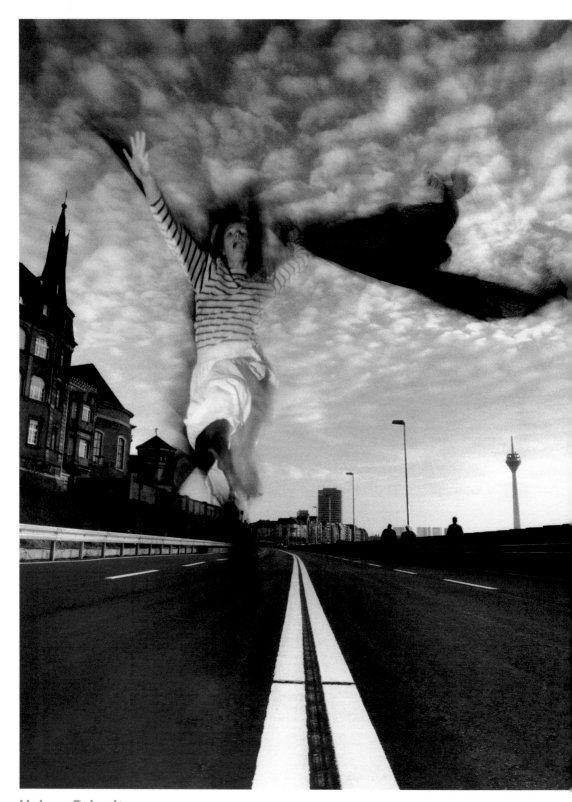

Heiner Schmitz
1990

5

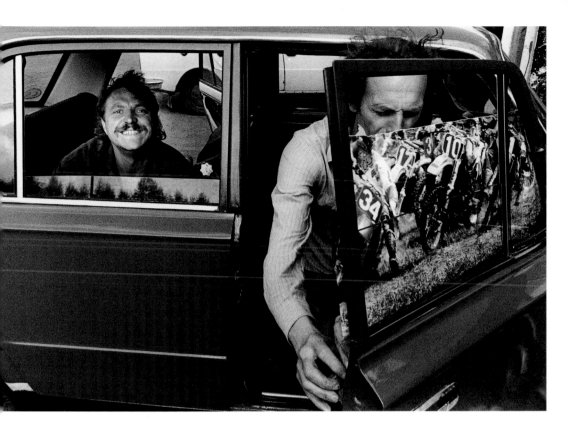

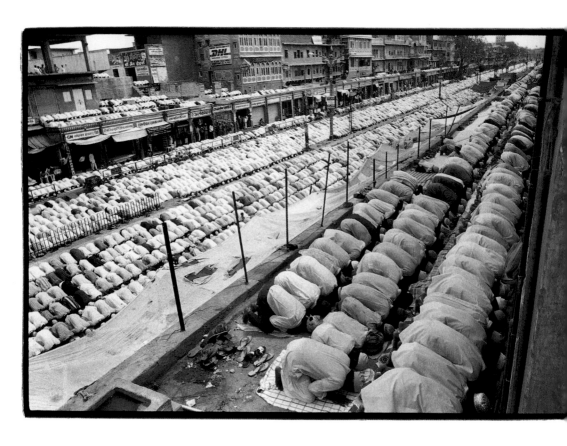

Axel Nordmeier
Praying Moslems / India, 1991

5

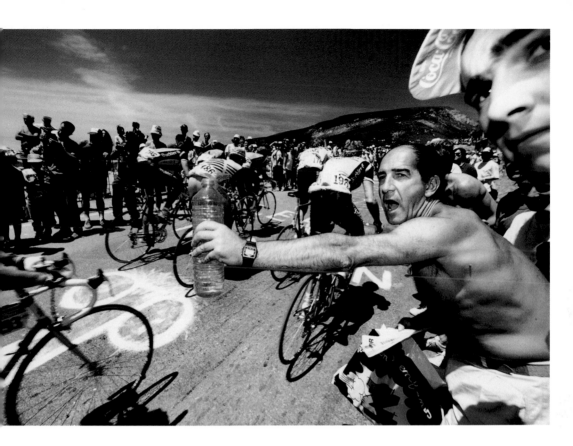

Christiane Marek / Christoph Seeberger
Skies of the Bavarians, 1987

Hans-Juergen Burkard
Burning rain forest in Rondonia / Brazil, 1987

Petra Senn
Prison for Female Convicts, 1991

Hans-Juergen Burkard
Sauna at the camp for severe female offenders in Beresniki in the Ural / Russia (top), 1993
Convicted criminals at the Sima labour camp for particularly dangerous inmates (bottom), 1989

524

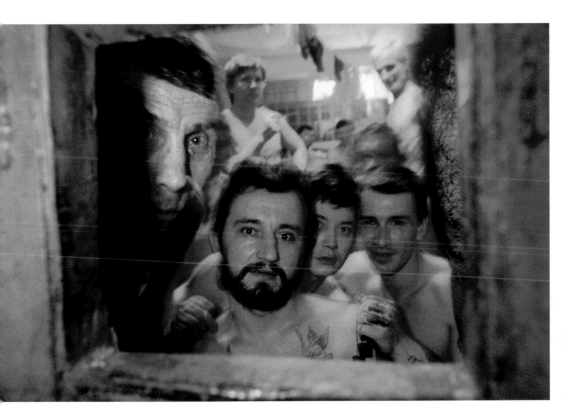

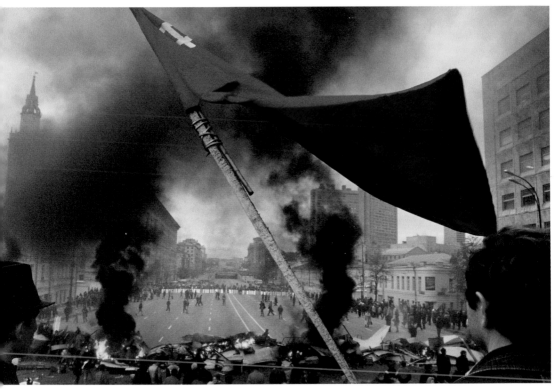

⁀ns-Juergen Burkard
⁀nand prison »The Cross« in St. Petersburg (top), 1991
⁀ning barricades before the storm on the »White House« in Moscow (bottom), 1993

Hans-Juergen Burkard
Cell for juvenile vagrants / Yaroslavl station / Moscow, 1991

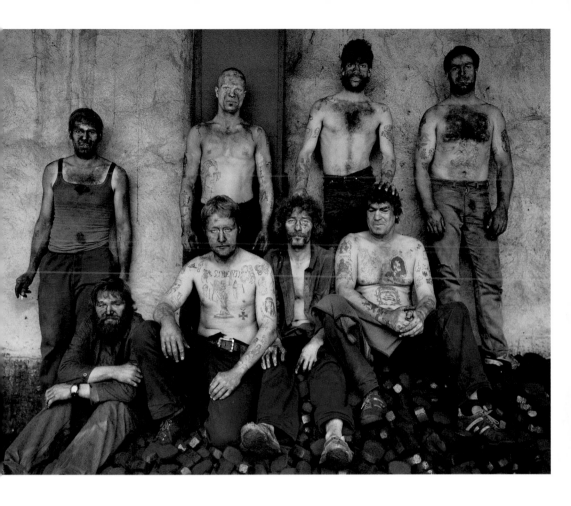

Eberhard Grames
Coal tugs / GDR, 1989

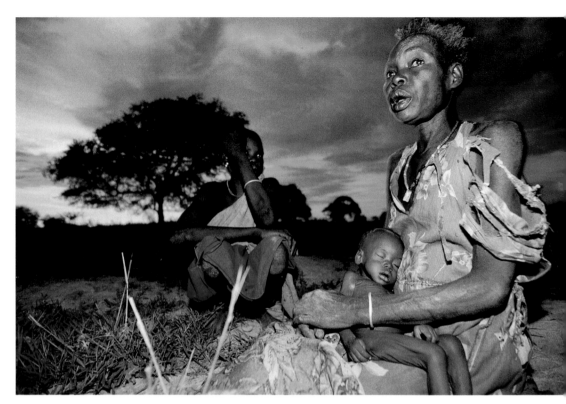

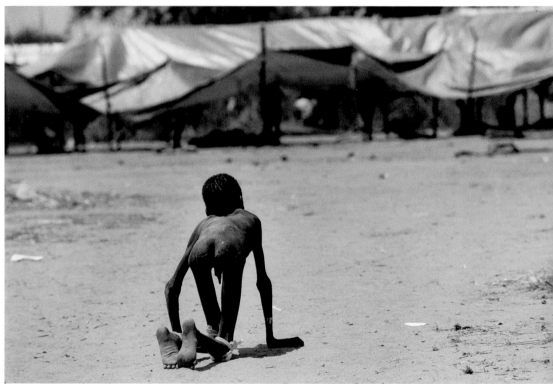

Hans-Juergen Burkard
Famine in the Sudan / Women with dead child (top), 1998

5

we H. Seyl

om the new world, 1987

The Photographers in the Portfolio
Summary

Production Team

Publisher

BFF Bund Freischaffender Foto-Designer e.V.
PO Box 750330, D-70603 Stuttgart,
Tel. 0711 / 47 34 22, Fax 0711 / 47 52 80,
e-mail: BFF_de@csi.com, http://bff-pilot.igd.fhg.de

Curator

Manfred Schmalriede, Pforzheim

Articles by

Rainer Dick, Prof. Dr. Hellmuth Karasek, Walter E. Lautenbacher,
Dr. Hans Scheurer, Prof. Manfred Schmalriede, Jacques Schumacher,
Prof. Kurt Weidemann, Ruprecht Skasa-Weiss, Conny J. Winter

Pictures Selected by

Hans Hansen, Manfred Schmalriede

Articles Selected by

Manfred Schmalriede

Editor

Norbert Waning

Overall Co-ordinator and Producer

Norbert Waning

Assistant and Text Processing

Jan Merker

Cover Photographs

Christian von Alvensleben

anslations

Rosalind Kessler

xhibitions

This publication is to accompany the exhibition »Zeit Blicke« which
will be presented by the BFF at the Museum fuer Kunst und Gewerbe
in Hamburg in 1999, in the Galerie der Stadt Stuttgart in the year
2000 and thereafter at venues worldwide.

oordination of the Exhibition:

Norbert Waning

1999

Photographs: The picture authors

Texts: The text authors

Despite intensive research it was not always possible to identify
the copyright owners. Please advise the BFF if necessary.

thography

Bruellmann-Reprotechnik, Stuttgart

roduction

Dr. Cantz'sche Druckerei, Ostfildern-Ruit

ublished by

Hatje Cantz Verlag

Senefelderstrasse 12, D-73760 Ostfildern-Ruit

Tel. 00 49 / 7 11 / 44 05-0, Fax 00 49 / 7 11 / 44 05-220

http://www.hatjecantz.de

rinted in Germany, 1999

ISBN 3-7757-0863-4 hard cover (German trade edition)

ISBN 3-7757-0870-7 hard cover (English trade edition)